CINCINNATI
FROM RIVER CITY TO
HIGHWAY METROPOLIS

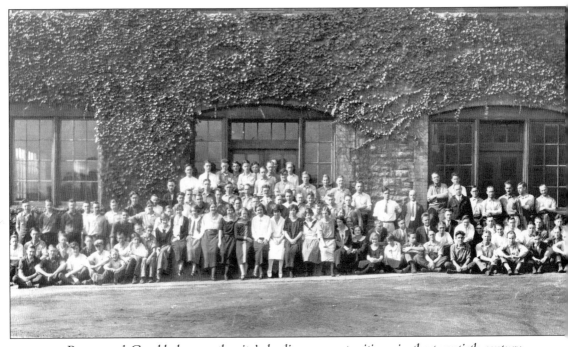

Procter and Gamble became the city's leading corporate citizen in the twentieth century through its remarkable growth, fueled largely through product development and excellent marketing. Here chemists stand outside the Ivorydale plant. (Courtesy of Procter and Gamble Company.)

THE
MAKING OF AMERICA
SERIES

CINCINNATI
FROM RIVER CITY TO HIGHWAY METROPOLIS

DAVID STRADLING

ARCADIA
PUBLISHING

Published by Arcadia Publishing
Charleston, South Carolina

Printed in the United States of America

Library of Congress Control Number: 2003107131

For all general information contact Arcadia Publishing at:
Telephone 843-853-2070
Fax 843-853-0044
E-mail sales@arcadiapublishing.com
For customer service and orders:
Toll-Free 1-888-313-2665

Visit us on the Internet at www.arcadiapublishing.com

Front cover: *What could be more patriotic than baseball in Cincinnati in the 1940s? (Courtesy of the Cincinnati Historical Society Library.)*

CONTENTS

ACKNOWLEDGMENTS

In writing this book I have relied almost completely on the hard work of other historians. The format of this series does not permit footnotes, but I would like to acknowledge the historians whose work has been most helpful to me. Zane L. Miller has long been Cincinnati's most important historian, and his work has been critical to my thinking about this city. Other accomplished historians have also produced important work on the Queen City, including Carter G. Woodson, Richard Wade, Carl Condit, Steven J. Ross, and Daniel Aaron. I have also found the work of several other authors to be of great help, including that of John Clubbe, whose *Cincinnati Observed* is a wealth of information. I have learned from works by Walter Stix Glazer, Stanley Hedeen, Millard Rogers, and Don Tolzmann. I would also like to thank my University of Cincinnati history graduate students, many of whom have conducted fine research on the history of Cincinnati, with special thanks to Gregory Long and Suzanne Maggard.

I am deeply indebted to the staff at the Cincinnati Historical Society, especially Ruby Rogers and Linda Bailey, who were instrumental in helping me acquire the majority of the images contained in the book. I am also indebted to the Taft Memorial Fund at the University of Cincinnati, which provided critical financial aid in acquiring the images. I would also like to thank Ed Rider and Lisa Mulvany at the Procter and Gamble Corporate Archives for their aid in acquiring images from their collection, and Kevin Grace and Katherine Lindner of the University of Cincinnati Archives. Kevin was particularly helpful in finding suitable images and discussing the project generally. The University of Cincinnati's Faculty Technology Resource Center was very helpful in handling scanned images.

I am indebted to Jodie Zultowsky, who edited my work and aided in innumerable other ways. This book is dedicated to Zane L. Miller, who taught me a small part of what he knows about Cincinnati history and a large part of what I know about being a historian.

PREFACE

What follows is a comprehensive but brief history of Cincinnati. Since an urban history must center on the people who lived in and built the city, I attempt to say something about the many people who made Cincinnati—the innovative and successful residents like William Proctor and Powel Crosley, and the powerful and influential citizens like William Howard Taft and Theodore Berry. At the same time, the story must say something of average residents, those who worked hard but attained neither wealth nor influence, for they built the city as well. So, although this history is full of names well known to Cincinnatians, those that grace companies, streets, and buildings, this story is also about working-class residents, about African Americans who found it nearly impossible to rise, and about women whose lives were circumscribed by custom.

Beyond the story of its residents, though, the history of a city is also a history of a place, one continually shaped over time. This history attempts to tell that story, too, to describe the changing physical nature of the city—its environment, architecture, and public space. Each generation has inherited a city built in the past. What each generation of Cincinnatians made of it, how they shaped it, tells us much about what they thought about their city.

What follows, then, is a history of the building of Cincinnati, a story about its people, businesses, institutions, and places. In this regard, it is a unique story, one peculiar to Cincinnati. But this book also contains some understanding of larger forces at work. More than just the hard work and ideas of its residents built and shaped this city. National and even international developments played critical roles in making Cincinnati the place that it is today. Any comprehensive history of a place must take us well beyond that place, to describe long-term developments like industrialization, dramatic changes such as the introduction of new technologies, and transformative events, especially military conflicts. In this way, Cincinnati's past shares much in common with the histories of other American cities. The growth and decline of factories, the development and partial abandonment of downtown, the building of canals, railroads, and highways, and the construction of sprawling suburbs are all critical events in the story of Cincinnati, as they are in essentially all other American cities. In this regard, what follows is not a unique story.

Many Cincinnatians express great pride in their city's history—its rapid growth, its distinctive German heritage, its important role in building a wealthy, industrial nation. Perhaps more so than any other American city its size, Cincinnati has a rich history, one that has left us rich in cultural legacies and lore today. Others express more dismay regarding Cincinnati's past, noting that theirs is a city that peaked more than 150 years ago. Once one of America's most important cities, it is now, and has long been, an urban also-ran, no longer among the nation's elite cities. Much of this city's history is one of relative decline and, in the late twentieth century, of real decline. This dichotomy of thoughts regarding Cincinnati's history no doubt mostly reflects the widely different interpretations of the current state of the city rather than a detailed knowledge of the past. Those who cherish the city today take pleasure in recounting how Cincinnati earned its wealth, developed its culture, and created its beauty. Those who find Cincinnati a fundamentally troubled place seek explanation in the past, finding fault with errant decisions or misplaced faith.

My objective here is to give some explanation for the rapid growth of the city and its long relative decline. Like all historians, I also hope to describe what was gained and lost by both the growth and the decline. As a native Cincinnatian, I have a personal interest in knowing this city as a place of which I can be proud. As a historian, I have a professional interest in writing a book of which I can be proud. (Those two interests have at times clashed over the last year of work.) If Cincinnatians can disagree about whether our city's history is one to be proud of, we should certainly agree that it is one worthy of knowing.

1. Founding a River Town

The history of Cincinnati begins on the riverbank. After the American Revolution cleared obstacles to westward movement, including a British proclamation that colonial settlements remain east of the Appalachians, families and single men moved across the mountains in search of fresh agricultural lands. Most came overland, at least part of the way, particularly through the Cumberland Gap into the rich farmlands of Kentucky. Others came over the Pennsylvania mountains, arriving at the origins of the Ohio River, which meandered southward from Pittsburgh. In the 1780s and 1790s, for the first time large numbers of European Americans headed into the Ohio territory, land won in the Revolution and then granted to the federal government for the making of future American states.

Rivers were critical to the settlement of Ohio, as overland travel without roads was nearly impossible, particularly through thickly wooded territory. Migrants traveled by water whenever possible, and the long course of the gently falling Ohio River made movement deep into the interior relatively easy. As settlers headed south on the Ohio, often on primitive boats of their own making, they found numerous tributaries that offered access to rich lands both north and south, including the Muskingum, Scioto, Licking, and the Little and Great Miami. The confluence points of these rivers, and many others, became favored stopping points, where pioneers gathered news and supplies as they could. On or near these sites the region's first towns would grow, and some of them would grow further into cities.

Prospects for rapid growth in the West improved with the passage of two important acts of congress. The Land Ordinance of 1785 created the rules by which the vast new public domain would pass into the hands of settlers, establishing the now familiar grid system of township lines and regular plots of 640 acres. Just as important, the Northwest Ordinance of 1787 created the political structure of the new territory, establishing the rules by which the land north of the Ohio reaching west to the Mississippi could enter into the union as equal states. This act also outlawed slavery in the Northwest Territory, ensuring that the Ohio River would constitute one of the great barriers between southern slave culture and northern free labor. Eventually, Cincinnati would become the largest city along this divide.

With a sour economy in the East and a weak currency in the new nation, western lands proved an attractive investment in the 1780s. Speculators jumped at the chance to secure large tracks of land in the new territory through purchase from the federal government. One of those speculators was John Cleves Symmes, who had fought in the Revolution and served as one of New Jersey's representatives to the Continental Congress. On the encouragement of fellow New Jersey resident Benjamin Stites, who traveled down the Ohio River in 1786, Symmes took a trip down river to the falls where Louisville would grow. Along the way, Symmes liked what he saw. Upon his return to the East, Symmes used his connections in Congress in 1788 to acquire the Miami Purchase, a million acres of potentially rich farmland.

Like all speculators, Symmes hoped to make a great profit on his land, but he could only do so if settlers purchased his land to make their homes. Symmes, of course, encouraged the migration. Traveling in groups of flat boats, three expeditions in quick succession led to the establishment of three settlements on the north bank of the Ohio between the Little and Great Miami Rivers. First, in November 1788, an expedition of twenty men and five women led by Benjamin Stites founded Columbia, just west of the Little Miami, where its location would give it good access to the flat fields at the confluence of the two rivers. Then, just before the new year, a group of 26 men led by New Jersey land speculator Mathias Denman and two Kentuckians—Colonel Robert Patterson and schoolmaster Robert Filson—founded Losantiville, a town whose name theoretically revealed its location. An awkward mix of Greek (l'os, meaning mouth), Latin (anti, meaning opposite), and French (ville, meaning town), the new settlement lay just across the river from the mouth of the Licking River. Although a small river, the Licking would prove important to the new settlement, as it reached deep into rich Kentucky farmland, a region that had already begun to fill with settlers from Virginia.

Israel Ludlow surveyed the land just west of Deer Creek, laying out town lots and roadways, using Philadelphia's plan as a model, in the hope that Losantiville would grow well beyond the first crude dwellings constructed just up from the river. Indeed, drawing up such a plan was an important step in encouraging settlement, establishing a vision for future growth and creating expectations of success. The grid pattern, used almost everywhere in the West, was ideal for giving this impression, as streets could conceivably reach out to the horizon, affording endless space for future growth, if only in the imagination. In laying out a regular grid of streets, Ludlow ignored the most striking feature of the site: the steep embankment that separated the bottoms along the river and the table-like upper reaches that sloped gradually toward the larger hills that nearly enclosed the basin. The embankment imperfectly followed the curve of the river, but Ludlow's design of the city took none of the natural features of the location into consideration, except, of course, that the city should face the river. Unfortunately, unlike Philadelphia, which had large public squares, Ludlow's original plan saved almost no room for public space and no parks whatsoever, and for decades the

only significant public space in Cincinnati would be the public landing, indicating the central importance of the Ohio to the young city.

In January of 1789, John Symmes himself founded the third settlement within his Miami Purchase, North Bend, a name that indicated its location at the northern-most point of the Ohio River in the area. Although Symmes clearly hoped North Bend would flourish, its location made it susceptible to flooding. Just a year after he founded his own town, Symmes looked in admiration at Losantiville up river, noting, "the advantage is prodigious which this town is gaining over North Bend, upwards of forty framed and hewed-log two story houses have been and are building since last spring, one builder sets an example for another, and the place already assumes the appearance of a town of some respect." Unlike North Bend, Columbia had flourished as a trading town upon its founding, taking advantage of its location near the quickly occupied flats along the Little Miami. But, suffering from the same flooding problems that plagued North Bend, it too quickly lost supremacy to Losantiville, which lay perched safely above the river, at least from Third Street northward.

Losantiville's flood resistance was clearly important to its early success against local rivals, but the military played an even more important role. In August 1789, troops arriving in the area to protect settlers from Native Americans selected Losantiville to build their battlement, naming it Fort Washington. Soon hundreds

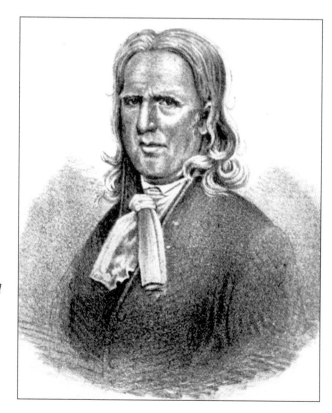

John Cleves Symmes acquired the land that would become Cincinnati in 1788, and a year later he founded North Bend. (Courtesy of Archives and Rare Books Department, University of Cincinnati.)

of troops occupied the fort, giving the young city all of the advantages of a newly enlarged population, which made the city a ready market for local produce and the most logical stopping point for manufactured goods heading downriver.

The fort also provided Losantiville the best protection in the area against attacks from Native Americans. Indeed, the greatest impediment to growth in Ohio Territory rested on one simple but often overlooked fact: it was already occupied land, the home of several well-established, powerful Native-American tribes, especially the Wyandot, Delaware, and Shawnee. Indeed, the Ohio region had a deep Native-American history, most famously evidenced by the area's many Indian mounds, including the mounds just outside of Cincinnati, including Fort Ancient above the Little Miami River, and the Miami Fort, overlooking the Ohio and Great Miami Rivers. The Hopewell, the architects of these earthworks, occupied the region two centuries before the arrival of Europeans in Ohio, and their ceremonial sites, containing pottery, clothing, and jewelry, provide ample evidence of the sophistication of their culture. Of course, the Hopewell themselves had long since disappeared when Europeans began to speculate on the origins of the mounds they found scattered across the Midwest.

As Europeans first began making contact with native tribes in the interior of the continent in the 1600s, Ohio was largely uninhabited by Indians. Instead, various groups used the region for seasonal hunting grounds, both for sustenance and to provide furs for trade with the French in the north and the British to the east. Indeed, it was the fur trade that encouraged much of the conflict among native tribes, especially as the powerful Iroquois Nations, based in New York, expanded their influence westward into Ohio, often battling the powerful Miami and Illini tribes based in territory that would eventually make up Indiana and Illinois. In the mid-1700s, however, three major tribal groups moved into Ohio. The Shawnee and Delaware came from the east, both pushed out of Pennsylvania and other eastern states by growing Euro-American demands for land. The Shawnee established their base of influence in the Scioto Valley, founding a town on the site currently occupied by Portsmouth by the 1750s. The Delaware occupied parts of central Ohio. From the north, the Wyandots entered Ohio, centering their territory near current Sandusky. Other native groups occupied parts of Ohio, including the Miami, who came from the west and inhabited the upper reaches of the rivers that bear their tribal name.

Wary of white settlers and the prospect of losing their lands, Native Americans struggled to protect their territories. Whites would often portray Indians as menacing to well-intentioned settlers, but clearly the newcomers were more menacing than the natives. Not content to found cities along the river, white immigrants to the Ohio Territory pushed northward along the Miami Rivers. When the inevitable conflicts between natives and whites flared, the new residents called out to the federal government for aid, which came in the form of soldiers.

In 1789, General Josiah Harmar brought 300 troops downriver to garrison the newly constructed Fort Washington. The fort, and the soldiers it housed, would be the prominent feature of the town until it moved across the river to Newport

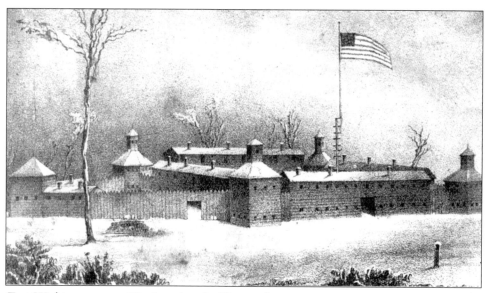

Fort Washington gave Cincinnati a significant advantage over competing town sites in the region. The soldiers gave the village protection and a much needed economic boost. (Courtesy of Archives & Rare Books Department, University of Cincinnati.)

in 1803. The fort took advantage of Losantiville's central position between the Miami Rivers and just across from the then more important Licking. The soldiers gave the town a rough reputation. Even William Henry Harrison, who arrived as a soldier in 1791, noted the behavior of the troops, claiming to have seen "more drunken men in forty-eight hours succeeding my arrival at Cincinnati than I had in all my previous life." The young town's rough reputation and its large component of soldiers, combined with the difficulty and dangers of frontier life, kept the population disproportionately male. Indeed, in all of Hamilton County in the mid-1790s, perhaps less than one-fourth of the population was female, even without counting the soldiers.

The first major offensive against the Native Americans initiated out of Fort Washington came in 1790, when Harmar led troops northward, first following a crude road roughly along the path of today's Reading Road. Over 150 miles away from Losantiville, Harmar's troops came upon native villages, but the villages had been temporarily abandoned. Without warriors to battle, the general decided to destroy the villages instead, burning shelters and stored crops. A second group of militia, separated from Harmar and his regular troops, engaged in an unwise attack on a force of Native American warriors and suffered an embarrassing defeat and a substantial loss of life.

After these early failures, General Arthur St. Clair, governor of the Northwest Territory, tested his hand at commanding the troops in 1791. Leading underprepared troops northward, St. Clair and his men met an even worse fate than had Harmar's. As his provisions faltered and his volunteer militia dwindled through

desertion, St. Clair and his men camped along the Wabash River. Attacked at night by Little Turtle and his Miami warriors, St. Clair's men were caught by surprise and badly defeated. Nearly 600 of St. Clair's soldiers were killed in a battle that took the lives of just 21 native warriors.

Thus, agricultural territory north of the fledgling city had gained little security through military action, but it had gained a new name—Cincinnati—given by St. Clair himself, who disliked the awkward Losantiville and wished to honor the organization of Revolutionary officers called the Society of the Cincinnati. Even with the new name, however, the town seemed only to grow by adding more and more troops to those garrisoned at Fort Washington, with civilians vacillating between conflicts with resident soldiers and an ongoing desire to see more soldiers arrive so that the Indian wars might be successfully concluded.

Not until the arrival of General "Mad" Anthony Wayne would Native Americans be largely removed from southern Ohio. Leading yet another army north out of Fort Washington in July of 1794, Wayne's troops scored a decisive victory against a confederacy of Midwestern tribes, including the Delaware, Shawnee, and Wyandot, at Fallen Timbers along the Maumee River. Although it was not a terribly bloody battle, Fallen Timbers did force Native-American leaders to sign the Treaty of Greenville the following year. The treaty essentially excluded Indians from southern and eastern Ohio, thus removing one of the great impediments to rapid settlement in the state, including the farmlands north of Cincinnati. With Native Americans confined to northern Ohio, their prospects within the state continued to dim. White demands for Indian lands led to further

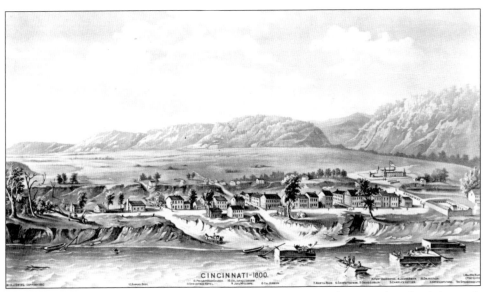

CINCINNATI-1800.

The river town grew along the Ohio, with Fort Washington on the east side. This lithograph purports to show Cincinnati in 1800, but the exaggerated Mount Adams ought to give us pause about assuming its accuracy. (Courtesy of the Cincinnati Historical Society Library.)

and further contraction of their domain, until the last native tribe was forced out of the state in 1843, when the diminished and demoralized Wyandots traveled south from their former home in northern Ohio to Cincinnati, where they boarded two steamships that took them westward to what is now Kansas.

With Native Americans removed from the region, agriculture flourished in Hamilton County, and the city flourished, too. With just 500 residents in 1795, Cincinnati could boast of more than 1,000 residents when it gained its municipal incorporation and Ohio gained its statehood in 1803. The city grew rapidly in the next few years, reaching more than 4,000 residents by 1815, with most of the newcomers arriving from the Mid-Atlantic states, especially Pennsylvania and New Jersey, and a significant number coming from Virginia and Kentucky. The growth was so rapid, in fact, that the city could barely keep pace with new housing and other facilities. Shortages became particularly severe during the summer months as new settlers arrived from the east, disembarked at Cincinnati, and prepared themselves for life on the agricultural frontier.

Cincinnati owes its existence to the Ohio River, but it owes its early growth to the smaller rivers in the region: the two Miami Rivers, the Licking, and the Mill Creek. These rivers, and the agricultural produce they brought to the Ohio, helped make Cincinnati the most important market city between Pittsburgh and the falls at Louisville. Like other frontier towns, fur trading proved an important early economic activity, but before long, the rich soils of southern Ohio would be instrumental in Cincinnati's development into the largest city west of the Appalachian Mountains.

The making of a city required first the unmaking of a forest, as settlers cleared the dense woodlands along the Ohio. Obviously the forest would be removed from the basin where the city would grow, but more importantly, farmers would deforest great expanses both to the north and the south of the city, replacing ancient woods with crops of corn and wheat. Settlement proceeded up the various tributary valleys, including the Mill Creek, where several mills had been built as early as 1809, including one constructed by Israel Ludlow in the area now occupied by Northside. Eventually the deforestation that came with the spread of agriculture would cause a number of environmental problems, including increased flooding due to rapid runoff and accumulating silt in riverways, but residents in the newly opened territory could hardly anticipate such problems as they struggled to make a frontier living.

Clearly, river trade drove the city's economy in the first decades of the 1800s. Agricultural products, particularly wheat flour, gathered on the banks to be shipped downstream, often all the way to New Orleans at the mouth of the Mississippi. In this era, the boats that carried the products of the Ohio Territory rarely made the return trip, the currents of the Mississippi and the Ohio being simply too strong to battle for that long distance. In the era before the steamship, a roundtrip from Cincinnati to New Orleans took about 100 days, the majority of which involved making the way back upstream. Indeed, the commerce on the inland rivers was essentially unidirectional. In 1807, over 1,800 boats came down

the Mississippi to New Orleans, but only 11 went up river from the Gulf port. Often little more than large rafts, these early flatboats and keelboats were wooden structures nimble enough to negotiate the wide rivers, and inexpensive enough to be economical for one-time use. In New Orleans, dockworkers dismantled the rafts and sold the wood. In this way, Ohio lumber helped build Louisiana's port city. This also meant that as long as goods flowed down the river and boats did not return, boat builders would have plenty of work upstream. Therefore, Cincinnati, like other sizeable cities along the Ohio, developed an early boat-building industry, which in turn increased local demand for lumber, iron, tools, and, of course, labor.

Although still essentially a large town in the early 1810s, Cincinnati seemed much larger than it was. As in other frontier towns, visitors swelled the population, giving the city a bustle disproportionate to its size. Particularly in the summer and fall, dozens of travelers stayed in town on business, including farmers seeking to sell produce and purchase supplies, and dozens of others would simply pass through Cincinnati on their way to their own agricultural futures. It became a place where settlers, arriving with little of the equipment they would need to make a living, could purchase the fundamental agricultural tools—the axes, plows, harrows, saddles, harnesses, nails, etc.—that would enable them to set up a homestead. Thus, Cincinnati benefited doubly from its agricultural hinterland, making money from the shipment of products southward and from the supply of goods to farmers, both established and newly arrived.

In the early decades, much of the manufactured goods sold in the city came from the east, particularly Philadelphia and Baltimore, brought to the city via the Ohio. But the steady demand for manufactured goods created by the growing agricultural community, combined with the high cost of transporting those goods over the Appalachian Mountains, made the establishment of Ohio Valley industries inevitable. By the 1820s, Pittsburgh had already established itself as a manufacturing city, supplying many of the goods that settlers required, and Cincinnati would soon follow. Eventually, the city would deal not just in imported goods, but in locally manufactured goods as well. One of the first extensive industries involved furniture, which was expensive to ship due to bulk, but relatively inexpensive to manufacture in Ohio's wood-rich environment, and in high demand in the growing region.

The young city produced considerable wealth, though the quickest fortunes were not made through the sale and manufacture of goods. As in all booming frontier towns, Cincinnati's greatest wealth came through the increasing value of its land. The largest real estate fortune was accrued by the New Jersey–born Nicholas Longworth, who arrived in Cincinnati at the beginning of the new century, having spent several years in South Carolina. Once in Ohio, Longworth learned the law and set out to make a living as an attorney. At the same time, he parlayed a payment of land for legal services into a real estate empire, one that included rental and development properties in the basin and other property in the surrounding hilltops, where he famously attempted to turn Cincinnati into

a wine-producing region. Fondly remembered for his horticultural adventures, Longworth became most important as a benefactor to local artists.

Also around the turn of the century, Martin Baum made a considerable purchase of land on the east side of town, a tract that ran from near Fort Washington up the neighboring hill, which would later take the name Mount Adams in honor of President John Quincy Adams. Baum engaged in many businesses, but the most lucrative would be land speculation. He made purchases in many Ohio locations and built a family fortune through timely sales. That fortune would help build one of Cincinnati's most famed houses—now the Taft Museum on Lytle Park. The park itself took the name of another wealthy family that made its home in the east side of town—that of General William Lytle, who moved into the city from Clermont County in 1806. Though the Lytle Park area saw significant changes through the subsequent decades, it remained a prominent address for Cincinnati's wealth, from Nicholas Longworth in the 1830s to Charles Phelps Taft in the 1910s.

Obviously the first generation of prominent Cincinnatians was native to some other place. Almost all of them came from eastern states, such as New Jersey, Pennsylvania, and Virginia. One such migrant was native Virginian William Henry Harrison, who came to Cincinnati while in military service. After arriving, however, Harrison met Anna Symmes, daughter of John Cleves Symmes. To

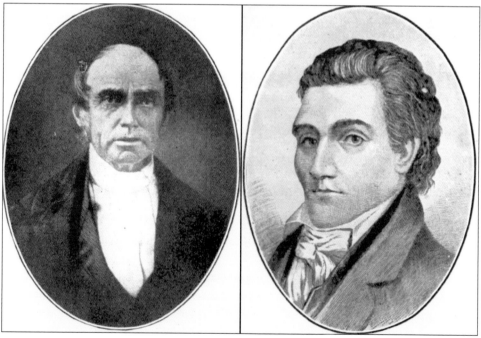

Nicholas Longworth (left) and Martin Baum (right) turned early investments in real estate into two of Cincinnati's great fortunes. (Courtesy of Archives & Rare Books Department, University of Cincinnati.)

marry Symmes, Harrison resigned from service, left his post at Fort Washington, and settled in North Bend with his new wife. Harrison would continue to serve in the military even after his marriage, particularly in fighting Native Americans in the Indiana Territory, where he gained an appointment as governor. His most famed victory came at Tippecanoe, where Harrison's forces defeated the Shawnee in 1811.

Harrison moved back to Cincinnati in 1814 and attempted to turn his military fame into a political career, not an uncommon practice. Harrison desperately desired to be President and initiated the most extensive campaign to gain the post yet seen. In the process, he helped transform presidential politics. Organizing his campaign out of Cincinnati, Harrison gained the Whig Party's nomination in 1840. His Democratic opponents criticized Harrison's backwoods origins, suggesting that he did not have the political skills to run the nation. But Harrison's campaign made use of his military experience and turned criticism of his western background to his advantage. Calling himself "the Ohio Farmer," Harrison ran what would be called the "Log-Cabin Campaign," one that positioned Harrison as a man of the people despite his considerable wealth. Harrison won the election, but unfortunately died from pneumonia just a month after entering the White House. Still, he was the first of many Ohioans to win the Presidency and not the last Cincinnatian to gain the office.

By the 1820s, Cincinnati had established its supremacy in the West, but never did city boosters rest assured that their city would retain its good fortune. Throughout the developing region, cities and towns, some of which failed to grow

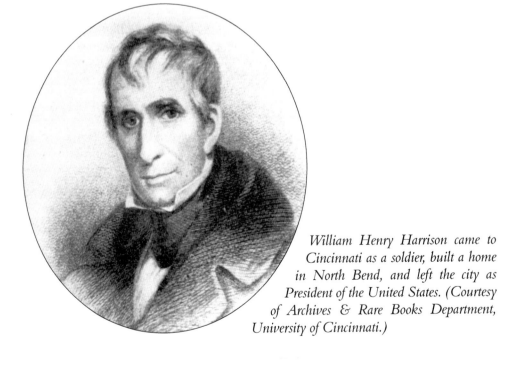

William Henry Harrison came to Cincinnati as a soldier, built a home in North Bend, and left the city as President of the United States. (Courtesy of Archives & Rare Books Department, University of Cincinnati.)

at all, struggled to reach an ever-higher position in the ranking of cities. Critical to improving property values, the basis of speculative interest in western cities, booming economic growth could only be secured in successful competition with rival burgs. One visitor to Cincinnati noted the intensity of the urban rivalry in the Ohio Valley in the late 1810s: "I discovered two ruling passions in Cincinnati; enmity against Pittsburgh and jealousy of Louisville." Louisville had one advantage over Cincinnati, its location at the only falls along the Ohio, but it would not keep economic pace with its upstream neighbor. Pittsburgh, on the other hand, would eventually surpass Cincinnati in economic growth, but not until later in the century when it took great advantage of its coal stores and good access to Great Lake iron ores. In the meantime, Pittsburgh was too distant (and upstream) from the booming Ohio Valley agricultural region that fed Cincinnati's growth.

Instead, another rival would pose a more difficult challenge to Cincinnati: Lexington. The central Kentucky city was older than Cincinnati, founded in 1775 in the heart of rich agricultural lands, the first in the region to be occupied by white settlers. As late as 1800, Lexington remained the largest city in the West, but its growth would be stunted by the absence of a navigable river to aid in commerce. By the early 1800s, Lexington was no longer a serious economic rival to the city at the mouth of the Licking River, but it did remain a cultural rival, becoming known as the "Philadelphia of Kentucky." Among other achievements, its Transylvania University was the first institution of higher learning in the West and the envy of Cincinnatians. Indeed, the positive reputation Lexington garnered because of Transylvania inspired Cincinnati to found Cincinnati College in 1819. The following year, city leaders established the Western Museum, featuring displays on archaeology and natural history. Perhaps the museum's most important legacy is that it employed a young James Audubon, who worked in Cincinnati in 1819 and 1820 as a taxidermist. In his free time, Audubon traveled around the region sketching the birds he found. In late 1820, he left the Western Museum and headed down to New Orleans, and later, of course, published the most famous work in ornithology, *Birds of America*.

Although neither the museum nor the college flourished immediately, they represented Cincinnati's developing urban culture. Perhaps the city's expanding press gives an even better indication of Cincinnati's growing urban dominance in the region. In the 1820s, the city had two daily newspapers, seven weekly papers, a medical journal, and a literary monthly—a long list that indicates not just the city's growth, but also the importance of print media in the early nineteenth century.

Despite the city's reliance on the economic vitality of the Ohio Valley for its own continued growth, by the 1810s Cincinnatians had come to understand that they had interests distinct from those of the region, the state, and certainly other nearby cities. The city was in continuous competition with other cities for economic growth, a competition that would shape Cincinnati's politics for the next two centuries.

2. A RIVER CITY

In the first three decades after its founding, Cincinnati experienced relatively slow growth, with much of the hard work of settlement taking place in the developing agricultural lands to the north and south of the city. Farm families would drive economic growth in the region through the early nineteenth century. With increasing population growth in the region around Cincinnati, the city too experienced more rapid expansion. Indeed, by the 1820s Cincinnati was no longer a river town; it had all the problems and promise of a city.

The challenges of rapid growth were met with expanded public services. Over time, the municipal government would be asked to solve the problems caused by dense settlement. Increasing crime and concerns for public safety led to a program to introduce gas lighting in the city in 1827. An increasing threat from fire, extremely dangerous in cities made largely from wood, led to the development of a water supply system, with the laying of wooden pipes beneath streets to deliver water from a 200,000-gallon reservoir, providing water pressure for firefighters and consumers alike.

By 1840, the city's growth was astonishing, representing the dramatic rise of the West and promising a remaking of the nation as a whole. No longer was the United States a coastal nation; the fertile lands and flowing rivers of the continent's interior looked like the future. And Cincinnati, it seemed, would be at the center of it all.

From under 10,000 residents in 1820, the city leapt to nearly 25,000 by 1830, and the rapid growth was really just beginning. The city retained its compactness, with the vast majority of citizens living within walking distance of the public landing, by far the most important space in the city. Yet, despite the compactness of the walking city, geographical separation based on class and race was already underway. The wealthy clustered on fashionable streets, especially along Lytle Park, while poorer residents found housing primarily on lower ground, on the east and west ends. By the 1830s, African Americans had already experienced segregation, especially on the low land on the east side. These poorer districts, both black and white, contained the least valuable land in the city, due to their distance from the landing and the fact that they were subject to more frequent and damaging flooding.

The city owed its heightened growth to a new commercial order, one driven by the recently invented steamboat and the increased value of a river location the new boats brought. Although developed in the East, culminating in 1807 with Robert Fulton's successful operation of the *Claremont* on the Hudson River, the steamboat would have its largest impact in the Mississippi Valley. In 1815, the *Enterprise* successfully navigated the Mississippi and the Ohio, traveling all the way from New Orleans to Pittsburgh. In relatively short order, steamboats revolutionized trade in the West, dramatically decreasing the costs of shipping upstream and creating a two-way trade throughout the region. Although cities all along the major rivers would benefit from steam travel, cities that had already developed sizable markets would benefit disproportionately, particularly Louisville, Cincinnati, and Pittsburgh.

Additional transportation improvements would further Cincinnati's economic prospects in the 1830s. Following the lead of New York State and its very successful Erie Canal, in 1825 Ohio initiated the construction of the Miami Canal, funded by the state. The canal opened in early 1829, giving Cincinnati access to Dayton and points in between. By increasing the city's reach into the interior of Ohio, the canal

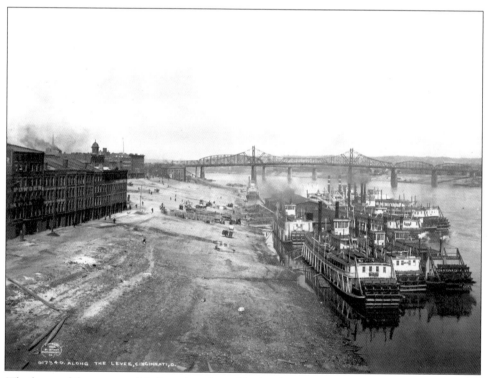

The heart of the commercial river city, the public landing would remain important to the city for more than a century. In this 1904 photograph, steamboats cluster at the landing, while in the background railroad bridges reveal the new economic order. (Courtesy of the Cincinnati Historical Society Library.)

further solidified Cincinnati's position as the key marketplace in southern Ohio. The canal also increased the amount of valuable commercial space within the city itself. The canal entered the city from the north through the Mill Creek Valley, and then cut sharply across the northern edge of the city, in the space now occupied by Central Parkway. Real estate along the canal increased in value, as merchants and manufacturers sought easy access to the barges bringing agricultural produce southward and taking manufactured goods northward. By 1845, the Miami Canal reached Toledo, giving Cincinnati good access to the lake trade to the north and earning a new name, the Miami and Erie Canal.

The canal brought economic growth to more than just Cincinnati, as towns flourished along its length. Middletown and Lockland, in particular, would translate access to the canal into industrial growth. Lockland, founded in 1828 along four locks on the canal, had the advantage of access not just to the commerce the waterway brought, but also the power provided by the falling water. The Miami Canal's success also encouraged the development of the Whitewater Canal, heading west out of the city and into Indiana. Undertaken by a private company, this canal included a spectacular 1,900-foot tunnel that reached into the

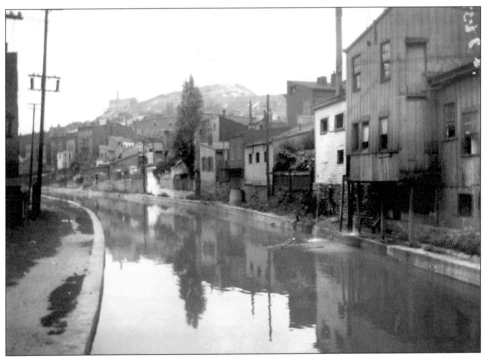

Since its opening in the late 1820s, the Miami Canal has been an important commercial thoroughfare, connecting Cincinnati with central Ohio and eventually Lake Erie. Dense neighborhoods of mixed housing and industry crowded along its lengths within the city, including the Mohawk neighborhood, pictured above. (Courtesy of the Cincinnati Historical Society Library.)

Great Miami River Valley at Cleves. Although it reached Brookville, Indiana by 1843, the Whitewater was never as important to Cincinnati as the Miami Canal. Indeed, the Whitewater Canal closed in 1860, after a short life with limited success. The canal's right-of-way would take on a more lasting utility, however, when the Cincinnati and Indiana Railroad purchased the land and laid tracks that eventually stretched farther into the Hoosier state.

Improvements in transportation clearly brought increased commercial activity, but they also aided the growth of manufacturing. As early as 1811, visitors could comment about the city's industrial diversity. Some industries related directly to the growth of the city: brick making, carpentry, and cabinetmaking, for example. But the city had grown wealthy enough to support silversmiths, tinsmiths, and watchmakers, too, and by 1820, the city also had a fledgling textiles and tanning industry. Most of the city's early industrial growth came directly from its booming agricultural trade. Grain coming into the city fueled the growth of milling but also distilling. Livestock entering the city fueled meatpacking but also soap- and candle-making, which were dependent on the lard from animals. These industries in turn encouraged the growth of others, including glassmaking, especially for bottling, and a fledgling chemical industry to supply needed ingredients to soap makers. Commerce itself encouraged an even greater variety of industries, including the manufacture of carriages, wheels, and barrels.

While the city became home to the Phoenix foundry in 1819, Cincinnati did not develop into a center of iron manufacturing. Its steamboat industry, however, flourished. Ohio River trade needed all the boats that Cincinnati could manufacture, and in turn the city needed the materials that made up the boats, including the steam engines themselves. By 1829, Cincinnati had built 81 steamboats, more than a quarter of all the ships plying western rivers. The industry centered in the East End, particularly near the outlet of Deer Creek.

The growing steamboat industry encouraged the development of other industries, including the manufacture of machinery to outfit the boats. Eventually, the building of mills and steam engines went beyond the demand created by the ships, and the city exported machinery, particularly to southern states. Louisiana's sugar industry, for example, looked to Cincinnati to supply its mills. Beyond machinery, steamboat manufacture sparked the growth of industries providing bedding, furniture, brass, light fixtures, doors, and any number of other items required to equip the vessels.

The economic success of the young city brought migrants, many of whom were easterners seeking better fortunes in the West. Although this migration included mostly unskilled workers, it also included extraordinarily talented men and women, people drawn to the city by the prospects of wealth, fame, or simply adventure. Many others traveled to Cincinnati as part of expeditions West, forays to experience the American frontier, perhaps the most exciting place in the world. Through the mid-1800s, Cincinnati was an important destination in the West, a place where those who wanted a new start could make it, and a place where those who wanted to witness the West could find it.

The importance of this migration to Cincinnati can be represented by the life of Daniel Drake, who in 1800 arrived in the city at the age of 15, having left his boyhood home in Mayslick, Kentucky in search of education and opportunity. Drake would develop into one of Cincinnati's most important residents. After studying with a local doctor, Drake went to Philadelphia at the age of 20 to study with Benjamin Rush, perhaps the nation's most famous physician. After a short stay there, he eventually returned to Cincinnati and established his own practice. He also became a city booster, collecting and distributing information about the young town. Published in 1815, his *Natural and Statistical View* of Cincinnati gave readers good reason to anticipate the city's continued growth. Moving beyond praise for the city's geographical advantages, Drake extolled the city's residents as well, claiming they "are obviously destined to an unrivalled excellence in agriculture, manufactures and internal commerce; in literature and in the arts; in public virtue, and in national strength."

In 1832, another important figure arrived in Cincinnati, one who would help shape the young city nearly as much as Drake. Lyman Beecher, a well-known Boston minister, had been recruited to lead the new Lane Theological Seminary. Desiring to save the West from Catholicism and other forms of infidelity, Beecher joined eminent biblical scholar Calvin Stowe in teaching at Lane, and also preached at the Second Presbyterian Church. In short order, Beecher moved to a home on Gilbert Avenue near the seminary in Walnut Hills. There he lived with several members of his large family, including daughter Catharine, who started the Western Female Seminary and eventually gained fame as an author on issues related to women, education, and domestic life. Beecher's other daughter, Harriet, would gain even more fame, authoring one of the nation's most important novels, the antislavery *Uncle Tom's Cabin*, published in 1852. By that time, Harriet had left Cincinnati, returning east with her husband, Calvin Stowe, whom she had met through her father at Lane. While not written in Cincinnati, *Uncle Tom's Cabin* contains knowledge of slavery that Harriet gained while living in the city.

Well before the publication of Stowe's incendiary novel, the Beecher household and Lane Seminary had become centers of abolitionism within Cincinnati. In the mid-1830s Lane students, led by Theodore Weld, who would go on to prominence in the national abolitionist movement, attempted to improve the lot of African Americans within the city, particularly through the development of close personal relationships. The growing radicalism of Lane drew criticism from outside Cincinnati, and in protest, Weld and all of the other seniors at the seminary quit the school because of the trustees' attempt to reign in student antislavery activities. Most of those who left Lane left Cincinnati altogether, with many moving to Oberlin to attend the liberal college there.

Lane Seminary clearly suffered due to the abolitionist conflict, as would the city as a whole. Many Cincinnatians held strong sympathies for the South, including the sizable population that had migrated from south of the Mason-Dixon line or had familial ties there. Perhaps just as important, the city's economy still

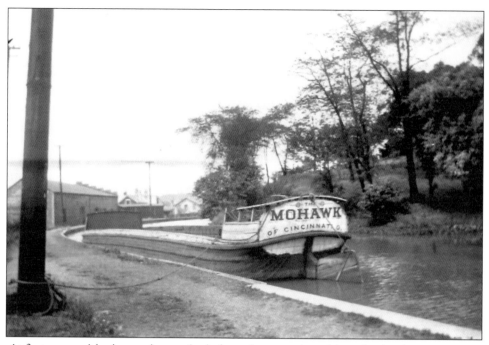

At first powered by horses that trudged along the toe path and later by diesel engines, canal boats provided cheap transportation for bulky goods. Here the Mohawk *rests near Clifton in 1917. (Courtesy of the Cincinnati Historical Society Library.)*

looked southward, with important industries such as meatpacking dependant on southern plantations for much of their market.

Newcomers like Drake and Beecher clearly made Cincinnati, but in many ways those who came and went, offering reportage about the city, had a greater hand in making the city's reputation. In 1828, Frances Trollope, an English woman, came to Cincinnati determined to bring culture to the American frontier. She established a bazaar on Third Street, opened adjoining salons, a gallery, and a ballroom, and waited for culture-starved customers to make her rich. Unfortunately for Trollope, her store offered nothing unique, except perhaps elevated prices. After two years of rejection from customers and Cincinnati's high society, Trollope returned to England, much impoverished by her experience. Unfortunately for Cincinnati, the real loss to the city would come with the 1832 publication of *Domestic Manners of the Americans*, Trollope's account of her experiences while in the United States. Trollope's bitterness came through in her negative portrayal of Cincinnatians, and she had the last laugh as her book made her both famous and wealthy, while her bromides against the river city would stand largely unchallenged. Trollope helped establish stereotypes of Cincinnatians as lacking sophistication, indeed lacking all manners. If most Americans could ignore the ranting of an English snob, Cincinnatians perhaps took her barbs too seriously, even quoting her assertions regarding the lack of charm and grace in local conversations, the lack of manners

in eating, which she claimed took place with "the greatest possible rapidity, and in total silence," and "the little feeling for art that existed" in the city.

Despite her many slanders against Cincinnati, Trollope could not help but mention the city's strengths, its economic vitality and its relative equality, though she disparaged the latter as unfortunate "leveling." In the end, Trollope's critique of the city might be seen as unintended praise. Why would anyone suggest that a city only 40 years old should be compared to the great cities of Europe? That people took her comparisons seriously suggests the rapid rise of Cincinnati and the expectation that it would someday rival European cultural centers. If Cincinnati still lacked culture in the 1830s, in the form of art and theatre, it clearly thrived as an economic center, one that would in time generate its own sophisticated urban culture.

In 1831, another, more welcome visitor arrived in Cincinnati—Alexis de Toqueville, who was on the extensive tour of the United States that would provide the experience needed to author *Democracy in America*, a more flattering portrait of American society first published in 1835. He found in Cincinnati what he would describe as the quintessential American city, with the flaws and advantages of American democracy writ large for all observers—an American primer, in his analogy. Unlike Trollope, who found in American egalitarianism only crassness, Toqueville reveled in the energy of the streets, the confidence

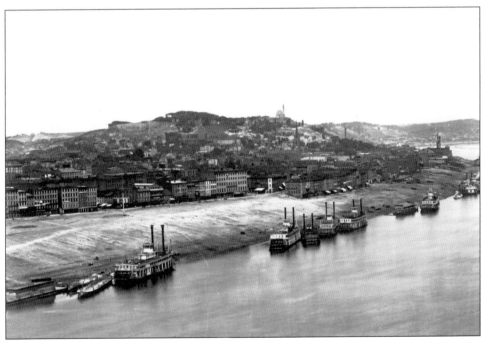

Taken from the Roebling Bridge, this photo reveals the extent of the public landing at its peak. The ship building industry is still alive at the foot of Mount Adams. (Courtesy of the Cincinnati Historical Society Library.)

of the residents. Toqueville commented on the consequences of the city's rapid growth: "Great buildings, thatched cottages, streets encumbered with debris, houses under construction, no names on the streets, no numbers on the houses, no outward luxury, but the image of industry and labor obvious at every step." Toqueville was clearly impressed with the chaos of the rapidly growing city, but not put off by it.

Charles Dickens visited Cincinnati in 1842, and left so impressed with the young city that his commentary in *American Notes* might easily be mistaken for advertising text. "Cincinnati is a beautiful city," he wrote, "cheerful, thriving, and animated. I have not often seen a place that commends itself so favorably and pleasantly to a stranger at the first glance as this does. . . ." Clearly the city retained its natural beauty, the river and the hills providing much of what pleased Dickens and other admiring visitors. But Dickens found more to admire, including the grand "villas" on the hilltops, particularly Mount Auburn, where wealthy Cincinnatians had begun to build their homes removed from the dirt and chaos of the city's basin. Dickens's more pleasing pronouncements about Cincinnati thrilled city boosters who were eager to replace Trollope's barbs with more flattering images.

Though not much discussed either by wealthier white immigrants who shaped the city or by visitors who reported on the city's culture to the rest of the Western world, a growing African-American population experienced extreme discrimination in antebellum Cincinnati. Indeed, race relations became a critical issue as the city grew and the nation moved toward its dramatic sectional conflict. Although federal law prohibited slavery in the state, nothing prevented legal racial discrimination. In an attempt to limit the power of blacks in the state, the Ohio constitution denied African Americans the right to vote. The state's Black Laws of 1804, written to discourage the immigration of free blacks into Ohio, prevented African Americans from serving on juries or testifying in cases involving whites. Blacks could not serve in the state militia or attend public schools, even though they did have to pay taxes in support of those schools. The Black Laws reflected the racism so prevalent in the nation as a whole and the specific demands of migrants to the state, from the north and the south, who desired to live without the presence of a large free black population.

Despite the discrimination, however, the small black community in Cincinnati grew, and some individuals within that community thrived. By 1840, more than 2,200 blacks lived in the city, more than five percent of the city's total. Many of those coming to the city arrived from the south just out of bondage, some having purchased their own freedom, others having been manumitted by their owners. In the antebellum decades, perhaps as much as half of the black population in Cincinnati had been enslaved for some part of their lives. Black life centered around a number of churches, including Bethel A.M.E., founded in 1824, and Union Baptist, which separated from the city's white Baptists in 1831.

Not surprisingly, the majority of African-American men worked as unskilled laborers, as porters, draymen, stewards, and waiters. Although we have less

evidence about black women, most likely a majority worked as domestics. An economic diversity did exist in the African-American community, however, with the most successful blacks working as barbers in their own shops or as ministers in one of the black churches. Henry Boyd may have been the wealthiest African American in the city, having made his money as a carpenter and a manufacturer of bedsteads.

Although blacks lived throughout the densely settled city, two neighborhoods contained a large percentage, as reflected in their commonly used names— Bucktown on the eastside, near the Deer Creek, and Little Africa, near the public landing. Since African Americans made up such a small percentage of the city's overall percentage, we shouldn't be surprised that even in these small areas blacks composed just a minority of residents, often even sharing buildings with white residents. Bucktown and Little Africa contained some of the least desirable housing in the city, and suffered bad reputations as centers of crime and vice. Both of the integrated neighborhoods suffered environmental problems, too, which kept rents lower than in more desirable sections. Bucktown, also called the Bottoms, backed up against the frequently foul smelling Deer Creek, while Little Africa lay in the flood-prone neighborhood along the river.

Despite the discrimination African Americans faced in Cincinnati, the community grew and prospered, which in turn encouraged a violent response from whites eager to prevent the black population from increasing. In the late 1820s, the African-American population of the city surged, more than tripling in the last four years of the decade. By 1829 the city's 2,258 black residents made up almost ten percent of the city's total. Some whites feared the influx of largely uneducated blacks would taint the city's reputation and ruin its chances for further growth. Other whites simply expressed a desire to remove blacks from the city, claiming they did not belong. In 1826, dozens of Cincinnatians had initiated an effort to encourage the removal of free blacks to Africa, creating the Cincinnati Colonization Society, a local branch of the national American Colonization Society. By 1829, however, tensions increased so quickly that this long-term "solution" could not mollify agitated whites. Violence broke out as groups of whites roamed the city for three days, periodically attacking African Americans and damaging blacks' property.

As a result of the violence, and the extreme racist rhetoric that accompanied it, many blacks acceded to white demands and simply left the city. Canada became the last hope of African Americans seeking refuge from oppression, and one place in particular became a favored destination. Two former Cincinnati residents, Thomas Cressup and Israel Lewis, traveled to Ontario, where they acquired the land that would become the home of a new community: Wilberforce. After the violence, Lewis and Cressup had little difficulty convincing African Americans to travel north. In total more than 1,000 African Americans may have fled Cincinnati after the riot of 1829, though most did not settle in Wilberforce.

In 1841, tensions between the races rose yet again, especially after a note from a fugitive slave to family members still in slavery announced the names of two

Headed by Lyman Beecher beginning in 1832, the Lane Theological Seminary became the center of Walnut Hills in the mid-1800s and for a time the center of Cincinnati's abolitionist movement. (Courtesy of the Cincinnati Historical Society Library.)

black Cincinnatians as participants in the Underground Railroad. Encouraged by incendiary language in the pro-slavery *Enquirer*, a group of angry whites gathered at the Fifth Street Market in the center of the city on September 3. The mob moved toward Bucktown, where armed blacks awaited the assault. A gun battle raged for hours and finally ended when the mayor belatedly called upon militia to step in. While blacks successfully defended their homes against the mob, they could not so easily defend themselves against a racist legal system, as eventually about 300 black men were jailed and held until they could post the bond required by the Black Laws.

Despite the periodic violence against blacks and the constant discrimination, the black community did grow, as African Americans came to the city for the same reason whites did—for the jobs offered in the strong economy of a growing city. By 1850, more than 3,100 blacks lived in the city, making it the largest African-American community in the state. Still, with the rapid influx of European immigrants, especially Germans and Irish, blacks decreased in their percentage of the population, constituting less than 3 percent of the total at mid-century.

As abolitionism grew in the north, the Underground Railroad expanded, with more and more citizens risking the harboring of fugitive slaves from the South. Cincinnati and the region around the city were particularly important in this effort, with the Ohio River marking the real boundary between slavery and freedom. Still, escaped slaves were not truly free in Ohio, as federal law required the return of slaves even from free states and indeed threatened abettors of fugitives with jail and fines. Given the sorry state of affairs for free blacks in Cincinnati and the constant fear of recapture into slavery, citizens of the state, including many in Cincinnati, arranged for the runaways' passage north to Canada, where real freedom awaited.

In 1836, James Birney moved his abolitionist newspaper, *The Philanthropist*, into the city from New Richmond. Within months an angry mob invaded the print shop that handled the paper, destroying the equipment. Birney defiantly continued to publish the paper, even calling attention to the outrageous attack on the freedom of the press. Two weeks later a mob again attacked the print shop, this time dragging the press down Main Street and pushing it into the river. Rioters had hoped to attack Birney himself, but he had prudently fled the city. With Birney safely out of town, the crowd turned its anger toward the city's African-American population, in yet another instance of random violence against the struggling black community. Although Birney had his supporters in Cincinnati, including the Beechers and a young lawyer, Salmon P. Chase, Birney soon left the city for good, finding a more secure location in Indiana. Chase, however, remained in the city, having just arrived in 1830, developing his antislavery credentials as a litigant and later developing Republican credentials too, first serving as governor of Ohio, then as Abraham Lincoln's treasury secretary, and finally as the chief justice of the Supreme Court.

Despite the dominant anti-abolition sentiment in the South-facing city, Cincinnati did become home to several important abolitionists, even after the destruction of Birney's press. In 1847, Levi Coffin moved to Cincinnati from Wayne County, Indiana, where he had been extremely active in the Underground Railroad for 20 years. Once in Cincinnati, Coffin continued this activity, even while expanding his commercial business. A merchant, Coffin traded only in goods produced by free labor, including cotton and sugar, two crops generally produced by slave labor. Eventually known as the "president" of the Underground Railroad, Coffin worked vigorously not just for freedom, but also equality for blacks. Through the Civil War, Coffin helped direct the Western Freedmen's Aid Society, collecting money to aid in the education of freed slaves. Coffin died in Cincinnati in 1877, the year after the publication of his reminiscences. He was buried in Spring Grove Cemetery.

Antebellum Cincinnati, a bustling river city with a wildly fluctuating economy and a steadily growing and diversifying population, was nothing if not exciting. Racial conflict and deep political divides periodically united with one of the nation's regular economic panics to create moments of violence, tension, and uncertainty. Through it all, however, the city grew remarkably, not just in size but also in complexity. The river city, it seemed, would thrive, as long as the river connected the city to a vibrant national economy.

3. THE QUEEN CITY

The river and the canals had served Cincinnati well, and by 1850 it was among the most prosperous cities in the nation and already the sixth largest metropolis in the United States. Its population had doubled in each of the previous five decades, encouraging grand dreams of an inland national capital, moved here to the new center of the West. After all, the nation's future lay in westward expansion, and with river traffic only increasing, Cincinnati's prospects seemed as bright as its recent past.

Cincinnati's economic growth attracted immigrants, some of them political refugees from tumultuous Europe, but most of them simply in search of better fortunes for themselves and their families. Although many European immigrants remained in Eastern cities, swelling the populations of Boston, New York, and Baltimore, others with the ability to do so headed inland to the thriving Midwest. In the mid-1800s, Cincinnati became a primary destination for German immigrants, who also settled in large numbers in other growing Midwestern cities, including St. Louis, Milwaukee, and Chicago.

Germans had a long history in Cincinnati. David Ziegler, a native of Heidelberg, had become the city's first mayor after serving as an officer at Fort Washington. Still, as late as the 1820s, Germans constituted just five percent of the city's population. However, economic and political turmoil in Germany over the next three decades, combined with remarkable economic growth in the United States over that same period, encouraged millions of Germans to immigrate. The influx transformed the Queen City, and by 1850, more than 40 percent of all Cincinnatians were either German or born to German parents.

The city clearly benefited from the great influx of Germans, who filled open jobs and added more fuel to the economy. Unlike the Irish, who arrived in smaller numbers during the same decades and who also represented a distinct immigrant group in the city, many Germans came to Cincinnati with skills, and some even brought wealth. Very rapidly, some Germans gained economic and political status, operating businesses and gaining government offices. Irish immigrants, much more likely to arrive impoverished and without skills, represented 12 percent of the city's population in the 1850s, but did not gain nearly the influence the more populous and powerful Germans had.

Although German immigrants lived in every part of the city, they famously congregated in the neighborhood north of the Miami Canal, dubbed "Over-the-Rhine" due to the Germanic character of its population. Although not exclusively German, the neighborhood did take on the flavor of its largest immigrant group, with Vine Street in the heart of Over-the-Rhine lined with beer gardens and the neighborhood dotted with small breweries. Germans created a number of important communal and political organizations, including the nation's first Turnervereine, in 1848, dedicated to both the physical and mental improvement of its members and most famous for its gymnastics.

Germans worked in nearly every trade, constituting a significant percentage of the workforce, particularly in tanning, tailoring, shoemaking, and furniture making. Some immigrants turned hard work into great success, including Samuel Hecht, who came to Cincinnati in the 1840s, made his fortune in the liquor business, changed his name to Pike, and then built Pike's Opera House, the largest opera house in the United States when it opened in the 1850s. Standing on Fourth Street, which by the 1850s had become the focus of the city, Pike's Opera House immediately became one of the city's cultural centers and would eventually be the first home to Cincinnati's Orchestra, organized in 1852.

European immigrants provided Cincinnati much needed labor. Although immigration to Cincinnati slowed in the late 1800s, workers and families continued to arrive. Here immigrants learn English in Winton Place in 1914. (Courtesy of the Cincinnati Historical Society Library.)

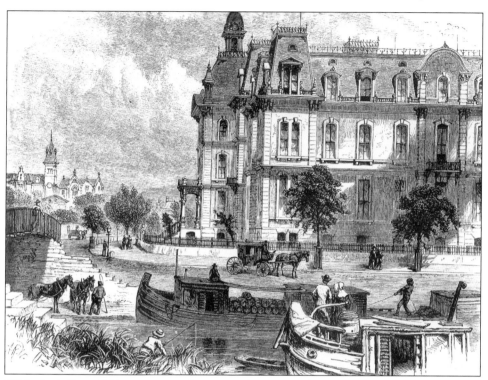

With the influx of Germans into the city in the 1840s, the Miami Canal became known as the Rhine. Note the man fishing in the "Rhine" in this nineteenth-century lithograph. (Courtesy of the Cincinnati Historical Society Library.)

Cincinnati's Germans represented a remarkably diverse group, both in skills and economic attainment and in political and religious practices. Many of the Germans were Jews and Protestants, but up to two-thirds of them were Catholics, giving that church remarkable visibility and influence in the city. The growing Catholic influence of the city was reflected in the construction of St. Peter's Cathedral, completed in 1844 near city hall. The cathedral's atypical Grecian style was the personal choice of Bishop John Purcell, who had risen to his post in 1832. German immigrants filled Cincinnati with religious institutions to serve their diverse needs, and like other American urban neighborhoods, Over-the-Rhine became a community dominated by its church spires, even more than its smokestacks. In many of the churches, German prevailed as the language of choice. As late as 1890, the newly constructed Philippus Kirche chose to hold all its services in German, as it would until 1921.

Many prominent German immigrants held liberal views and supported the Democratic Party. These included Karl Reemelin, who came to Cincinnati in 1833 and helped found the German-language Democratic newspaper *Volksblatt* in 1836. Other, more conservative immigrants helped found the weekly *Wahrheits-Freund*, the country's first German-language Catholic paper. The wave of immigration

that accompanied the revolution of 1848 brought another political faction into the city, one with radical politics. The "Forty-eighters," as they were called, brought with them the leftist politics that inspired the German rebellion.

German immigration continued through the late 1800s, and in the 1870s, Cincinnati was still the home to two daily German-language papers, the *Volksblatt* and the *Volksfreund*. Just as important, Over-the-Rhine retained its German flavor for decades to come. One observer in 1875 noted that a Cincinnatian "has no sooner entered the northern districts of the city lying beyond Court Street, across the canal, than he finds himself in another atmosphere—in a foreign land, as it were."

Cincinnati's economic success drew a diversity of immigrants, not just the German Catholics who played such an important role in the development of the city's distinct culture. Although not nearly as large a group, European Jews arrived in Cincinnati through the second half of the nineteenth century, and the city would become home to one of the most influential Jewish communities in the nation. In 1853, the congregation B'nai Yeshurun made a wonderful choice in electing Dr. Isaac M. Wise as its rabbi. Departing from Albany, where he was serving as rabbi, Wise arrived in Cincinnati with great expectations. The congregation built the Plum Street Temple in 1865–1866; its grandeur spoke to the success of Jewry in the city, and its two beautiful minarets provided diversity to the city's skyline.

The successes were just beginning for Cincinnati's Jewry, however, as in 1870 a $10,000 gift from Henry Adler of Lawrenceburg, Indiana allowed Wise to begin constructing a rabbinical college. The next year a conference of rabbis met in Cincinnati to discuss the college idea and the possibility of a union of congregations, another of Wise's ideas. In the end, the conference supported both developments, the Hebrew Congregational Union and the Hebrew Union College. The college opened in 1875, with Wise serving as president, a post he held until his death in 1900. By the time of his passing, however, Wise and his supporters had long since secured Cincinnati's central place in Reform Judaism.

Not surprisingly, as the city's population grew and diversified it required new space. The population expanded northward, moving into a territory known as the "Northern Liberties," laying north of Liberty Street, which the city annexed in 1849. In 1855, this area became the home of Findlay Market, an open-air market square in the heart of the developing Over-the-Rhine. At that time, Cincinnati already had six market places, including one centrally located on Fifth street, where Fountain Square now resides. These markets provided residents access to fresh produce from the Miami and Mill Creek Valleys, as well as meats delivered from the city's many butchers.

As further evidence of the growing city, a new and extensive burial ground opened well beyond the densely populated basin. Opened in 1845, Spring Grove Cemetery was at first 167 acres, but following a national trend of creating "rural" cemeteries just outside large cities, Spring Grove continued to grow, eventually

reaching 782 acres, making it one of the largest cemeteries in the United States. In 1855, landscape gardener Adolph Strauch created much of the grounds' beauty, giving the cemetery the feel of a spacious park, which was part of the intention of having such a large space reserved for burials close to the city. Over time, Spring Grove would become the resting place of the city's elite, including Daniel Drake, Nicholas Longworth, James Gamble, William Proctor, and Salmon Chase. Spacious grounds, narrow winding roads, and a series of small lakes and ponds ensured that Spring Grove would provide a permanently peaceful resting place for both the living and the dead.

When first opened, Spring Grove lay well removed from the city's crowded neighborhoods, distant from most who would seek its relaxing landscape. Indeed, until a trolley system developed later in the century, only the wealthy could afford to move great distances around the city on a regular basis. By mid-century, horse cars helped expand the city, but most residents still relied on their own power to move them from home to work or shopping. So, with only modest improvements

Philippus Kirche, built in 1890, was just one of dozens of religious institutions constructed by the German immigrant community in and around Over-the-Rhine. (Courtesy of the Cincinnati Historical Society Library.)

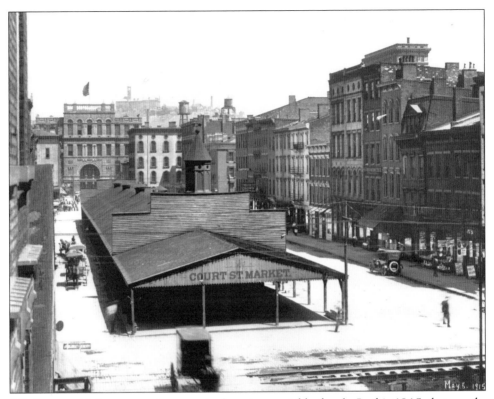

Markets provided a community center in downtown neighborhoods. In this 1915 photograph, the Court Street Market is clearly not in operation. This space is now occupied by parking. (Courtesy of the Cincinnati Historical Society Library.)

in transportation, Cincinnati remained primarily a walking city, and the basin grew ever more densely populated. Indeed, in the second half of the nineteenth century, Cincinnati became well known around the nation as one of the most densely settled American cities. The city had more persons per dwelling than the average Midwestern city and lower rates of home ownership. The working class lived overwhelmingly in tenement apartments, some of which became infamous for their unhealthful conditions. One particular building, the Big Missouri, housed approximately 300 residents in just 95 rooms. Since the building lacked indoor plumbing, the residents had to make use of a hydrant on the street. Conditions grew so poor in some areas of the city, particularly in the West End, that one observer noted that some "poorer parts of Cincinnati are wretched as the worst European cities."

The problems associated with population density were exacerbated by the limited open space in the basin. The original city plan included no spacious parks, and the city had been slow to add them even as the population mushroomed. In 1817, John and Benjamin Piatt gave one acre to the city for the creation of a market, and by 1843 the land along Eighth Street had become

a park, though it was not formally dedicated as such until 1868. The city laid the groundwork for a larger park in 1829, when it purchased 10 acres in the West End. In 1857, the city finally developed the land, which eventually took the name of the soon-to-be assassinated president. Lincoln Park became an important oasis of green within the city's rapidly growing working-class and African-American neighborhood.

Of the few mid-century parks created in Cincinnati, the most important was Washington Park. From 1858 to 1863, the city purchased the land, parcels that had served as Presbyterian and Episcopal cemeteries. The 6-acre site became critical open space in the heavily populated Over-the-Rhine, serving as a prime location for political rallies, protests, and festivals, as well as day-to-day recreation. As Mary McMillan noted in 1912, Washington Park served as important cultural space for the entire city, particularly after the construction of Music Hall in 1878. "So often late," McMillan wrote of the park, "we have hurried breathlessly through it to a concert or an opera in the great hall opposite, and, later—very much later—towards midnight, after listening to the wild ride of the Valkyries or the wonder of Wotan's farewell, we have wandered back through the park in the magic of moonlight and with the magic music making a dreamland of beauty and thrilling joy where the bare benches and bushes stand deserted." Washington Park also became home to some of the city's first Civil War memorials, constructed right along with the rest of the park during the mid-1860s.

To escape the problems of the dense city and to seek out greener home sites, by the 1850s many of Cincinnati's wealthier residents had moved out of the busy basin and up into suburban neighborhoods growing in the hills. The first of these suburbs took the name Mount Auburn in 1837, named after the recently opened Mount Auburn cemetery in Boston. Still very rural in appearance as late as 1842, the area garnered special praise from Charles Dickens who found himself "charmed by the appearance of Cincinnati and its adjoining suburb, Mount Auburn." In 1851, two years after the city annexed the growing community, Charles Cist praised developments in Mount Auburn and Prospect Hill: "These offer great inducements for those who desire dwellings removed from the dirt, tumult, and impure air of the crowded city, on which the last looks down from a commanding height." Indeed, good health and the ability to find cleaner environments, particularly less smoky air, encouraged more and more wealthy residents to flee the crowded basin. By 1871, D.J. Kenny could rave, "The suburbs of the Queen City are equal to any in the world." He praised in particular "the green sward and leafy glades" of Clifton, Avondale, and Walnut Hills.

A number of the city's most prominent residents made their homes in the pure air of Mount Auburn, including John Shillito, who moved to a great Elizabethan mansion on Highland Avenue in 1866. In 1851, Alphonso Taft bought a large Greek Revival home on Auburn Avenue, from which he continued to pursue his successful career in politics and law. However, Alphonso Taft became most famous through the careers of his sons, Charles Phelps Taft, who became editor

of the Cincinnati *Times-Star*, and William Howard Taft, who became the twenty-seventh president of the United States in 1909.

Not all of the city's suburbs lay in the hills above the city basin. Begun in 1851, Glendale offered wealthy Cincinnatians an escape from the city, 12 miles up the Mill Creek Valley at a station on the newly opened Cincinnati, Hamilton and Dayton Railroad. As a planned community, Glendale's curved streets and large yards reflected a growing suburban ethic, emphasizing rural and picturesque qualities in eschewing the straight lines, intensity, and commercialism of the city. Named for a farmer, Edmund Glenn, who originally owned some of the land on which it grew, the suburb was actually the creation of the Glendale Association, a joint stock company that purchased 600 acres for the founding of the village. The private nature of the development ensured that stockholders could sell only to Cincinnati's elite, and it soon became home to William Cooper Proctor and other wealthy men.

Unlike Glendale, the early hilltop suburbs would all eventually join the city through annexation, but their continued growth reflected a widening geographical segregation based on wealth. Early in the century, wealth and poverty lived separated by mere streets, with the finest homes lying clustered through the city and within easy access of all the residents of the city. Increasingly, however, the wealthy of the city were retreating to more exclusive neighborhoods, surrounded largely by others of their own stature. Clifton's fine homes lay too far from the basin to ever be seen by the city's impoverished residents. This segregating trend would only intensify over the next century and a half.

Built as a railroad suburb of Cincinnati in the 1850s, Glendale was one of the nation's first planned suburbs. Its curvilinear streets represented just one of its many contrasts with the city at the end of the rail line. (Courtesy of the Cincinnati Historical Society Library.)

The hilltop suburbs offered wealthier Cincinnatians the advantages of open space and cleaner air. After 1872, Clifton residents had easy access to a new park, Burnet Woods, which offered peaceful trails, carriage paths, and boating on a small lake. (Courtesy of Archives & Rare Books Department, University of Cincinnati.)

In addition to contributing to geographic expansion, economic growth facilitated cultural growth as well, and by the 1840s Cincinnati was home to a flourishing art scene. Here painters could hope to find customers for their work and, if fortunate, the patronage of one of the city's wealthy class. Among the most famous of the painters to arrive in the Queen City was Robert S. Duncanson. Some of Duncanson's best known paintings are landscapes of the Ohio Valley completed in the style of the Hudson River School. He also painted huge landscape murals for the home of Nicholas Longworth, Cincinnati's most generous arts benefactor. Duncanson spent much of his career in Cincinnati, becoming one of the first African-American painters to gain international attention.

Other significant artists spent time in Cincinnati in the 1840s, including William Louis Sonntag, Worthington Whittredge, and James Henry Beard. Beard's presence helped attract Lilly Martin Spencer, who lived in eastern Ohio. After arriving in Cincinnati, Spencer enjoyed the patronage of Longworth and developed her style under the influence of Beard, who was at the time one of the leading portraitists in the city. Spencer moved on to the New York area in 1849, and her continuing work established her as one of the most important woman artists of the antebellum era.

In 1859, Henry Farny's family moved to Cincinnati. Farny received training in art and found work as an illustrator. Farny's work became nationally famous when he took a job at *Harper's Weekly* in New York City, but he returned to

Cincinnati where he painted his well-known Western landscapes, drawn from his traveling experiences in the 1880s. At that point, Farny spent much of his time in Cincinnati, becoming an important member of the art scene in the late 1800s. Even more vibrant than during the antebellum period, Cincinnati's arts community continued to benefit from local talent. Elizabeth Nourse, for example, was born in Mount Healthy, and as a young woman took courses at the McMicken University School of Design, which had opened in 1869. After studying in Cincinnati for several years and selling her works to support herself and her sister, Nourse left for Paris in 1888, where she continued to paint rich canvases, many of them focused on women and their children.

The best-known Cincinnati artist was Frank Duveneck, who was born in 1848 just across the river from the Queen City in Covington. Duveneck spent most of his career as an expatriate, painting in Munich, Italy, and other parts of Europe. When he returned to Cincinnati in the 1890s, he turned his attention toward teaching young artists at the Art Academy. Through this work, Duveneck established as grand a reputation as a teacher of art as he did a painter in his own right, and he provided great leadership in a thriving arts community.

Even as Cincinnati's economy and culture flourished in the mid-1800s, the nation's sectional divide would lead to the most damaging war in American history. Though tensions between North and South had been rising for decades, the 1860 election of Republican Abraham Lincoln had sparked the secession of several Southern states from the union. While making his way from his Illinois home to Washington, D.C. to take office, Lincoln stopped in Cincinnati in February of 1861. The city honored the incoming president with a parade before he spent the night at the Burnet House. By the time he arrived in the Queen City, seven states had already seceded, and the nation was in crisis. Despite a warm welcome in February, Cincinnatians revealed a less unified commitment to Lincoln's Republican, anti-slavery politics when in April the city elected a Democratic mayor, George Hatch. Later that month, however, the rebellious South Carolina fired upon the federal fort in Charleston Harbor, beginning the Civil War, and solidifying the city's Northern allegiance.

After the attack on Fort Sumter, Cincinnatians experienced the war fervor like much of the rest of the North, with volunteers signing up in large numbers and congregating at the impromptu Camp Harrison established at the county fairgrounds. Here training proceeded under Cincinnati native William Haines Lytle, whose fine house lay on the near east side of the city. Lytle went on to be one of the city's heroes during the war. He fought in Kentucky, where he was wounded, captured, and later exchanged back to the Union army. Lytle was then mortally wounded at the battle of Chickamauga in northern Georgia in 1863. He was buried in Spring Grove Cemetery. His family name graces the park near his old home.

Camp Harrison served as a temporary training ground in Cincinnati, but General William Rosecrans planned the development of a larger camp, named for Ohio Governor William Dennison, farther from the city. At Camp Dennison near

the small town of Milford, recruits trained for what they assumed would be a brief war. Across the river, Kentucky struggled to find some middle ground, declaring neutrality in a war that really afforded no such thing. Many Kentuckians, including the state's slaveholders, revealed Southern sympathies, providing supplies and soldiers to the Southern cause.

Kentucky's official neutrality did at least keep Cincinnati in relative safety. On the border between free and slave territories, Cincinnati had much to fear from the war, beyond the extreme financial damage caused by the cutting of commercial ties to the seceded South. In August of 1862, fighting in the city seemed inevitable as a Confederate army under Kirby Smith moved through Kentucky, reaching first Richmond and then, on September 2, Lexington. Smith's Confederate army rested just 75 miles from Cincinnati. Ohio called for volunteers to protect the Queen City, and residents prepared for the worst. Thousands of men flooded into Cincinnati, including rural marksmen called "Squirrel Hunters" because of the long rifles they carried. Defenses were established in northern Kentucky, after a temporary bridge to Covington constructed of barges allowed thousands of volunteers and recruits to pour into the hills surrounding Covington and Newport.

African Americans from Cincinnati provided much of the hard labor required to build the fortifications. In the panic that ensued upon hearing the news of the Confederates' advance through Kentucky, and as a sign of the racism that pervaded

General William Rosecrans developed Camp Dennison near the Little Miami River north of the city to train recruits to fight in the western campaign. (Courtesy of the Cincinnati Historical Society Library.)

41

Cincinnati, dozens of African-American men were arrested, held in pens, and marched to Kentucky during the first evening of defensive preparations. Some black men were even taken from their homes. Whites assumed that blacks would not volunteer to aid in the defense of the city, particularly since that work would be done in a slave state, so some officers took matters into their own hands. The next day, however, when the injustices became widely known, Judge William Dickson took on the task of organizing a "Black Brigade" of volunteers to work with shovels and axes to build the fortifications. His first step involved a trip to Kentucky to ask those already forced into the labor if they would like to go home. Some did return to Cincinnati, if only to make proper preparations for the work ahead, including simply getting appropriate clothing. In the end, African Americans volunteered in large numbers to fortify their city, working for three weeks. These men, and the many white men who worked alongside them, received the gratitude of the city and fairly good pay for the last two weeks of their engagement.

At the end of their labors, the city's volunteers, black and white, had created a line of defense through the hills of northern Kentucky. The largest defense took the name Fort Mitchell, but most of the defenses were little more than a string of rifle pits and batteries for cannons overlooking the accessible routes from the south. Although never tested, the defenses served their purpose, as General Smith chose not to risk the assault on the heavily guarded city. Instead, the battle for Kentucky focused on Perryville, south of Frankfort, from which the Confederates retreated after fighting in early October.

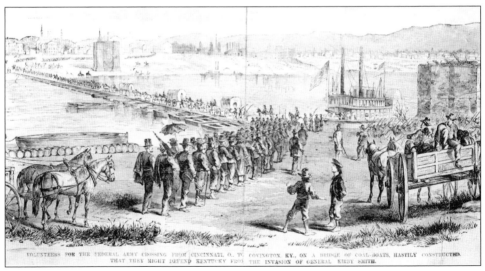

VOLUNTEERS FOR THE FEDERAL ARMY CROSSING FROM CINCINNATI, O., TO COVINGTON, KY., ON A BRIDGE OF COAL-BOATS, HASTILY CONSTRUCTED. THAT THEY MIGHT DEFEND KENTUCKY FROM THE INVASION OF GENERAL KIRBY SMITH.

Volunteers from around Ohio streamed into Cincinnati as a Confederate army occupied central Kentucky and menaced the Queen City. The drawing above captures the volunteers crossing a temporary bridge into Covington, on their way to take up defensive positions in the hills south of the city. Note the Roebling Bridge under construction. (Courtesy of the Cincinnati Historical Society Library.)

During the early September events in Kentucky, Cincinnatians clearly had cause for concern, but their eyes were only partly trained on regional military events. Even as Smith's small Confederate army made advances in the Commonwealth, more significant fighting was underway in the East. In the closing days of August, Robert E. Lee's much larger force battled the Army of the Potomac at Bull Run for the second time. Another victory for the Confederates kept the nation's eyes fixed on northern Virginia and less concerned about the battle of Kentucky.

Cincinnatians romanticized their city's role in the Civil War, a very common tendency in the years following the fighting. Even before the war ended the story of the "Siege of Cincinnati" had gained national attention. Five months after the threat to the city, the *Atlantic Monthly* published a dramatic account of the remarkable defense of Cincinnati, emphasizing the unity among citizens that the crisis had encouraged. "Here were the representatives of all nations and classes," the magazine wrote:

> The sturdy German, the lithe and gay-hearted Irishman, went shoulder to shoulder in defense of their adopted country. The man of money, the man of law, the merchant, the artist, and the artisan swelled the lines hastening to the scene of action, armed either with musket, pick, or spade. Added to these was seen Dickson's long and dusky brigade of colored men, cheerfully wending their way to labor on the fortifications,

gushed the author. While clearly relying on all the stereotypes of the day, the article did highlight the diversity of the city as it prepared for war and the sense of unity that an impending invasion could bring, at least temporarily.

Perryville marked the end of large-scale military engagements anywhere near Cincinnati, but in 1863 the city had renewed cause for concern when Colonel John Morgan and his Confederate Raiders moved through Kentucky and into Indiana. Morgan's band of 2,400 men avoided the once-again well-protected city, but he fought through southern Ohio until surrendering with his remaining 335 men. Although Morgan's Raiders caused considerable damage and even more panic in Ohio, Cincinnati itself was spared any harm, as it would be through the war's entire course. Residents would only feel the sting of battle through the pain and suffering of wounded Union soldiers sent to hospital in the city, and through the words of the city's own sons sent into battle, many of whom would not return.

Cincinnati's most important contribution to the Civil War did not come in the fighting, however, but through the supply to the Union Army. With economic connections to the South cut, supply contracts with the federal government provided the city with a much-needed boost. Local factories supplied boots, clothing, and other necessary war supplies, including war vessels manufactured at the East End shipyards. The city's large iron manufacturer, Eagle Iron Works, employed more than 400 men in producing cannon and gun carriages, and in

retrofitting muskets with rifling. The city helped supply the Union troops in the West, particularly in sending bacon, pork, hard bread, candles, and soap downriver. In addition, the city's extensive carriage industry supplied the Union Army with mountings for mobile cannons, carts for ammunition and other supplies, and special wagons for carrying wounded soldiers. In this way, Cincinnati contributed to the Union victory, supplying both soldiers and the supplies those soldiers would need to win the fight.

Fittingly, the war came to a close in Virginia, in Appomattox, where Robert E. Lee formally surrendered to Ulysses S. Grant and sent his men home on April 9, 1865. Just five days later, however, an actor named John Wilkes Booth shot President Lincoln, who died the next day. At the time, the assassin's brother, Junius Booth, also an actor, was preparing for a two-week engagement at Pike's Opera House in Cincinnati. When he received word that his brother had killed Lincoln, Booth fled the city fearing reprisals from aggrieved Cincinnatians. Two days later Pike's became the site of a memorial service for the slain President.

The Civil War had far reaching consequences for Cincinnati, as it did for the rest of the nation. Many white Cincinnatians feared the freeing of the slaves, which occurred with the passage of the 13th Amendment to the Constitution in late 1865. Like other northerners, they assumed that the freedmen and women would rush northward, seeking jobs in the region's many cities and undercutting whites by accepting lower wages. This mass migration did not take place until decades later, but other changes afoot in the national economy did cause more immediate problems for Cincinnati. Although the major economic disruptions did not outlive the war itself, and Cincinnati was free to re-establish its economic ties to the South, the Queen City increasingly found it no longer held great advantages in the regional competition for growth. Some Southerners, embittered by the war, looked to fellow Southerners for their business, and even though Kentucky did not join the Confederacy, its largest city, Louisville, did benefit from this sentiment.

Louisville did not present the greatest threat to Cincinnati, however. Chicago had benefited greatly from the war, and its meteoric growth continued in the late 1860s. New rail connections tied Chicago to the Deep South, via the Illinois Central, and to the booming, rich farmlands of the upper Midwest and prairie states, including Wisconsin and Iowa. Perhaps most important, Chicago's location on Lake Michigan gave it real advantages in its trade with the East. By the early 1870s, Chicago had several direct routes connecting it with eastern markets, and its growth would continue unabated for decades.

One of Cincinnatians' favorite myths about their own city holds that the Queen City simply misjudged the importance of railroads and clung stubbornly to its old-fashioned riverboats. The myth projects backwards the conservatism for which the city would become known, concluding that the poor judgment of the city's elite, perhaps even their parochialism, led to the city's fading fortune. However, this myth is based on poor evidence. Certainly it would be unreasonable to expect a river city to turn its back on river trade, for steamboats continued to play a critical role in the region's economy, even as rail

After the Civil War, hilltop suburbs continued to grow, even developing their own business districts. The Walnut Hills business district developed at Peebles Corner, named for a store that long occupied a prominent location on Gilbert Avenue. (Courtesy of Archives & Rare Books Department, University of Cincinnati.)

transportation expanded. In addition, evidence reveals that Cincinnatians were no less eager to establish rail lines than other urbanites, fully aware that the constant urban competition required continuous innovation and investment and that the city would require rail links to solidify and expand market connections. Unfortunately, unlike river trade, which clearly favored the Queen City, railroad trade held no such advantage for Cincinnati, no matter how much city leaders sold the investment.

Through the 1840s and 1850s, more and more Cincinnatians came to realize that continued growth must come through good railroad connections. In 1842, the first railroad to enter Cincinnati, the Little Miami Railroad, ran up the Little Miami River Valley. By 1849, this route provided access to Lake Erie through Springfield. Construction began in 1851 on the Cincinnati, Hamilton and Dayton Railroad, which would generally follow the course of the Miami Canal, offering faster connections between cities already linked by water, and in that same year

Railroads reshaped the city in many ways, including through the construction of several rail stations downtown. In the late 1800s, the station of the Pittsburgh, Cincinnati & St. Louis Railroad lay at the intersection of East Pearl and Butler Streets near the foot of Mount Adams. Known for many years as the Panhandle Railroad, it eventually became part of the Pennsylvania system. (Courtesy of Archives & Rare Books Department, University of Cincinnati.)

construction began on the Ohio and Mississippi Railroad, which would reach East St. Louis by 1857. This latter road would connect the important Atlantic port of Baltimore with St. Louis on the Mississippi, and Cincinnati business leaders wanted to make certain that the route passed through the Queen City. City council even approved a loan of $600,000 for the construction of the line, and when the issue came before the electorate in a referendum, the people of the city passed it overwhelmingly. Another westward railroad, the Cincinnati and Indiana, used the Whitewater Canal route out of the city, draining the water and using the tunnel. By the time the Civil War began, lines spread out from the city, terminating in East Saint Louis, Chicago, Dayton, Toledo, Sandusky, Cleveland, Pittsburgh, Wheeling, and Lexington.

Unfortunately, the city would soon realize that its good connections to Baltimore and St. Louis would not be as useful as the better connections other cities had to the real metropolis of the East, New York, and the new, growing metropolis of the Midwest, Chicago. These two cities, connected by several rail lines and cheap water routes through the Great Lakes, would form the center of a new economic geography, one well to the north of Cincinnati and other Ohio Valley cities, one that favored the growth of Cleveland, Toledo, and Milwaukee.

Connections west and north were of importance to the city, but much of its commercial activity reached southward. After the Civil War, which delayed railroad construction, especially in the South, the city stepped up efforts to build lines through Kentucky. In 1872, the Louisville and Nashville railroad bridge connecting Newport and Cincinnati provided the first direct link between the city and the South. More important, after overwhelming popular support in an 1869 referendum, the city sold bonds to build a municipally owned railroad that would connect Cincinnati with Chattanooga, Tennessee. Construction on the Cincinnati Southern Railway began in 1873, after a delay caused by officials in Kentucky, through which most of the line would run. When completed in 1880, the line ran out of the city's west side, over the Ohio at Ludlow, Kentucky, and down to Tennessee. From there, Cincinnati gained better access to the Gulf Coast and the rest of the Deep South. The railroad was an immediate success, providing excellent income for those who leased the line from the city and giving new hope to a city once again well connected to its Southern markets.

By this time, of course, Chicago had long since passed Cincinnati as the regional commercial and industrial leader, and with most of the Midwest's railroad trackage pointing to that booming metropolis, the Queen City would clearly lose its crown, retaining only its ceremonial title. Still, from the perspective of the mid-1850s, the prospects of the city seemed anything but grim. In 1851, Cincinnatian S.H. Goodin expounded on the Queen City's grand destiny. "Cincinnati is the grand center of the United States," he claimed, "not geographically, perhaps, but the center of the forces and influences, which, when readjusted after the introduction of the great disturbing cause, the railroad, must settle and determine the destiny and relative position of the various cities. . . ." Goodin understood Cincinnati's dominant position in the West in 1850, but he failed to appreciate just how "disturbing" a force railroads would be. The reordering of the inland economy along railroad lines would eventually dethrone the Queen City as the great inland metropolis, even though it would not prevent its continued growth in commerce, industry, and population.

In the mid-1800s, Cincinnati gained two symbols of a city at its peak, both so important that they have remained central to the city's self image. The first of these symbols, the Roebling Suspension Bridge, clearly began as much more than just a representation of the city's power. It was a critical link between Cincinnati and Covington, the small Kentucky city just across the river. Begun in 1857, the bridge was designed by John A. Roebling, who would go on to everlasting fame as the builder of the similar but much larger Brooklyn Bridge. A group of Covington

merchants had hired Roebling to design the bridge, hoping better connections with the Queen City would encourage growth south of the river. Roebling initially designed a bridge with a large pillar sunk into the center of the river, which would have proved too much of an obstacle for the all-important river traffic. He then pushed bridge technology with the suspension design, and Roebling's graceful span would represent a leap for engineering as much as for the city. Delayed by the Civil War, the bridge opened for north–south traffic on New Year's Day, 1867.

The new bridge did more than facilitate traffic between Ohio and Kentucky, however. It symbolized the power and possibility of the city, just as the Brooklyn Bridge would for New York upon its completion in 1883. The Cincinnati bridge included the longest suspended deck in the world at the time, and became an instant source of pride for residents in Kentucky and Ohio. The stone towers supporting the steel cables, one planted on either side of the river, provided a visual unity to the riverfront just as the span provided greater economic unity across the north–south divide.

Four years after the completion of the suspension bridge, the city gained a new symbolic center, when Henry Probasco presented the city with a fountain as a memorial to his brother-in-law Tyler Davidson. The fountain initially replaced the old Fifth Street Market and was eventually moved to the redesigned Fountain Square. The fountain's central figure, the "Genius of Water," provided a fitting symbol for the city, given Cincinnati's relationship with the river.

The Roebling Suspension Bridge became a critical link between north and south upon its completion in 1867. It also became an important symbol of a working city at its peak. (Courtesy of the Cincinnati Historical Society Library.)

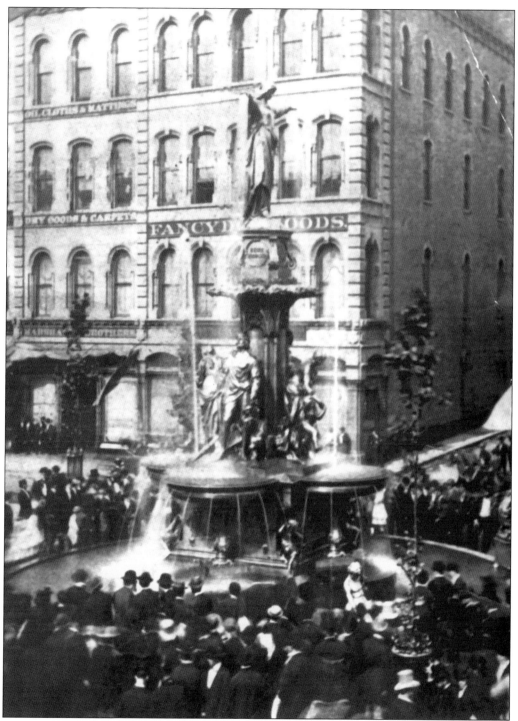

Tyler Davidson Fountain, the "Genius of Water," reflected the city's continuing debt to the river. Here Cincinnatians gather for the dedication ceremony in the fall of 1871. (Courtesy of the Cincinnati Historical Society Library.)

4. An Industrial City

Born a commercial city, Cincinnati's continued growth would require a more diversified economy. Industrial development, particularly in the second half of the 1800s, provided new opportunities for city workers, both native born and immigrant. A commercial giant, Cincinnati had certain advantages in acquiring new industries, including good transportation links, excellent access to raw materials, strong local demand, and an accumulation of available labor. Still, Cincinnatians had good reasons for apprehension as industrialization transformed the nation. Concern about the city's fading fortune encouraged the development of regular Industrial Expositions, held nearly every year from 1870 to 1888. The expositions provided the region an opportunity to explore new products and technologies, but they also offered the city an opportunity to sell itself as a home to industrial innovation and growth. At first held in a cavernous building on the site now occupied by Music Hall, the expositions attracted visitors from around the nation and garnered good press for the city. The expositions' festive air hid deeper problems, however, as intensifying industrialization would compromise the city's environment and exacerbate economic inequalities.

By the late 1800s, Cincinnati's industrial prowess was evident in its busy rail lines, massive factories, and many smokestacks. In the preceding decades, the commercial city had been reworked and made into an industrial city. With industry came many benefits—continued growth, good jobs, and rising incomes—but so too came negative changes, including increasing pollution. In a scathing essay on the state of Ohio in 1922, Sherwood Anderson mocked Cincinnati's progress. Occupying a naturally beautiful location, with green hills and winding rivers and streams, Cincinnati had cast aside poetic visions of "a white and golden city." Instead, Anderson claimed Cincinnati had achieved "something against all odds," creating an ugly, industrial city. "Today our river front in Cincinnati is as mean looking a place as the lake front in Chicago or Cleveland," he wrote, "and you please bear in mind that down there in Cincinnati we had less money to work with than they did up in Chicago or even in Cleveland." While some Cincinnati residents would bemoan the negative aspects of industrialization and work to ameliorate them, more residents took pride at what the city and its individual industries had accomplished.

In the early 1800s, industry had developed along with commerce, with small shops and factories mingling with warehouses and offices in the waterfront district and along most of downtown's streets. But even in the young city, industry concentrated in a few areas, particularly where access to water was good, especially along the Miami Canal. As the nineteenth century progressed, however, larger factories would require larger plots of land. As individual firms grew, they often sought property farther from the city center where they might expand more economically. By 1900, industrial growth concentrated in the Mill Creek Valley and even farther from downtown in industrial suburbs like Norwood and St. Bernard. As was the national trend, Cincinnati's development into an industrial city would bring with it a dispersal of employment away from the core. No longer would the city cluster close to the public landing. A diversifying economy also meant a dispersing one, and rail lines leading out of the city pointed the way for future industrial development.

Although industrial Cincinnati had a diverse economic base as early as the 1850s, the city gained a reputation for its dominance in certain areas, including the production of pork, soap, beer, machine tools, and carriages, five industries that would enrich the Queen City through the nineteenth century and in some cases much longer.

The city's most important nineteenth-century industry was meatpacking. By the 1830s, Cincinnati was the leading butcher of hogs in the United States, having surpassed Baltimore in the late 1820s. Already known as "Porkopolis," the city could gather pigs raised throughout much of Ohio and Indiana, butcher them in highly efficient factories, and send the pork southward, to the steadily growing market in the cotton belt, and eastward, to rapidly industrializing cities. Nearly all Ohio farmers raised hogs, in part because they needed to find some use for surplus corn crops and in part because pigs were so easy to raise. They were hardy animals, requiring relatively little labor, and they ate almost anything, including mast from the forests surrounding croplands. Farm families consumed some of the hogs they raised, but surplus animals became an important source of cash income for regional agriculture.

Until the 1870s and the introduction of ice-cooled storage facilities, most slaughtering and packing took place in the coldest months, beginning in early November, when farmers and drovers led thousands of hogs into the city. Traveling in groups of as many as 1,000 animals, the majority of the hogs who arrived in Cincinnati met their end in slaughterhouses on the city's east side, along the Deer Creek, where the cool winter air allowed the carcasses to chill and slowed the rotting of the meat. Since packers could not operate in the warm months due to rapid spoilage of the meat, as Cincinnati developed into the leading American pork-packing center the industry really only supplied seasonal work, with butchers and handlers finding other work in the summer, particularly in construction and other outdoor work.

Early pork packing involved considerable waste. In the 1820s, the entire process required many steps, including the awkward, hazardous, and annoying

droving of live hogs through city streets to the slaughterhouses, a trip frequently made from the Mill Creek Valley across the city basin to "Butcher's Hollow" on the east side. At the slaughterhouse, the hogs met their ends, had their hides and major organs removed, and were bled and cooled. While the slaughterhouses could find markets for these parts of the animals, the amount of waste from the thousands of pigs who passed through the city was remarkable, with so much blood passing down Deer Creek that it gained the undesirable nickname "Bloody Run." Indeed, as the packing business boomed, outpacing markets for the least expensive parts of the pigs, some meat, including spare ribs, found its way into local waterways. In 1835, visiting British author Harriet Martineau could marvel at the number of hogs that made their way to the slaughterhouses, but she called Deer Creek "little more than the channel through which their blood runs away," reminding us of the environmental consequences of the congregated slaughterhouses.

After the meat had chilled at the slaughterhouses, laborers moved the carcasses in large wagons to the packinghouses, mostly clustered along the Ohio River and, when it was completed, the Miami Canal. Fully loaded wagons could carry up to 100 carcasses. At the packing plants, butchers cut the pigs into hams, chops, and bacon, and the majority of the meat bathed in smoke or salt. Fresh meat entered the local market, but most of it passed out of the city on steamships heading downstream, especially in large barrels filled with brine. Until railroads began to change the economic geography of the Midwest, the majority of Cincinnati's packed pork headed south, finding markets in the slave-dependent cotton-growing regions. There, plantation masters would rather their slave labor work in the profitable cotton fields rather than in agriculture dedicated to their own sustenance. Some Cincinnati pork traveled farther, to eastern cities, via New Orleans, and even to Europe.

Over time, Cincinnati's packers developed remarkable efficiency. Moving into the Mill Creek Valley, packers joined the once-separate stages of the business, with hogs moving directly to holding pens at the packing plant, often above the cutting floors. When killed, usually by a sledgehammer blow to the head, the pigs could be strung up by their hind legs and passed through the plant via gravity. Frederick Law Olmsted visited the city in the early 1850s and provided a wonderful description of the process, which he witnessed as a tourist:

> We entered an immense low-ceiled room and followed a vista of dead swine, upon their backs, their paws stretching mutely toward heaven. Walking down to the vanishing point, we found there a sort of human chopping-machine where the hogs were converted into commercial pork. A plank table, two men to lift and turn, two to wield the cleavers, were its component parts. No iron cog-wheels could work with more regular motion. Plumb falls the hog upon the table, chop, chop; chop, chop; chop, chop, fall the cleavers. All is over. But, before you can say so, plump, chop, chop; chop, chop; chop, chop, sounds again.

Not surprisingly given its German heritage, Cincinnati became well known for its sausage making. Here men are at work at the Vine Street Busch Sausage Company in Over-the-Rhine in 1927. (Courtesy of the Cincinnati Historical Society Library.)

What Olmsted described others called the disassembly line, in which men passed hogs along, making the same cuts on each animal. The efficiency gained through this process allowed Cincinnati companies to pay more for live hogs, encouraging even more farmers to send their products to the Queen City even if the trip required greater shipping costs. Some disassembly lines would process up to 180 hogs per hour, with some butchers spending less than a minute with each hog. By 1840, the city's 48 meatpackers employed over 1,200 workers, and by the early 1850s, they packed nearly 400,000 hogs per year, more than 16 times as many as Chicago, the city that would eventually overtake Porkopolis as the largest American meatpacking city just a decade later. In peak years before the Civil War, the city could see the arrival of nearly 500,000 hogs.

During the Civil War, Cincinnati's packing industry suffered serious setbacks, as hostilities prevented Cincinnati from sending its products south to New Orleans. Other cities, particularly farther north, took advantage of Cincinnati's bad fortune, including the rapidly rising Chicago, which opened new, large facilities and transported its packed meat via lake steamers and railroads. After the war, Chicago's industry continued to grow as it capitalized on its superior access to farms in Iowa and Illinois and its superior access to eastern markets via rail lines. Although Cincinnati attempted to build its own rail connections, after the disruptions of the Civil War the Queen City could no longer match Chicago's growth, losing its crown to the new "Hog Butcher to the World." Still, Cincinnati continued to handle more and more animals, even more efficiently after the city opened its Union Stock Yard near the Mill Creek in 1871. The movement of the industry out of the basin continued apace, as railroads replaced the canal as the most important means of moving supplies and products. The city processed

nearly 900,000 hogs per year in the early 1870s, mostly in the West End and farther north along the Mill Creek's rail lines.

While meatpacking was critical to the city's economic growth, it did little to aid Cincinnati's reputation, which remained tainted by the stench of packinghouses, the manure of thousands of animals, and the sight of pigs roaming city streets. Visitors chuckled at the free-roaming pigs, but residents learned to put up wrought iron fences, many of them just tall enough to keep a hungry pig out of small city yards. Urbanites from the East's more established cities might scoff at a city so dependent on livestock for its livelihood, calling it "Porkopolis" disparagingly, but despite the inconveniences meatpacking brought, Cincinnatians would long express appreciation of the industry's role in building the Queen City and take pride in the once-derogatory moniker "Porkopolis."

Only some of the byproducts of meatpacking were negative, including water and air pollution and a soiled reputation. But the concentration of pork packing also created opportunities for other industries to develop, including barrel making. With so much packed pork heading south on the river, the industry needed a constant supply of barrels, most of which would be assembled in nearby shops, using wooden staves and iron hoops. The barrel industry itself then helped stimulate the lumber industry in the city, which thrived until raw timber became prohibitively expensive, as the forests receded from the region.

Of course, other byproduct industries would have a more lasting effect on the city, as the butchered hogs themselves left piles of waste materials, especially tallow and other fats. While meatpackers concentrated on the most valuable parts of the hogs, others purchased the byproducts and turned them into salable products. In this way, the manufacture of tallow candles and lard-based soaps grew right along with the packing industry. By the 1850s, the city had nearly 30 lard oil factories, where the rendered fatty material was separated into two key byproducts—stearine, a key ingredient in candles, and oleine, an ingredient in some soaps.

The abundance of tallow in the city encouraged dozens of entrepreneurs to try their hands at the candle and soap businesses. Michael Werk began his candle shop in 1832 on Poplar Street. By 1912, the Werk Company was so successful, having moved into soap manufacture, that it relocated to St. Bernard to seek more capacity in a larger factory. In making this move, the Werk Company was replicating the relocation of another Cincinnati soap company that also had its roots in the 1830s: Procter and Gamble.

The work of building the Procter and Gamble Company began in 1837, when William Procter and James Gamble operated a backyard kettle for boiling animal fats and manufacturing candles and soaps, which they themselves delivered to local customers. At the time, they constituted one of 18 small companies engaged in such work. This was not an auspicious time to launch a new business, coming in the year of an economic panic and at the beginning of what would turn out to be a lengthy depression. Still, Procter, who had arrived in Cincinnati with his wife and a large debt from England, and Gamble, who had migrated with his

parents from Ireland, used their experience in the candle and soap business to their advantage. They first occupied a building at Sixth and Main, a shop used by Procter before their partnership, but they soon moved to a new location along the Miami and Erie Canal, which gave them good access to both the meatpacking plants that would supply them with the fat they needed and the markets to which they would begin to ship great quantities of product. Despite hard economic times at the outset, by the mid-1840s the company had become a successful, established firm.

Procter and Gamble flourished during the Civil War, partly because foresight led to a timely purchase of rosin, a necessary ingredient in soap manufacture. The rosin allowed the company to fill large orders to supply Union troops with soap, giving Procter and Gamble reliable income through the war and distributing the company name throughout the West.

Although long known primarily as a soap company, in 1879 only one-quarter of the company's sales came from that category, with most of its income coming from candles and lard. The company's fortunes changed by famous accident in that year, when an employee left a mixing machine on through his lunch break, introducing too much air into a white soap mixture. The result was the soon-to-be-famous "floating" soap, originally simply called "White Soap," but later dubbed "Ivory" by Harley Procter, William's son. Harley Procter not only named the soap, but he also launched the company on its path toward extensive and innovative marketing, ensuring that advertising would help create brand identities and loyal customers, a critical feature in the development of the company over the next century. In 1882, Procter began marketing Ivory in the *Independent*, a national religious weekly, focusing on analysis that found that the soap was "99

Beginning in the 1850s, Procter and Gamble began using a symbol to label its crated products. The Moon and Stars evolved over time, changing from its 1859 incarnation (left) to that of 1882 (right). The symbol helped brand the entire company. (Courtesy of Procter and Gamble Company.)

and 44/100% pure." By that time, the company had registered the first incarnation of the Man in the Moon trademark, effectively branding the entire company.

The rapid growth of the company that came with the success of Ivory meant that Procter would soon require added production space. Procter officials debated moving out of the West End, where the company was spending approximately $60,000 in added transportation costs to reach rail lines each year. The Miami Canal, which had made the location of the Central Avenue plant ideal in earlier decades, no longer provided the best transportation connections for the company. Railroads provided faster, more reliable transportation, but the Central Avenue plant had no good rail access. A large fire at the Central Avenue plant in 1884 forced the issue of relocation. Procter and Gamble decided to build a massive new complex outside the city, where the company would have more room to grow, on 55 acres near the Bee Line Railroad, 7 miles from downtown.

Initially the company contemplated building a factory and a company town for workers, and it even hired architect Solon Spencer Beman, who had recently completed construction of Pullman, Illinois, the company town of George Pullman's Palace Car Company. George Pullman himself advised against the company town idea, however, and Procter instead simply developed a massive, modern factory, complete with pleasing, if not beautiful, limestone buildings. Building began in 1885, with the complex, called Ivorydale, affording good access to the north–south rail lines in the Mill Creek Valley and to the Mill Creek waterway itself.

Harley Procter gave Ivory its name and encouraged Procter and Gamble to market its new star product more aggressively in the 1880s. (Courtesy of Procter and Gamble Company.)

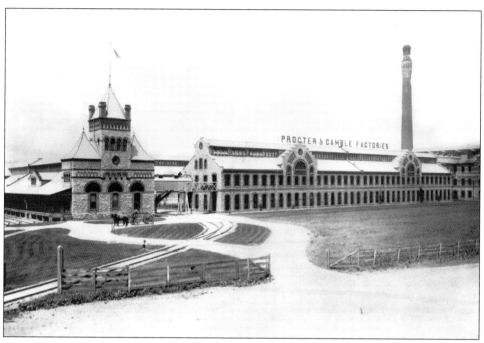

Ivorydale was one of the nation's most advanced industrial plants when it opened in the late 1880s. It was also part of the exodus of industry out of the city basin. (Courtesy of Procter and Gamble Company.)

Ivorydale grew outside the city limits in the village of St. Bernard. Incorporated in 1878, St. Bernard had long been a retreat for Germans, particularly Catholics, who wanted escape from the dense Cincinnati basin, some through weekend retreats, others through the purchase of homes in the suburban community. With the arrival of Andrew Erkenbrecher's starch factory in 1859 and good rail connections, St. Bernard grew into its role as an industrial suburb. In 1912, St. Bernard opted to incorporate as a city, permanently rejecting Cincinnati's annexation bid. Indeed, St. Bernard would join Elmwood Place and Norwood as cities completely surrounded by the city of Cincinnati, all of them providing industry with good access to urban markets and transportation and the benefits of lower taxes. By the 1940s, Procter and Gamble had 200 acres surrounding its original Ivorydale plant, where it employed 3,000 workers in 53 buildings. It had operated its own chemical laboratory at Ivorydale since 1890, securing research and development as one of the means by which the company would grow and prosper.

Procter and Gamble developed into an international corporation by the early 1900s, largely on its strength in product development and its ability to create strong brand identities, based not just in product quality but also in extensive marketing. Although Procter would gain a reputation as a conservative corporation, its success was predicated on constant innovation. In 1911, Procter

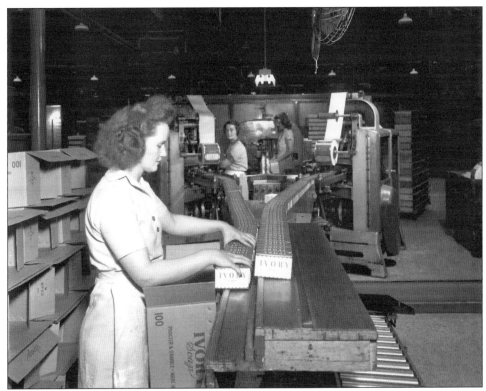

Successful marketing helped Procter and Gamble turn its Ivory brand into the core of an international consumer products empire. Here women wrap and box the soap at Ivorydale. (Courtesy of the Cincinnati Historical Society Library.)

introduced Crisco, the first all-vegetable shortening, and in 1933 it launched Dreft, the first synthetic detergent sold for household use. These and other products, including Tide, introduced in 1946, and Crest, the first fluoride toothpaste, launched in 1955, helped Procter develop a long list of innovative consumer goods. Indeed, in an age of an expanding middle class and increased consumerism, Procter and Gamble was well positioned to attain the status of world leader in the production of consumer goods and to become Cincinnati's most recognizable corporate citizen.

Other well-known names in Cincinnati also had connections to the soap industry. In 1840, Thomas Emery Sons got its start in candle manufacturing at a small factory near the public landing on Vine Street. An 1885 fire damaged the downtown plant, and following the lead of Procter and Gamble, the Emerys moved out to the Ivorydale area. While the soap business flourished, the Emerys would become better known for real estate and development, particularly in the early twentieth century. The name Andrew Jergens, on the other hand, would remain wedded to his soap company. Jergens opened his factory in 1882, positioning it near the stockyards along Spring Grove Avenue. In the 1890s, as the

cosmetics market expanded, so too did the Jergens line of products, which would eventually include face creams and powders. Jergens grew slowly, but by the late 1930s its Spring Grove plant employed 1,000 workers.

While the soap industry has had a longer-lasting effect on the city's economy, brewing has had an equally significant effect on the city's self-conception and reputation. As Cincinnati's German population grew, brewing developed into one of the city's most important industries. Small breweries developed in Over-the-Rhine and the West End, especially in the intensely German neighborhoods and along the Miami Canal. The canal offered the breweries the usual advantages, providing easy shipping in and out of the city, which was particularly important in the shipment of ice, brought south from lakes in northern Ohio. The ice was critical to the production of lager, which fermented at cool temperatures in large kegs, some of which were stored in sub-basements and tunnels that reached back into the hills north of the basin.

By the 1860s, some of the city's breweries had grown quite large, including the John Hauck, Windisch Muhlhauser, and Christian Moerlein breweries. By 1885, the city had 25 breweries producing over 24 million gallons of beer annually. In that year, Louis Hudepohl and George Kotte purchased a failing brewery and renamed it Buckeye. It took the more familiar family name, Hudepohl, in 1892, at about the time that the brewing industry peaked in Cincinnati. German

Christian Moerlein was one of the city's most successful brewers, well known in his own day and made famous again in the late twentieth century when Hudepohl created a new lager bearing his name and this photograph. (Courtesy of Archives & Rare Books Department, University of Cincinnati.)

immigration slowed, and drinking habits began to change, as steadily Americans consumed less alcohol per capita. Still, local breweries produced primarily for the local market, with Cincinnati residents consuming almost exclusively local beers. The city's heavily German, beer-drinking culture ensured that as long as alcohol remained legal, the city would have a substantial brewing industry.

While the industry had peaked decades earlier, the onset of Prohibition, begun in Ohio under state law in 1919 and then affecting the entire nation in 1920, meant dramatic decline for breweries. While residents yearning for a drink would easily find one at a local speakeasy—there were apparently up to 3,000 illicit drinking establishments in the city—brewers would have less luck evading the new law. Indeed, the largest breweries suffered the worst, and even the production of soft drinks in an effort to stay afloat until Prohibition ended could not prevent many bankruptcies. The three largest local breweries all closed permanently during Prohibition, darkening large factories in Over-the-Rhine and the West End. Prohibition ended in April of 1933, and by 1935 Cincinnati once again had several breweries in operation, including Hudepohl, which would become the most successful of the remaining breweries. When it joined with Schoenling in 1986, it became Cincinnati's last hometown brewery, a tiny remnant of a once-great local industry.

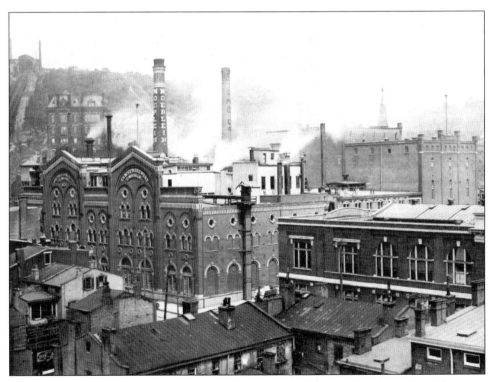

Christian Moerlein's brewery remained successful until Prohibition in the 1920s. (Courtesy of the Cincinnati Historical Society Library.)

Industrialization required the creation of machines that could replace the work of human hands. Obviously, these machine tools themselves would require manufacture, and nineteenth-century cities hoping to modernize their factories could do no better than to support a machine tool industry. By the late 1800s, Cincinnati had become home to several important manufacturers of machine tools, including the Cincinnati Milling Machine Company, organized by Frederick A. Geier in 1889 based on his experience in manufacturing screws. The company grew rapidly in Oakley, then a developing, distant industrial neighborhood with good access to rail lines. By the late 1930s, the company employed nearly 3,000 workers in the manufacture of milling machines, grinders, and planers at its 16-acre plant. Nearby, Richard LeBlond's Machine Tool Company expanded just off the main route to Oakley, Madison Road. LeBlond began his lathe manufacturing business in 1887, but the company only flourished as war in Europe dramatically increased the demand for firearms in the 1910s. LeBlond had developed a gun-boring lathe that became a critical machine in the rapid manufacture of rifles.

Dozens of other machine tool companies developed in the region in the nineteenth century and into the early twentieth century. The machine tool industry peaked in Cincinnati in 1929, when 35 firms employed 14,000 local workers. With the Great Depression, however, the industry nearly collapsed, as manufacturers dramatically cut back on capital investments. In recent years, Cincinnati's machine tool industry has withered. Indicative of larger transformations in the American economy, both the LeBlond and Cincinnati Machine factory locations have seen dramatic changes, first in the loss of industrial jobs and more recently in the destruction of manufacturing facilities to make room for retail space. The urban landscape can provide no clearer evidence of the deindustrialization reshaping American culture than in the LeBlond smokestack that once towered over the old factory site, now standing amidst restaurants and shops.

Cincinnatians would remain well aware of their city's relationship to the manufacture of soap, beer, machine tools, and pork, largely because those industries remained important to the city's economy as well as its self-conception. However, another important industry would largely fall from the city's lore after it faltered in the late 1800s: carriage making. Nearly universal conveyances until their gradual replacement by automobiles in the early 1900s, carriages crowded the streets of Cincinnati, transporting goods and people to and from the public landing and railroad stations. Carriages made commercial Cincinnati work, and they themselves became an important product of the developing industrial city.

Apparently the first Cincinnati carriage was built as early as 1793, but the local industry really began in 1812, when George C. Miller began the manufacture of carriages for sale. Miller's business grew steadily, as he offered a wide variety of coaches, sulkies, and other conveyances. Other firms opened through the mid-1800s, clustering in the West End and the edges of Over-the-Rhine, especially near the canal. Competition encouraged innovation, with manufacturers continually

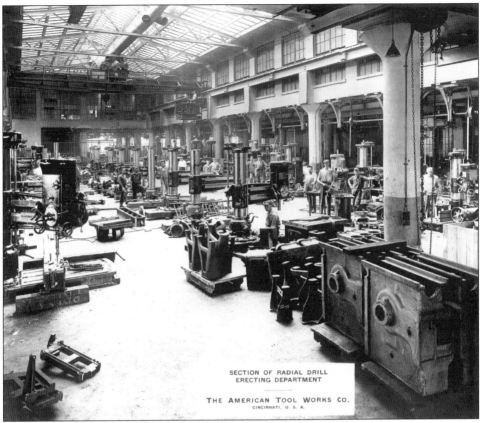

SECTION OF RADIAL DRILL
ERECTING DEPARTMENT

THE AMERICAN TOOL WORKS CO.
CINCINNATI, U. S. A.

The machine tool industry became one of the city's most important. Here men work on drills for the American Tool Works Company. (Courtesy of the Cincinnati Historical Society Library.)

developing lighter, finer, and more affordable carriages. By 1890, Cincinnati had become the center of the nation's carriage trade, manufacturing a stunning 150,000 units, nearly half the country's total. The industry did not centralize the way others had in the late 1800s, and in the 1890s more than 80 firms produced carriages for sale in the city.

Very few carriage manufacturers made the successful transition to automobiles, with most of the small shops simply unable to afford the tremendous cost of retooling factories and retraining workers. In Cincinnati, only Sechler and Company, manufacturers of wagons, successfully shifted businesses, moving into the construction of truck trailers and becoming the Trailer Company of America in 1928. Most carriage companies simply disappeared as the industry faded, representing a significant loss in employment and wealth for Cincinnati.

Meatpacking, soap making, brewing, the machine tool industry, and the carriage trade were central to Cincinnati's nineteenth-century growth, and the successful companies within those fields became many of the city's most recognizable

entities. But there were other industries, and other important companies, some of which helped give Cincinnati its reputation as an extremely diversified city. The abundance of corn and other grains in the region encouraged the development of distilleries, for example, and as early as 1820 nine firms produced liquor in the city. The city's largest distillery opened in 1893 in Carthage along the rail lines of the Mill Creek Valley. At the end of Prohibition, the Carthage Distillery became part of the National Distillers Products Corporation, and its familiar whiskey and gin products were added to the list of well-known local brands.

Two other well-known names grew from arts-based industries. Dwight Baldwin began his downtown music business in 1862. At first he simply sold pianos and organs, but then later he began to manufacture them as well. By 1920, his then famous Baldwin pianos and organs were popular enough to require more manufacturing and office space, and the company moved to its grand building on Gilbert Avenue. Just up the hill another company, Rookwood Pottery, had long since established its world-renowned reputation for its beautiful vases and ceramic tiles. Founded by Maria Longworth Storer, daughter of the wealthy Joseph Longworth, in 1880, the company took the name of her childhood home in Walnut Hills. Using native Ohio clay and skilled artisans, Rookwood developed an easily recognizable style. Workers handcrafted each unique piece, using some

By the late 1800s, Cincinnati had a very diverse economy. The Queen City Varnish Company depended on the strength of the city's carriage industry, which would falter in the years following the appearance of this 1891 advertisement. (Courtesy of Archives & Rare Books Department, University of Cincinnati.)

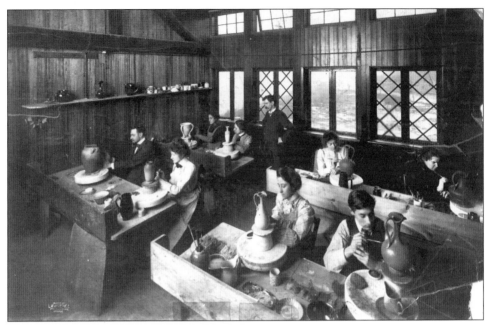

While never a large employer, Rookwood Pottery became an icon of Cincinnati's late nineteenth-century industry, producing distinctive and innovative pottery and tiles for decades. (Courtesy of the Cincinnati Historical Society Library.)

glazing techniques they themselves developed. Rookwood's beautiful products helped solidify Cincinnati's reputation in the late 1800s as an arts center, but unfortunately the company could not survive the Great Depression and the development of improved mass production techniques. Rookwood Pottery closed in 1941.

Cincinnati was never an important pharmaceutical city. The drug industry flourished around Philadelphia and New York even in its infancy in the nineteenth century, but Cincinnati did become home to one large pharmaceutical concern—the William J. Merrell Company. Begun in 1804 as a chemist's shop, the company grew until opening a large facility in Reading in 1937. Another nineteenth-century pharmaceutical company, Lloyd Brothers, did not grow nearly as rapidly, but it still left a significant legacy in the city: the Lloyd Library downtown, which houses a remarkable collection of medical and scientific literature.

Although not particularly glamorous, the coal industry also became critical to industrial Cincinnati. The Queen City had easy access to the coal deposits in eastern Kentucky, West Virginia, and southern Ohio, and the cheap fuel helped companies operate profitably and encouraged the city's diversifying industrial sector. The marketing of coal itself became a lucrative enterprise, as river barges and rail cars delivered thousands of tons of coal to the city, requiring wholesale, retail, and delivery around the city, not just to industries, but also to homes, offices, hotels, and any other building that required heating.

Rapid growth in the mid-nineteenth century brought with it rapid change for Cincinnati residents. As the population grew, the city too expanded—to 7 square miles by 1870. The population itself grew more diverse, and by 1850 nearly half of the city residents had been born abroad, mostly in Europe and especially in Germany and Ireland. The newcomers were drawn by economic opportunity in the Queen City, with most joining the ranks of those employed in factories and smaller shops. In 1850, Cincinnati's industries employed nearly 30,000 workers,

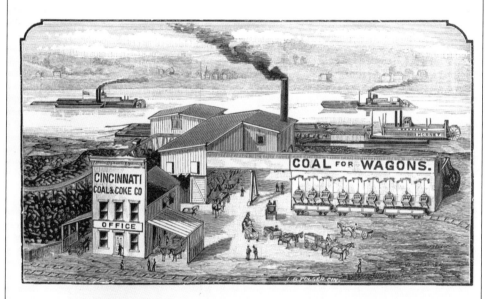

A. MONTGOMERY, President. . M. M. DURRETT, Sec'y & Treas. JAS. P. LINDSAY, Manager.

The Cincinnati Coal & Coke Co.

MINERS AND SHIPPERS OF ALL KINDS OF

COAL FOR WAGONS.

CINCINNATI COAL & COKE CO

OFFICE

COAL AND COKE

- - ANTHRACITE, PIEDMONT - -

Foot of Fifth Street and Freeman Ave. CINCINNATI, OHIO.

TELEPHONE 7144

Cincinnati had easy access to the coalfields upstream in eastern Kentucky, West Virginia, and southern Ohio. Coal fed industry but also caused terrible smoke problems. This 1891 photograph features coal barges, a coal wholesaler, and the black smoke. (Courtesy of Archives & Rare Books Department, University of Cincinnati.)

almost as many as Chicago, Louisville, Pittsburgh, and St. Louis combined. Although new industries and other businesses brought jobs, the periodic panics and depressions of an unpredictable economy kept most workers in a state of uncertainty. Even skilled workers had to worry about the longevity of their jobs.

Although economic growth clearly meant opportunities for workers, it just as clearly brought unequal benefits to Cincinnatians. The gap between the wealthiest and poorest residents grew, undoubtedly adding to working-class frustrations from periodic layoffs and pay cuts. Many families survived hard times by sending more of their members into the workforce, including women, who were finding more opportunities as teachers and sales clerks, but also in certain industries, including textile manufacturing. Children, too, entered the workforce, generally to provide necessary income for their families, not for extra spending money.

After the Civil War, Cincinnati failed to keep up its previously stunning growth, but the long-delayed opening of the Southern Railway in 1877 did help reconnect the city with its traditional Southern market. Owned by the city itself,

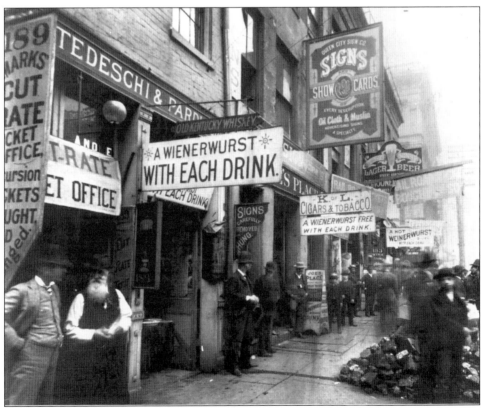

Saloon culture was critical to the lives of working-class men in the late 1800s. Here saloons on Vine Street advertised free hot dogs with each drink. (Courtesy of Cincinnati Historical Society.)

its construction represented a real understanding of the need to replace water routes with iron rails in order to keep the Cincinnati market well connected. Still, by the 1870s, commerce alone no longer drove the economy. Cincinnati had developed a wide array of industries, a diverse economy that was the envy of many other cities. In 1880, Cincinnati still led the nation in the production of carriages, furniture, and whiskey. It also led in smaller industries, including in the production of coffins, plug tobacco, and glycerin, a by-product of slaughtered pigs. And, of course, the city continued to pack considerable amounts of pork, brew remarkable amounts of beer, and manufacture machinery.

Still, the benefits of this growth fell unevenly across the city's population, and Cincinnati's working class attempted to change this inequality through several means. In 1877, workers supported the railroad strike begun in Martinsburg, West Virginia. Soon sympathy strikes turned the rail strike, begun to prevent reductions in pay for railroad workers, into a national walkout. In Cincinnati, railroad workers struck, but they gained the support of others as well. On July 21, 1877, about 2,000 men and women confronted militia members in the streets, and for several subsequent days, tensions remained high. The strikes ended on July 26, with the railroads agreeing not to cut wages.

Perhaps encouraged by the success of the railroad strike, thousands of Cincinnatians joined unions in the subsequent years, with over 12,000 active unionists in the city by 1884. In 1878, workers revived the dormant Trades and Labor Assembly, to coordinate working-class initiatives. The Assembly supported strikes and even boycotts, including those against establishments that didn't sell union-made beer. Although unions could fight for better wages, often simply demanding that pay not be cut in deflationary times, labor remained highly fractured in the 1880s. Few of the unions attempted to organize men from different ethnic groups. African Americans remained excluded from the best jobs, but they also remained excluded from most labor unions. Men and women rarely organized together, either, except in the Knights of Labor, which began organizing in Cincinnati in 1877, originally with shoemakers.

Labor organizations did win periodic, if temporary, victories for average workers, but frustration continued to grow among workers who well understood they had little control over their own lives. This growing frustration no doubt contributed to the worst episode of urban violence in Cincinnati's history: the Courthouse Riot of 1884.

In March of 1884, two teenagers beat to death stable owner William Kirk in the city's West End, in what seemed to be just another murder in a city with a rising crime rate. Many suspected that poor police work and even corruption in the prosecutor's office encouraged the high crime rate. When the trial of William Berner, one of the accused, ended in a manslaughter conviction rather than the anticipated death penalty for homicide, the city grew tense with disgust. Even after the judge sentenced Berner to 20 years in prison, a crowd of thousands gathered at Music Hall to protest the Berner case and express a lack of faith in the judicial system. Many of the city's leading citizens were there, including George

McAlpin, owner of the large department store that bore his name, and Andrew Hickenlooper, president of the Cincinnati Gas, Light and Coke Company, Cincinnati's major utility. The crowd soon grew restless and sought more than speeches. A large contingent headed off to the jail in the hopes, apparently, of hanging Berner themselves. As the crowd moved down Court Street, the jailor signaled for aid, and fire sirens sounded around the city. When firemen arrived, a crown of 10,000 began pelting the jail with rocks and other projectiles. Just 14 men guarded the jail, and they were reinforced by several patrolmen as rioters attempted to crash through the front door.

When the door finally gave way, fighting ensued inside the jail itself. The police gained the upper hand temporarily, but when bullets killed one of the young protesters, the mob regained its intensity. Using stolen kerosene, the mob set fire to the jail, and fighting continued for hours. By the end of the evening, 100 police officers and 200 soldiers were on hand to defend the buildings and the prisoners. Ironically, Berner, the target of the crowd's rage, had been sent out of the city earlier in the day to the penitentiary. By the time the crowd had fully dispersed, five people were dead, including one police officer, Joseph Sturm, and perhaps 50 others had been wounded.

The next day the fighting resumed; this time more militia were on hand with Gatling guns to defend the courthouse and jail. The crowd came better armed, too. Gunfire lasted for hours, continuing even after the Gatling guns were put to use. As night fell, some of the rioters successfully set fire to the courthouse and prevented the firemen from dousing the flames in time. The courthouse was almost completely destroyed. As the rioting continued, some men took to looting nearby stores, and in one instance a shopkeeper and his aids killed three such men as they attempted to destroy his business.

As Sunday began, it was clear that the carnage of the day before had sapped much of the strength of the riots. One final assault on the heavily reinforced militias left more dead and wounded, but by the end of the night the worst riots in Cincinnati history were over. In total 56 people had been killed and more than 300 wounded.

If the 1884 riots revealed the potential for chaos within the diverse and conflicted city, other forces brought a sense of unity and order. As industrialization continued to shape the work life of Cincinnatians, it also shaped the city itself. Through the late 1800s, Cincinnati developed an extensive transportation system, one that allowed the industrial city to reach outward to open lands. In 1859, the city witnessed the development of a horse-drawn streetcar line, which, although reliant on animal power, was able to convey people over greater distances at greater speeds than older omnibuses. The streetcars, pulled along tracks in the roadway, would help reshape the city, particularly after they shifted to electric power beginning in 1889. By 1875, the city had 14 separate lines, employing 1,000 horses to pull streetcars over 45 miles of track. By 1911, the Cincinnati Traction Company, which had unified the many streetcar lines into one system, operated trolleys radiating out of the city basin: westward to Anderson Ferry, out

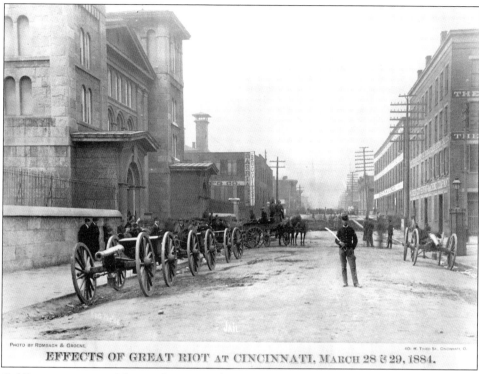

PHOTO BY ROMBACH & GROENE.
40: W. THIRD ST., Cincinnati, O.

EFFECTS OF GREAT RIOT AT CINCINNATI, MARCH 28 & 29, 1884.

Soldiers, cannon, and barricades occupied city streets in March 1884, too late to stop the destruction of the courthouse and jail during the city's worst riots. (Courtesy of the Cincinnati Historical Society Library.)

Eighth Street and Warsaw in Price Hill, out Harrison to Westwood, up Colerain and Hamilton Avenues to College Hill, up Vine Street all the way to Wyoming, up Montgomery Road to Norwood, out Madison Road to Oakley and out Eastern Avenue through Columbia. Other lines crossed the city along McMicken in the basin, McMillan in Mount Auburn, and Ludlow through Clifton. The system not only reflected the growth of all of these more distant places, but also encouraged it.

With the improvements that came with electrification, including greater speed and reliability, the streetcar system grew to 228 miles of track by 1920, and it provided over 100 million rides a year. Clearly, streetcars had become integral to intra-city transportation, giving working-class residents relatively inexpensive access to work and recreation and allowing the middle-class to move further and further from the congested core of the city. Like the steam railroads that preceded them, the trolleys encouraged outward growth, but they also focused development in particular places. Streets with trolley lines developed more intensely than those without, as business districts and apartment buildings thrived on the easy access provided by the streetcars. Downtown was the hub of the trolley system, and it benefited from the increased accessibility afforded by the clustered lines. In this

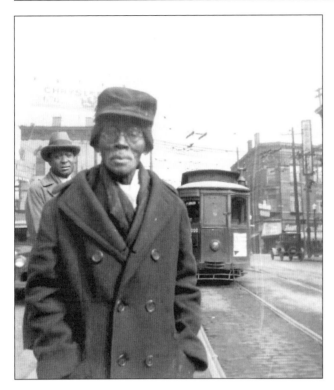

Cheap transportation provided by trolleys allowed the city to spread well beyond its core. Here men await a trolley in Walnut Hills, which was a thriving mixed-race neighborhood by 1928, when this picture was taken. (Courtesy of the Cincinnati Historical Society Library.)

way, trolleys were advantageous for both geographical expansion and the further development of urban streetscapes, alive with people clustered at worksites, theaters, and shops. Through the early twentieth century, trolleys became synonymous with urban vibrancy, as the cars connected the disparate pieces of the complex city.

Cincinnatians are most likely to remember fondly the unique aspect of their city's trolley system—the several inclines that raised streetcars up the basin's steep hills. The inclines first provided a means of lifting horse cars up steep grades, allowing greater suburban development in the city's hilltops. As electric traction gained in popularity, the inclines carried trolley cars up the same slopes, reducing the length of commuting trips that might otherwise be very circuitous.

The first incline, built in 1872, lifted cars up and down Mount Auburn, providing its passengers with spectacular views of the city. The ride proved to be such an attraction, in fact, that the owner of the incline, George Smith, built the Lookout House at its apex to give passengers a place to spend time and money while they enjoyed the views before returning to the city below. The Mount Auburn incline provided the model for four additional lines, one each up Mount Adams, Price Hill, Bellevue Hill, and Fairview Heights. The Price Hill incline came in 1874, built by William Price with part of his family fortune. Rising from Eighth Street and Glenway Avenue, the incline deposited riders on Matson Street, where Price's own establishment would not serve alcohol, thus earning Price Hill

the nickname "Buttermilk Mountain." The most popular of the incline restaurants was the Highland House, at the apex of the Mount Adams line. On busy nights its beer garden could accommodate up to 8,000 guests. After 20 years in existence, however, competition from other retreats from the city and its own increasingly rowdy reputation led to the Highland House's closure in 1895, when the building was razed. It was to be replaced first by the Sterling Glass Company, built in 1902, and later by the still-standing Highland Towers, completed in 1964.

The inclines, and the watering holes at the tops of the lines, remained very popular destinations until the fall of 1889, when a failed clutch allowed the Mount Auburn car to plunge more than 800 feet. All but one of the passengers died in the mishap, and despite subsequent improvements in the system, the inclines lost a bit of their luster. Thus, the Mount Auburn, the first of the inclines, closed in 1898. Two lines, the Price Hill and Mount Adams inclines, persisted into the 1940s. In the end, the demise of the inclines had more to do with the failure of the trolley system as a whole and the growing reliance on automobiles than with the dangers of runaway cars.

If the hundreds of trolleys on city streets could represent urban culture, so too did several new establishments that developed in the thriving downtown. Of particular importance were large department stores and grand hotels, both of which signaled urbanity to the city's many visitors. Following the national trend, Cincinnati witnessed the growth of several massive stores, whose ever-increasing list of products spoke to the abundance of the industrial city and the growth of a

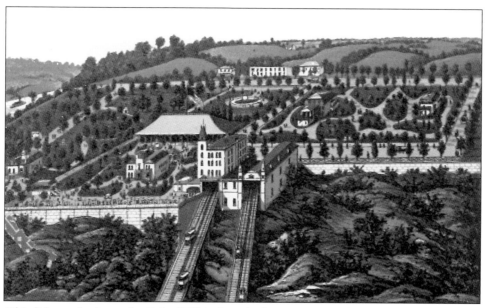

This lithograph shows the Price Hill incline, built in 1874. William Price's establishment at the top did not serve alcohol but did offer wonderful views of the city. (Courtesy of the Cincinnati Historical Society Library.)

consumer culture centered on the city itself. John Shillito opened the first of these stores in 1830 on Main Street, and although Shillito's would move more than once and go through several different corporate incarnations, it remains downtown, under the name Lazarus, more than 170 years later. In 1852 Ellis, McAlpin & Company opened, and in 1863 Henry and Samuel Pogue opened H. and S. Pogue Company, which moved to Fourth Street between Race and Vine, right in the heart of the city. Pogue's eventually occupied much of the lower parts of the Carew Tower in the mid-1900s. Two years after Pogue's opened, Frederick and William Alms partnered with William F. Doepke to create the Alms and Doepke department store on Main Street. In 1878, the store moved south to occupy a choice location along the canal on Main. Mabley and Carew, which occupied prime real estate on Fountain Square at the heart of the city, opened in 1877.

By the turn of the century, these and other department stores made downtown Cincinnati the place to shop, not just for those who lived within the city limits, but for others who traveled great distances to experience the excitement of urban streets, the conveniences of department store selections, and the advantages of lower prices. The big, vibrant department stores tapped into, and came to

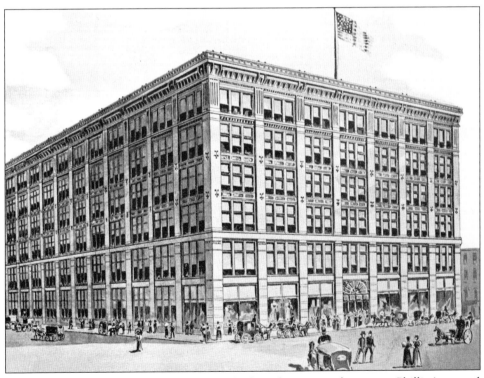

One of several downtown department stores built in the nineteenth century, Shillito's opened its grand store on Race and Seventh Streets in 1878. The spectacular building featured five elevators and a dome providing natural interior light. (Courtesy of Archives & Rare Books Department, University of Cincinnati.)

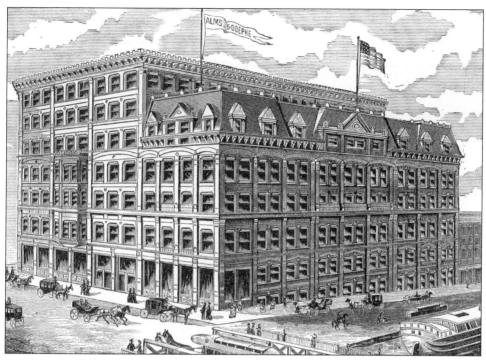

The growth of department stores in the nineteenth century represented the growing power of consumerism in the nation. The stores also represented the centrality of downtowns in the American economy. Here the Alms & Doepke department store looms over the Miami Canal, which would soon become Central Parkway. (Courtesy of Archives & Rare Books Department, University of Cincinnati.)

represent, the city's energy. The stores' extravagant promotions, announcing new seasons, new product lines, or simply celebrating the calendar's many holidays, began to sound like advertisements for the city itself. Combined with the marquees of Cincinnati's many theaters, the lights and window displays of the department stores represented the golden age of downtown in the early 1900s.

In addition, stunning hotels dotted downtown, offering sophisticated accommodations to the many rail passengers, tourists, and businessmen who stopped over in the city. In 1850, the 340-room Burnet House opened on Third and Vine, and was widely hailed as among the finest hotels in the country. In 1874, the Grand Hotel rose opposite the Union Central Railroad station. When the Palace Hotel opened at Sixth and Vine in 1882, it was the tallest building in the city. The eight-story French Second Empire edifice was a beautiful addition to the skyline. It remains a luxury hotel, now called the Cincinnatian. Other hotels clustered around Fountain Square, including the Hotel Emery and the Gibson Hotel. Each of the hotels featured a grand lobby with seating and most offered meals and drinks. For many, the urban experience began with the mingling within these lobbies.

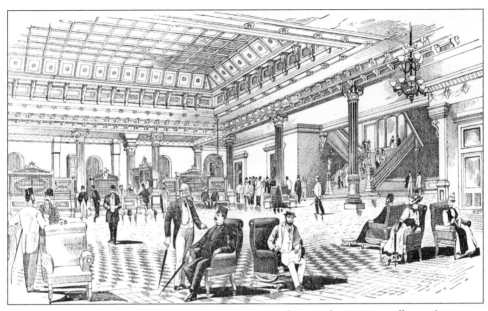

In the late 1800s, fashionable hotels represented urban sophistication, offering luxurious accommodations, Continental cuisine, and inspiring architecture. Here an exaggerated illustration shows the lobby of the Grand Hotel, built opposite the Union Central Railroad station in 1874. (Courtesy of Archives & Rare Books Department, University of Cincinnati.)

The city's center continued to thrive, but its suburbs grew as well. Continuing a trend that had begun decades earlier, wealthier Cincinnatians continued to move out of the congested basin and into hilltop neighborhoods, including Linwood and Hyde Park to the east, Clifton and Avondale to the north, and Westwood to the west. Significantly, the movement out of the basin did not necessarily signal a desire to leave the city altogether, only an effort to escape the negative qualities of the cramped inner city, especially its poor air quality, lack of green space, and high crime rate. The hilltop neighborhoods offered environmental amenities and personal safety, and they grew largely because although they were out of the basin, they still had good access to the jobs, shopping, and entertainment in and around downtown.

A series of annexations of outlying neighborhoods evidenced the continuing desire among hilltop residents to remain part of the city, as for decades the municipality expanded its limits to recapture population lost to relocation. The most significant annexation occurred in 1896, when Linwood, Avondale, Clifton, and Westwood all joined the city. Over the next ten years, the city limits would continue their rapid expansion, as western Price Hill (1902), Bond Hill (1903), Winton Place (1903), Hyde Park (1903), Evanston (1903), California (1909), Mount Washington (1911), College Hill (1911), Mount Airy (1911), Sayler Park (1911), Carthage (1911), Madisonville (1911), Pleasant Ridge (1912), Hartwell (1912), Oakley (1913), and Kennedy Heights (1914) all joined the city.

Although some smaller parcels would join the city later, by the beginning of World War I, the expansion of the city limits was nearly complete. By the 1920s, municipal annexations of suburbs became less common around the nation. Particularly middle-class and wealthy urbanites decided to remain aloof from the city, seeking particularly the lower taxes of smaller places and the greater opportunity to control their local communities afforded by separate incorporation. Henceforth, Cincinnati would no longer recapture lost population, though the real significance of this sea change would only gradually become apparent.

Although Cincinnati experienced relative decline over the second half of the 1800s, falling well off the pace of growth experienced by many midwestern municipalities, the city did continue to serve as a cultural center, and in this many residents continued to express great pride. This was particularly true in relation to sports, especially baseball. Sport was an important part of urban culture, particularly for working-class males who used the competition, both as spectators and participants, as diversions from their work-a-day lives. By the mid-1800s, baseball had become among the most important of these sports. Despite the rural myths surrounding its creation, baseball was a truly urban sport, even though it required some open space for real games.

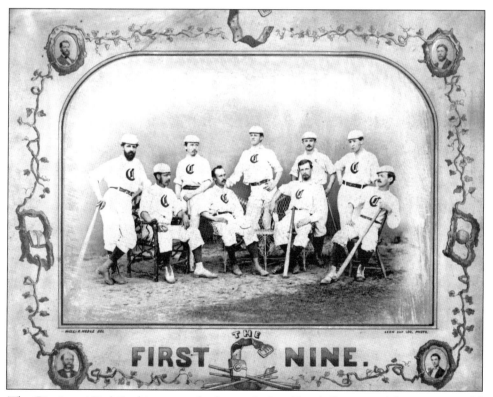

The Cincinnati Red Stockings were the first professional baseball team and the most successful team ever. (Courtesy of the Cincinnati Historical Society Library.)

By mid-century amateur teams toured the nation, representing the cities from which the players came. In the late 1860s, some in Cincinnati decided to ensure the success of their traveling team, offering to pay all of the players. The first professional team, the Red Stockings, toured the country in 1869, winning all of its 65 games, outscoring its opponents by a total of 2,395–575. Clearly Cincinnatians had something to cheer about, and they took special pride when their team bested squads from larger East Coast cities, including the New York Mutuals. Eventually, the Red Stockings team would win 130 games in a row, setting a record that cannot possibly be broken, and ensuring that Cincinnati would long remain a baseball city, even through periodic droughts in victorious seasons.

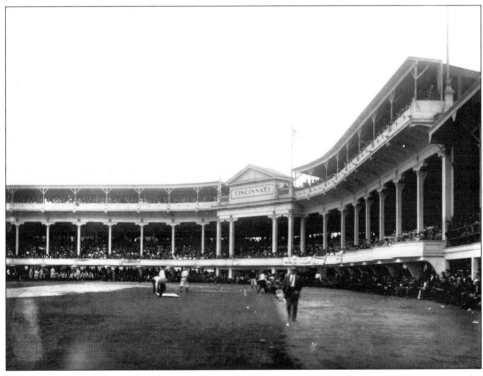

The popularity of baseball grew through the late 1800s, and by the early 1900s it was the most important male pastime in the country. From 1902 to 1911, the "Palace of the Fans" served as home to the Reds and a favorite afternoon getaway for thousands of Cincinnatians. (Courtesy of the Cincinnati Historical Society Library.)

5. A Progressive City

By 1900, Cincinnati had clearly lost the race for midwestern preeminence. Chicago had long since outpaced the river city, becoming by the 1880s the largest and most spectacular city in the nation's heartland. St. Louis, too, had surpassed Cincinnati, and now Cleveland, Detroit, and even old rival Pittsburgh had grown larger. The new economic order in the Midwest, based in the heavy industries of steel and iron, would be centered on the Great Lakes rather than the rivers. Iron ore from the upper Midwest traveled inexpensively in massive ships on the lakes, helping fuel the growth of steel industries in Milwaukee, Chicago, Cleveland, and Buffalo. Easy access to coal and coke in eastern Pennsylvania gave Pittsburgh the greatest advantage in steel production and a new surge of growth around the turn of the century. Cincinnati, once favored by its location on the Ohio, struggled to keep pace with the new industrial giants to the north, its river still of use but no longer of great advantage.

Cincinnati's relative decline was so apparent that even traditional boosters began to ask why their city had faltered. In 1925, the Chamber of Commerce published an *Industrial Survey* of the city with an introduction that asked, "*What* is the Matter with Cincinnati?" The authors correctly noted that the city had suffered through some specific industrial declines that hurt Cincinnati more than other places, including the crippling blow of Prohibition on the once-important brewing and distilling businesses and the complete disappearance of the once-thriving carriage industry. The city had also suffered through nationwide changes in the leather and meatpacking industries, as the epicenter of American agriculture shifted westward to the plains states, disadvantaging Cincinnati while favoring cities such as Chicago, Kansas City, and Omaha.

In these ways, Cincinnati's decline did not reflect badly upon the city's character. These were changes well beyond the control of local residents. Still, the Chamber of Commerce wondered, as many other Cincinnatians would for the next century, if the "stand pat" attitude of the business community had prevented the city from taking risks and pursuing new avenues for growth. Had the city become too conservative, too complacent, even after its boom had ceased? Had the city become, as the chamber put it, too "insular"? That the Chamber of Commerce would ask such questions is a good indication that the city had already

gained a strong reputation for conservatism, one that suggested an unwillingness or inability to be innovative.

Despite the relative decline in the late 1800s and the philosophizing about what was the matter with Cincinnati, it remained vibrant and among the most progressive communities in the nation, and even though many cities outpaced the Queen City, it did indeed grow in the early 1900s. Just as important, it continued to develop institutions and build new edifices that reflected Cincinnatians' interest in creating a more complete community, one rich in arts and culture and one reflective of the wealth that the city still generated. By the end of the 1920s, the city could point with pride to nationally recognized attributes, including its opera, symphony, zoological gardens, art museum, and public library. Downtown, new skyscrapers revealed the city's vibrancy, while in the West End a new train station would become an instant architectural and practical asset.

If the building of these cultural institutions and prominent structures spoke to the city's continuing successes, many other realities spoke to the failings. In the dense urban basin, obvious filth and vice evidenced the growing disorder of the industrial city. On most days, heavy coal smoke shrouded the city, and on the worst days one could not see from Mount Adams to the hills behind Covington. Of course, the smoke diminished more than just the views, as human health suffered, the smoke contributing to high death rates for lung ailments like pneumonia and asthma. Soot soiled every surface, including furniture in people's homes and merchandise in the city's stores. Beneath the smoke pall, a remarkable percentage of the city's population lived in cramped tenement housing, most of which had inadequate plumbing, with no running water and only privy vaults in backyards for human waste. Contagious diseases remained problematic in such situations, and the city suffered one of the highest tuberculosis death rates in the nation. By the late 1800s, Cincinnati's cramped geography had garnered the city a national reputation for density and dirt.

Clearly the congested city posed serious public health and environmental problems, but the basin contained well-noted social vices as well. Certain districts became famous for their brothels and rowdy saloons. Religious leaders pointed to the evils of the city, taking special umbrage at the many bars that operated illegally on the Sabbath. Crime rates rose in the city's dense neighborhoods, as vice, theft, assault, and even murder became regularized parts of the city's culture. In the mid-1800s, only the wealthy had fled the city's core for the hilltop suburbs, but late in the century the exodus of those with means became more complete, and the basin's poverty slowly became an identifying feature of the segregating city.

Even those who fled the basin neighborhoods remained concerned with their condition, and by the 1880s local political debate centered on the disorder of the city. In this milieu, the Republican Party gained support as it ran on platforms dedicated to law and order. Republican strongholds on the hilltops, anchored by such leading figures as William Howard Taft, could not gain control of City Council without the help of some basin neighborhoods, however. In the mid-1880s, that aid came from George B. Cox, a former bootblack turned

bartender turned saloon owner, who managed to gain the trust of the Republican leadership by regularly securing the votes within his West End ward. Cox's influence within the party grew through associations with George Moerlein, a brewer, and Joseph Foraker, a Cincinnati lawyer who became governor in 1885. With Foraker's support, Cox became Cincinnati's "Boss," distributing political favors and collecting kickbacks for his influence peddling. With his allies in and out of office over the next 30 years, Cox maintained influence through a series of shifting political alliances, including one with Charles P. Taft and his newspaper, the *Times-Star*.

Although Cox's Republican machine clearly worked in undemocratic ways, Cox saw himself as an honest broker. His allies gained political posts or government contracts in exchange for their loyal support on election day. With the aid of close political allies, including Rud Hynicka, who controlled the Hamilton County Republican party after 1900, Cox lined up Republican votes using a small army of precinct captains and ward bosses, all of whom, in typical machine fashion, had the power to exchange gifts for votes. On the other hand, while influence peddling kept the machine well oiled, the undemocratic means did not mean the municipal government would remain ineffective. Indeed, the

Most Cincinnatians were dependent upon coal to heat their homes and fuel their industry through the 1940s, a reliance that caused serious smoke problems. Here a pile of coal sits street-side, ready to be carted into the basement of a fashionable Clifton home. (Courtesy of the Cincinnati Historical Society Library.)

79

Republican-controlled councils initiated remarkably activist agendas, including those of Republican Julius Fleischmann, who served two terms as mayor from 1900 to 1905.

Even if the reformers were unsuccessful in completely taming the disorder of the city, the extent of their program was remarkable. If Cox's cronies did not eradicate vice, they did control it, even to the point of licensing prostitutes, which ensured some oversight of the business in an effort to guard public health from sexually transmitted diseases. Although crime persisted, at least the police force had been reorganized and better trained, and it grew more trusted by city residents. Drinking on the Sabbath continued, but disorderly saloons and illegal gambling came under control. Poverty in the basin persisted too, but the reform-minded Republicans took steps to improve inner-city living, building public baths and playgrounds and improving services at the city hospital in the West End. Looking toward long-term improvements, the Republicans also supported increased investments in the city's water supply, park system, and schools.

In 1905, Cox's influence began to waver, as E.W. Scripps launched an attack on Cox in his newspaper, the *Post*. Revelations about corruption within the Republican machine were not new, as Cincinnatians had long known about the graft that made Cox wealthy enough to build his mansion across the street from Burnet Woods in Clifton. Still, hearing exactly how Cox traded his influence for wealth convinced many to abandon the Republicans, at least temporarily.

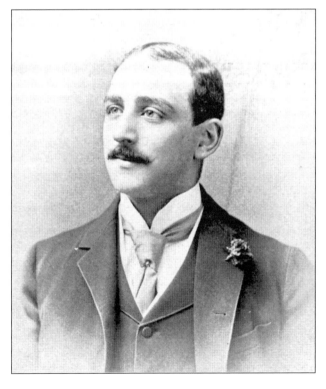

Julius Fleischmann used his considerable wealth, gained through his family's yeast business, to garner political office. (Courtesy of Archives & Rare Books Department, University of Cincinnati.)

Cox survived the initial attacks, but eventually his influence within the party dissipated, especially after William Howard Taft entered the White House and expressed a desire not to be embarrassed by any Cox-related scandals back home. However, the quintessential political operative, Cox was able to outlast most of his opponents, even by successfully fighting off criminal charges. He retired from politics in 1915, and he died just a year later. Although his Republican party had worked for reform and order in the city, in the end his machine, like the many others around the country, would become representative of urban disorder, of the corruption, fraud, waste, and inefficiency of municipal governance. Indeed, Boss Rule came to represent the failure of municipal politics, just another sign of the lawlessness within the city.

Clearly Cincinnati's sordid politics did not reflect the city's continuing progress. But even while corruption persisted in the political realm, urban cultural institutions continued to bloom. Ironically, even as the slowing growth of the city dropped Cincinnati in the rankings of the largest American cities, the continued florescence of its culture bolstered the city's national reputation.

In 1875, the city had opened the nation's second zoological gardens, closely following Philadelphia's lead. Largely the work of Andrew Erkenbrecher, who had made a fortune in the starch industry, the zoo's original design reflected the Victorian sensibilities of the era, with its emphasis on picturesque beauty. A large pond and curvilinear paths inspired reflection as they did in the landscaped parks then becoming common in the nation's cities. Beyond the soothing landscape, of course, the zoo provided residents access to exotic animals, including many acquired from circuses and even Erkenbrecher's own collection of song birds. Over time, the Cincinnati Zoo established itself as more than just one of the first in the nation, gaining a reputation as one of its finest as well. In 1905, the zoo added its most distinctive building, the elephant house, whose Muslim domes could be seen from around the Avondale neighborhood. At that point, the city's trolley operator, the Cincinnati Traction Company, owned the zoo, and not coincidentally, the attraction's entrance faced Vine Street where a central trolley line turned.

A year after the zoo opened its gates, a number of Cincinnati women involved in the Women's Pavilion at the Centennial Exhibition in Philadelphia began to plot the development of another critical cultural institution: an art museum. Again following the lead of larger Eastern cities, in 1877 these women, led by Elizabeth Perry, organized the Women's Art Museum Association and quickly gathered financial support for the idea. In 1882, City Council granted the new institution land within Eden Park for an edifice, one that would have commanding views of the city. The museum opened in 1886, and just a year later the Cincinnati Art Academy opened next door. While the museum gathered works of art from patrons in the city, the Art Academy gained a national reputation for its training of young artists. Through the Progressive Era, the two institutions flourished, with the museum adding space through significant additions in 1907 and 1910, the former designed by Daniel Burnham Associates, among the most famous

architectural firms in the nation. While the growing collection displayed in the museum reflected the diverse interests of its patrons, a particular interest in local artists led to the gradual accumulation of a remarkable collection of Cincinnati art, including Rookwood Pottery and the paintings of Frank Duveneck and Henry Farny.

The musical arts flourished in Cincinnati, too. Since the 1840s, music-loving Germans had organized choirs and musical societies. By 1870, Cincinnati supported at least 61 such organizations. In addition, in 1867, German-trained Clara Baur founded the Cincinnati Conservatory of Music, which would instruct students in musical arts, many of whom would staff the growing musical organizations, including a Philharmonic Society, founded in 1857, a symphony, organized in 1872, and finally, the Cincinnati Symphony Orchestra, constituted in 1895.

The most important development in the Cincinnati music scene, however, was the initiation of the May Festival in 1873. Music lover Maria Longworth Nichols had attended the concerts conducted by New York's Theodore Thomas, whose touring orchestra had made successful stops in Cincinnati in 1869, 1870, and 1871. During that last visit, Nichols convinced Thomas to return to the Queen City to direct a festival in which several different musical societies would participate. After the success of the first May Festival, another followed in 1875. Subsequent support for the symphonic music led to a successful fund-raising effort, initiated by merchant Reuben Springer's substantial gift. The monies went toward the building of Music Hall, completed in 1878 in time for the third May Festival. Designed by Cincinnati's most prized architect, Samuel Hannaford, the massive Music Hall towered over Washington Park, which it faced, and became the city's most important cultural icon, a lasting representation of German-inspired appreciation for fine music and an anchor in Over-the-Rhine, a neighborhood that would be set adrift in subsequent decades by the out-migration of the German-American working class and the influx of more impoverished newcomers.

Appreciation of opera grew more slowly in Cincinnati. Opera festivals took place in the 1880s, but not until 1899 did the city enjoy a season of opera performances, held in Music Hall. In the early 1900s, opera became a regular feature in the city and another example of the growing high culture.

If Cincinnati's slowing growth did not inhibit the development of fine cultural attributes, it similarly failed to slow the development of the skyline. Downtown continued to flourish, and rent pressure in the financial center along Fourth Street encouraged the planning of ever-taller structures. In 1913, workers put the finishing touches on the Union Central Building, now the PNC Tower. At the time of its completion, it was the fifth tallest building in the world and the tallest in the Midwest. Designed in part by Cass Gilbert, one of the era's great architects, the Union Central Building provided the city with a beautiful addition to its skyline, complete with its shining terra cotta exterior. Participating in a national trend, Cincinnati's skyline had begun its upward

growth, lending prestige to the companies that would bring towers and status to the city as a whole.

The Union Central Building was not the only significant addition to the skyline in the early twentieth century. In 1914, the Gwynne Building opened on the corner of Sixth and Main. Perhaps Cincinnati's most ornate skyscraper, the 12-story building included detailed metalwork and large windows, complete with retractable awnings. Its ornamentation reflected the Beaux Arts enthusiasm then popular, but it also reflected the energy of downtown streets and a continuing confidence in the city itself. Here, downtown, was the place to create exciting architecture, to display wealth. The new towers spoke of a continuing faith in the future of the city.

The most important addition to the skyline awaited the 1920s, however, when the Carew Tower's construction would give the city a new tallest building. Opened in 1930, just as the Great Depression began, the Carew Tower was a state-of-the-art skyscraper. Designed in the Art Deco style popular at the time, the building was much more than an office tower. Thomas Emery's Sons, prominent Cincinnati developers, envisioned a "city within a city," a complex of buildings providing visitors with a wide range of services, from parking in a massive garage, to rooms in one of the city's finest hotels, the Netherland Plaza, which retains

Despite its relative decline, Cincinnati remained the home of innovative and important architecture. Here the Carew Tower rises over Fifth Street in 1930, on its way to becoming the city's tallest building. (Courtesy of the Cincinnati Historical Society Library.)

its rich Art Deco interior. In addition to office space in the 48-story tower, the base of the skyscraper provided prime retail space for Mabley & Carew, a large department store, and a number of smaller shops that lined the arcade running parallel to Fifth Street. In total, the Carew Tower complex gave Cincinnati a remarkably successful, inviting, and important urban centerpiece.

Another important addition to the city's skyline occurred at some distance from downtown. In the West End, Union Terminal opened in 1933, but it was years in the making. In 1926, agreements with seven railroads cleared the way for a "union" station that would handle all the passenger traffic in and out of the city. Planners would have to find a location close enough to downtown for the convenience of passengers, but at the same time limit disruption in the cityscape from the massive project. The eventual location, in the West End's Lincoln Park, provided a compromise. It provided easy rail access through the already rail-clogged Mill Creek Valley and to the bridges that crossed the Ohio. On the other hand, the terminal and its extensive parking lot would consume an important green space in the heart of the city, just one of many intrusions that would eventually clear nearly the entire West End over the next 50 years. At first imbedded in a densely populated neighborhood, urban renewal projects and the eventual construction of the Mill Creek Expressway would leave the terminal building nearly alone in a sea of parking and low-occupancy buildings. The terminal would be close to downtown, but much too far for easy foot travel.

Construction began in the summer of 1929 and finished ahead of schedule in early 1933. In the end, the total cost of the project was $41 million, funded largely through bonds to be retired through rents at the station. Although the cost greatly exceeded expectations, the terminal's great beauty quashed criticism. Architect Paul Cret's Art Deco half-dome instantly became one of the city's most distinctive buildings, truly an architectural gem. Visible from all of the surrounding hillsides, from downtown's skyscrapers, and from neighborhood streets leading to its long approach, the imposing edifice suggested that good times would soon return to a city then mired in depression. Inside, the station proved even more inspiring. The mosaics of Winold Reiss covered the walls of the station with beautiful murals featuring Cincinnatians at work. The concourse contained 14 such murals, each of which referenced a significant local industry, including soap making, meat packing, and pottery. In the rotunda, two very large murals highlighted the growth of the nation and Cincinnati and the city's relationship to transportation. Perhaps most important, the mosaics featured the hard work of individuals, some of whom stand in the murals, tools in hand. The glorification of work and industry inside the terminal contrasted sharply with the reality of the economy in the city, struggling through the worst year of the nation's Great Depression. Still, the art inside the building, and the great success of the structure itself, suggested good times could not be long off.

Although the station would not initially require all its capacity of 216 trains per day, it did average 150 trains per day in its first year of operation. Only in the early

1940s would the station utilize its full capacity, as the nation mobilized for World War II and service men and women moved through the city.

Union Terminal's architecture did more than reflect the dominant Art Deco style of the era. Its design mediated between the past and the future, its massive half-dome nearly hiding the tangle of railroad tracks to its rear. In the front, curving wings welcomed in taxis and buses, and an expansive parking lot lay between the building and the city, giving clear evidence that the future would have to account for the car, to make room for the automobile.

Though not as dramatic as the additions to the skyline, other structural changes in the city were just as important. By the 1910s, the Miami Canal had lost its functionality and was now little more than an obstacle within the city. Long debate about what should be done with the canal ended with an effort to build a subway line buried in its bed. Construction from 1919 through 1926 ended with a subway tube, complete with stations, running between Over-the-Rhine and downtown, but the money ran out and Cincinnatians decided not to throw good money after bad. Instead, the subway tunnel was covered by a wide boulevard, Central

In an attempt to update the city's transportation infrastructure, progressive reformers began to replace the underutilized Miami Canal with a subway line in the early 1900s. Construction around 1920 created a subway tube complete with stations under Central Parkway, but with growing expenses the project was abandoned and the tube never used. (Courtesy of the Cincinnati Historical Society Library.)

Parkway, and never became part of the city's transportation system. Completed in 1928, Central Parkway did at least provide good automobile access from the Mill Creek Valley into the heart of the city, and it provided a pleasant drive at that. Despite the failure of the subway, and the wasted money it represented, the removal of the Miami Canal and the creation of the parkway signaled the passing of a transportation watershed.

A less symbolic change came with a massive investment in the city's education system. In the early 1900s, the city built a series of beautiful and functional school buildings, each of which became a focal point within their neighborhoods. In 1910, Hughes High School arose in Clifton Heights, across Clifton Avenue from the University of Cincinnati, which also expanded significantly in this era. The striking tower at the center of Hughes continues to speak for the importance of education to the city. At about the same time, Woodward High School also opened a new building in Over-the-Rhine, a building more recently occupied by the School for Creative and Performing Arts. In 1919, East High School opened on

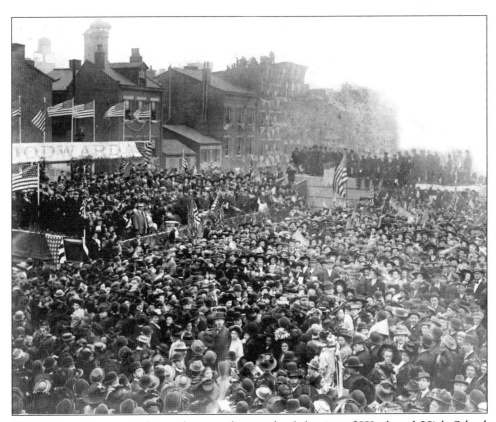

Men and women crowded in to hear speakers at the dedication of Woodward High School in Over-the-Rhine in 1908. The beautiful, ornate building, now the School for Creative and Performing Arts, spoke to the era's faith in both education and the city. (Courtesy of the Cincinnati Historical Society Library.)

Madison Road in Hyde Park and changed its name to Withrow in 1926. In 1928, Western Hills High School opened on Ferguson Road. The last of the grand high schools, Walnut Hills, was completed in 1931, with its monumental Colonial façade facing Victory Parkway, and eventually Interstate-71. Taken together, the development of these high schools, and several primary schools, represented a critical investment in education. The significance of each of these buildings, their size and beauty, reveal a city eager to invest in its future.

Not all of the important structural changes in the city involved the construction of new buildings. The city also benefited from the generosity of several wealthy residents who understood the need for more public parks. The city had added Eden Park in 1870, after a purchase of Mount Adams property from Nicholas Longworth's heirs, necessitated by the need to expand the water supply system. Eventually the park would entail much more than just the new waterworks reservoir, becoming one of the most beautiful treasures of the city and home to the Cincinnati Art Museum and the Krohn Conservatory, built in 1933 as a replacement for the original greenhouse built in 1894. Shortly after the opening of Eden Park, the city purchased an even larger tract from Jacob Burnet. Opened in 1874, this expansive landscaped park, designed by Adolph Strauch, included a small artificial lake, complete with imported ducks and rowboats for renting.

After 1900, however, with the city still expanding rapidly outward, Cincinnatians understood the need to add more parkland. In 1906, the city hired the well-known landscape architect George E. Kessler to conduct a study of Cincinnati's parks and recommend changes. Kessler's report, published the next year, envisioned an extensive park system, a series of open lands connected by parkways that would provide greenways running through the city's hilltops and along its valleys. Although little of the Kessler plan came to fruition, a surge in park building did accompany the plan's creation.

Some of the new parks were small, including the Owls' Nest in Obrienville, added by gift in 1905, but others were sizable, including Mt. Echo Park, 46 acres in Price Hill with glorious views of the river, added by purchase in 1909. Although not the largest of the new acquisitions, Inwood Park, nearly 20 acres in Mount Auburn purchased in 1907, may have been the most important. It became the home of the city's busiest playground, close to the dense neighborhoods on either side of Vine Street as it wound up the hill toward Corryville. In 1911, Levi Addison Ault donated more than 200 acres to create the east-side park that bears his name. Also in 1911, the city purchased land for a nursery on the west side of the city, creating the nub of what would become over time the 1,345-acre Mount Airy Forest, by far the largest park in the city. With miles of trails, an arboretum, and extensive forests, Mount Airy Forest provided critical green space for the congested city. In 1916, Mrs. Frederick H. Alms donated land on the hilltop above Columbia for the creation of a park to memorialize her late husband, and with later additions this 85-acre park would provide stunning views of the city.

All of these purchases and donations represented a rapid expansion of the park system. The growth signaled a new understanding of how the city would

City parks provided critical open space for the dense city. The finest city park, Eden Park, served as home to festivals and celebrations, as well as the Cincinnati Art Museum, the Conservatory, and, eventually, the Playhouse in the Park. (Courtesy of the Cincinnati Historical Society Library.)

grow—ever outward—and the need to protect lands for use before they were lost to development. Like Cincinnati, other cities expanded their open spaces too, including Chicago and Cleveland, both of which created extensive park systems that protected open space for public use well beyond the city limits. Indeed, while the growth of Cincinnati's parks was significant, it did not keep pace with developments in many other cities.

Like other cities in the Progressive Era, Cincinnati witnessed a number of reform movements well beyond the efforts to expand parkland. Led largely by the middle class, these reforms were remarkably various, speaking to the diversity of problems that plagued the city, but they were also remarkably conservative, reflecting the continued faith in the city itself. Indeed, the reformers primarily intended to improve life in Cincinnati, fully expecting that their own fates rested with the fate of the city itself. The biases of the reformers were apparent in their agenda. Better lives for the poor could be built through the construction of playgrounds. Better morals could be encouraged among the populous through the creation of public baths. Public health could be improved through a campaign to stop spitting on the sidewalk (to stop the spread of tuberculosis). A series of modest changes, the reformers believed, would make Cincinnati a cleaner, more moral, and healthier place to live. In this regard Cincinnati resembled other American cities.

Still, these reform efforts could be significant in their implications, including the movement to control smoke. Here, Cincinnati took on national significance, not just in its early and intense effort to control smoke, but also in the activism of some of the movement's leaders. The Cincinnati Woman's Club took an early leadership role, thanks to Julia Worthington, who in 1904 demanded that Mayor Julius Fleischmann enforce the antismoke ordinance. The next year the Woman's Club invited Dr. Charles Reed, a nationally known surgeon and gynecologist, to speak to the club on the smoke issue. Reed delivered a stirring speech that energized not just the Woman's Club but also others in the community, especially in his emphasis on the unhealthy aspects of air pollution and the ethical implications of polluting one's neighbors' property. Reed's speech even found a national audience through publication outside Cincinnati. While the antismoke movement gained only partial success, since the city remained reliant on highly polluting coal through this period, the Woman's Club, Reed, and others clearly convinced many city residents that the government could and should protect the city's environment, particularly as a means of protecting human health.

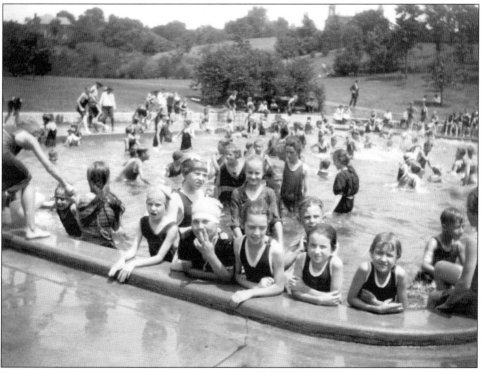

Progressive reformers sought to improve city life through several reform efforts, including building new parks. Inwood Park, pictured above, became one of the city's most successful (and crowded) parks after its completion in 1907, offering children from Mount Auburn and the crowded Over-the-Rhine neighborhood much needed play space. (Courtesy of the Cincinnati Historical Society Library.)

In 1909, at the height of progressivism in America, Cincinnati sent another native son to the White House: William Howard Taft. Born in 1857, William was raised in a grand Mount Auburn home, the son of distinguished judge Alphonso Taft. William attended Woodward High School in Over-the-Rhine, and after earning a Yale degree, he returned home to earn a degree from the Cincinnati Law School in 1880. He began his practice and eventually joined the faculty of the University of Cincinnati Law Department and served as its dean. He hoped to follow in his father's footsteps, making a career as a judge, but in 1900 William McKinley selected him to administer the Philippines, the nation's new possession in the Pacific, gained through the Spanish-American War. In 1904, he became Theodore Roosevelt's Secretary of War, a post he held for four years. In 1908, Roosevelt determined that his good friend Taft should be his successor in the White House, and with the popular President's support Taft defeated William Jennings Bryan. More conservative than his predecessor, Taft disappointed the progressive wing of the Republican Party, and he lost his reelection bid in 1912, when Teddy Roosevelt ran as an independent in the "Bull Moose Party," effectively splitting the Republican vote and giving the victory to Woodrow Wilson.

William Howard Taft became Cincinnati's most famous politician when he won the White House in 1908. Here he campaigns in 1908, near the home of his half-brother, Charles P. Taft. (Courtesy of the Cincinnati Historical Society Library.)

Taft's career was hardly finished with the loss in 1912, however. He joined the faculty at the Yale Law School, where he taught, with a brief interruption during his service in Wilson's administration during World War I, until being appointed as the chief justice of the Supreme Court in 1921. He is still the only person to have held the highest post in both the executive and judicial branches of the federal government. Taft thrived as chief justice, a job he much preferred to the presidency. He died in 1930 and was buried in Arlington National Cemetery. His long and successful career made Taft Cincinnati's most distinguished native son. Taft's boyhood home in Mount Auburn has been National Park property since 1969 and has been open to the public since 1988.

Cincinnati's progressive reform fervor was hardly deterred by the onset of war in Europe in 1914. Although clearly concerned with the conflict, particularly since it pitted Germany against Britain, Cincinnatians could at first remain aloof from the war. This gradually changed as the war itself evolved. The horror of northern France's killing fields, the demonizing of Germany, and the rising sense that somehow the United States would have to become involved, combined to heighten concern about American participation in the European war. In 1917, the United States formally entered the conflict, having already lost citizens in the submarine warfare that made traveling the North Atlantic so dangerous.

Mobilization for war brought considerable change to the city, including economic growth. At the outset, the war seemed little threat to the United States, and as long as American diplomats kept the United States out of the conflict, it would little more than an opportunity to profit through the sale of war goods, food, and clothing. In Cincinnati, this was most evident in the growth in machine tool orders, as the British, her allies, and the United States geared up for more military manufacturing. In this way, Cincinnatians benefited from America's "waging neutrality" by sending war materiel to belligerents. In another way, however, Cincinnatians were particularly hurt by the conflict in Europe, as the American press and the government expressed a distinct pro-Anglo bias. Anti-German sentiment grew, first through reports of the "Rape of Belgium," the German army's rapid swing through the small neutral country to out-flank French defenses, and later because of Germany's decision to engage in unrestricted submarine warfare, which resulted in the sinking of American ships and the loss of innocent American lives.

With American entrance into the war in the spring of 1917, anti-German sentiment spiked. The "Huns" were now the enemy, and government posters encouraging enlistments, the purchase of war bonds, and the conservation of war-related resources frequently pictured Germans as vicious animals. The vilification of the German army in Europe would spread to a denunciation of German culture generally, as critics connected that nation's militarism to a degenerate society. Most important to Cincinnati, Americans engaged in a national campaign to expunge German-American influences here at home. Anti-German hysteria had dramatic consequences for Cincinnati, where the German-born and the children of German-born residents constituted half of the population. As the war

As the University of Cincinnati grew, McMicken Hall became the city's most important symbol of higher learning. It perched above Clifton Avenue on one of the city's high points. This 1916 photo captures the first McMicken Hall, which opened in 1895 and was replaced by the current building in 1950. (Courtesy of Archives & Rare Books Department, University of Cincinnati.)

began, thousands of Cincinnati's children learned German in public schools, and thousands of others learned only in German in private schools. In 1910, the two remaining German-language newspapers in Cincinnati, *Volksblatt* and *Freie Presse*, had a combined circulation of 92,000. Clearly expunging German influences in Cincinnati would be terribly difficult and adamantly resisted.

Still, some attempted to equate patriotism with "100 percent Americanism," which required not just loyalty, but also Americanized behavior, including speaking exclusively in English. In 1918, the Americanization movement forced the firing of the city's many German language teachers, who were part of a tradition of bilingual education that had begun in 1840. In addition, German authors, including Goethe and Schiller, would no longer be taught in the public schools. Even the public library moved its German language books to the basement, out of view. City Council went further, removing German names from several streets, including Bremen in Over-the-Rhine, which became Republic Street, and Lower Price Hill's Berlin, which became Woodrow Street in honor of the president who led the nation into war. Some individuals with German surnames undertook their own Americanization projects, anglicizing them to remove any doubt about their loyalty to the United States.

The anti-German hysteria also led to some violence around the country, including mob action against German symbols or overtly pro-German activists.

Several German Cincinnatians suffered attacks, and although no one died from the Americanization project, mobs frequently violated civil rights. The end of the war in November 1918 brought as much relief to German-Americans as anyone else. Cincinnatians celebrated the victory with a burning of the Kaiser in effigy on Fountain Square.

Despite efforts to erase German culture, it clearly persisted in Cincinnati. Even after the successful conclusion of the war, Americans continued their calls for loyalty, but with the "Huns" defeated, a new threat began to gain more attention. Russian revolutionaries, the Bolsheviks, now represented the greatest danger in volatile Europe. The Americanization movement survived the end of the war, feeding an already strong anti-immigrant movement, but now radical Russians, Jews, Poles, Slavs, as well as Germans, would be cast as the real threat. While anti-German sentiment clearly waned after the war, overt Germanness remained muted, even in Cincinnati.

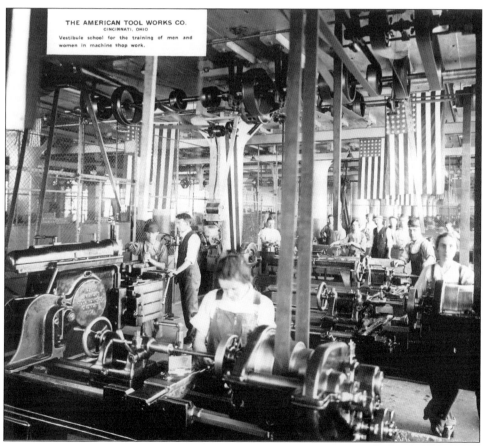

During World War I, Cincinnati's machine tool industry offered expanded employment opportunities. Here women and men train for new jobs at the American Tool Works Company. (Courtesy of the Cincinnati Historical Society Library.)

In one regard, German-Americans saw no improvement in Ohio after the war ended. German language instruction did not quickly return to city schools. In fact, in 1919, with the support of Governor James Cox, the Ohio Legislature passed the Ake Law, which required that all instruction in public and private schools be conducted in English up to the eighth grade. As supporters made clear, the intent of the law was to prevent the teaching of German. A legal challenge forced the Ohio Supreme Court to rule on the constitutionality of the Ake Law, which it did favorably in 1921, but the United States Supreme Court struck down the law in 1923, when it simultaneously struck down similar laws in Nebraska and Iowa. Although Cincinnati public schools would once again teach German, considerable damage had already been done.

German culture did persist in many traditional associations in the city. Although many smaller clubs closed in the 1920s, the city still boasted of Vereine, with approximately 5,000 members. German traditions did suffer the indignities of Prohibition through the 1920s, as near-beer proved a poor substitute for lager at German-American gatherings. Still, with over 80,000 residents born in the

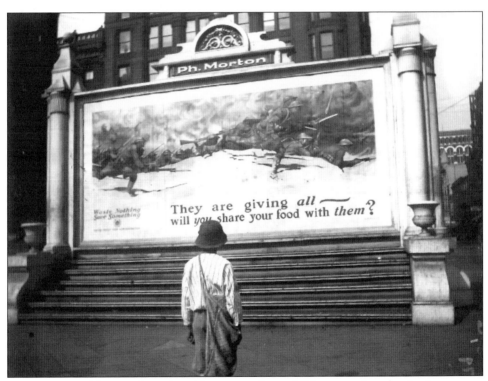

Entry into World War I brought with it a massive publicity campaign to gain the support of all Americans. Much of the propaganda included negative images of evil Germans, the "Huns." Other material, such as the billboard above, simply asked that Americans limit their consumption and reduce waste to support the troops abroad. (Courtesy of the Cincinnati Historical Society Library.)

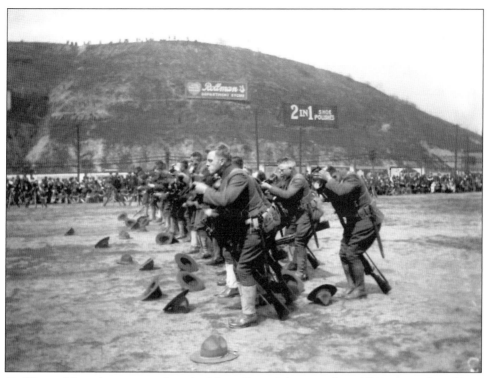

Drilling soldiers drew a crowd at the Hunt Street Playground in 1918. Here the soldiers practice putting on gas masks to protect against chemical weapons then being used on the battlefields of Europe. (Courtesy of the Cincinnati Historical Society Library.)

German-speaking regions of Europe, Cincinnati was unmistakably a German city in 1930. In that year, up to 225,000 Cincinnatians were either born in Germany or had a parent born there, meaning that still roughly half of the city had immediate connections to Germany.

Of course not all non-German Cincinnatians participated in the cultural purge, and many found it repugnant. Most participated in the war effort in more productive ways, including enlisting in the military, which German-Americans did in large numbers as well. On the homefront, women coordinated critical war efforts, attempting to reduce local consumption of key goods, including fuel, metals, and food. Women were particularly active in creating Victory Gardens in a program designed to increase food production on fallow lands. In Hamilton County, the Victory Garden program cultivated over 250 acres in 1918, including a large garden on previously open land on Blair Avenue in Evanston. Other gardens popped up in Price Hill, College Hill, and in the yards of war supporters all around the city.

While the intensity of the reformism waned during World War I, marking the end of the Progressive Era, the war did not end the effort to improve the city. Indeed, as in other cities, reformers continued to agitate for significant changes,

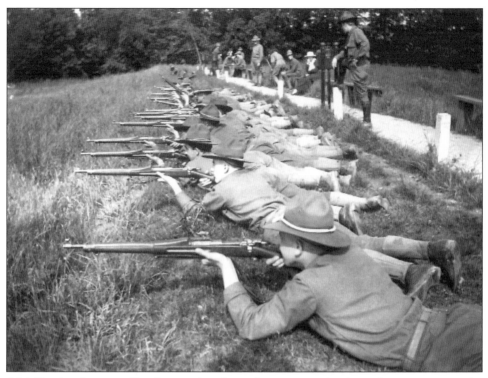

Mobilization for war affected most Americans, but none so deeply as the young men who prepared for war, including these trainees taking rifle practice in California on the city's far east side. (Courtesy of the Cincinnati Historical Society Library.)

including the creation of a new city charter. Designed to end Boss rule forever, this new charter came from a bipartisan effort begun in the 1910s—the City Charter Committee, usually referred to by the abbreviation "the Charterites." Passed by popular referendum in 1924, the new charter ended ward voting, instituting instead citywide proportional voting for nine council members. Elected council members would then elect a weak mayor to preside over council activities, and daily operations of the city fell to a city manager, who would hire most city workers through the use of civil service exams.

As promised by supporters, this new system of governance did destroy the machine in the city, and in the first election under the new charter, the Charterites won the majority of council seats, selected Murray Seasongood to be mayor, and hired Clarence Sherrill to serve as city manager. The results of this political reform were overwhelmingly positive, especially as efficiency in government services increased and the city's debt began to stabilize. Almost overnight, the city's reputation turned 180 degrees, from among the worst run cities in the nation to among the best.

Solving the city's problems would require more than just more efficient government, however, and so while the city created a new political structure, it

also authorized the creation of a comprehensive city plan. An effort to bring order out of the urban chaos, the city plan, completed in 1925, proposed a number of radical changes in the way the city influenced growth and development. To shape growth, the plan recommended new zoning regulations for the entire city and new rules concerning subdivisions. It also proposed specific solutions to existing traffic problems, including new thoroughfares through city neighborhoods, new traffic patterns for downtown streets, and an expansion of public transit. The plan even included sections on parks and schools. Essentially all areas in which the city would have to exert control to encourage and direct growth received attention in the plan. The plan even advanced the idea of regional planning, especially regarding transportation, as the best solution to manage the outward growth of the metropolis.

While the plan would encourage some positive developments, including the creation of comprehensive zoning regulations, it could hardly solve the problems of the city, even in conjunction with improvements at City Hall. Indeed, the plan's nod toward regional planning hinted at the real impediment to the city's continued success: Cincinnati might make plans for neighborhoods within its

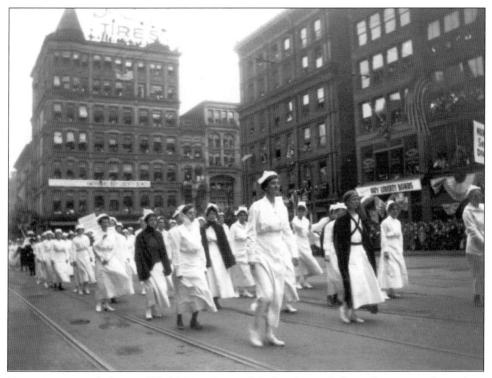

Patriotism surged during World War I, as did the demand that all citizens show their patriotism through active participation in the war effort. Here nurses parade downtown in 1918, as banners exhort everyone to buy war bonds. (Courtesy of the Cincinnati Historical Society Library.)

borders, but it could do nothing about changes taking place beyond them. Plans to alleviate traffic in the city could not hope to succeed if traffic continued to explode due to ever-increasing numbers of automobile commuters driving through the city. And efforts to shape urban growth could only have limited effects if suburbs continued to attract investments. Ironically, then, the city proposed to control its development with a comprehensive plan just as the city could no longer reasonably expect to exert that control. Literally, growth and development would be largely beyond the city's power after the 1920s, and efforts to ease traffic at the core of the region would only further encourage automobile dependence and outward growth.

A third reform effort may have been Cincinnati's most important in the 1920s. In the 1910s, Mary Emery, the widow of real estate magnate Thomas J. Emery, searched for ways to best spend her inherited riches. Emery became a generous patron to many charities, but one of her most pressing concerns would be the city's ongoing housing problem. Poor city residents simply could not afford adequate housing, and the neighborhoods of the working poor consisted almost exclusively of substandard shelter, generally lacking even rudimentary

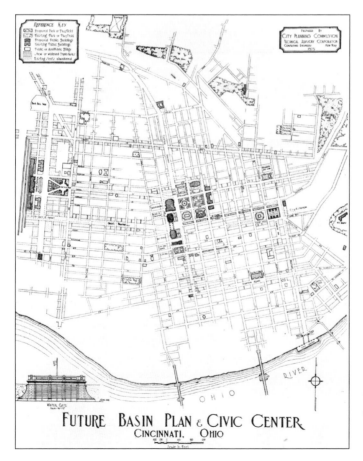

The 1925 city plan envisioned a new civic center around Washington Park in Over-the-Rhine, just one of many parts of the plan that never took shape. (Courtesy of Archives & Rare Books Department, University of Cincinnati.)

plumbing. In the city's slums of the 1910s, the working poor still lived in dense neighborhoods, small apartments with shared baths and even, sometimes, outdoor toilets. Some reformers hoped to improve conditions within these neighborhoods, including the Better Housing League and its energetic leader Bleecker Marquette. But Emery sought another solution—one that created an alternative to dense urban neighborhoods.

Inspired by the Garden City idea of England's Ebenezer Howard, Emery envisioned a new community built from scratch on the outskirts of Cincinnati. Entirely planned, this community would have ample open space, pleasing streetscapes, and none of the disamenities that made slums so dangerous to human health and morality. Emery's project would be carried out by Charles Livingood, who used early Garden City plans as models, including Letchworth, outside London, and Forest Hills Gardens, in Queens, New York. In 1915, Livingood began the quiet purchase of properties, mostly farmland, near the small village of Fairfax, and by 1922 he had put together enough property to begin the project.

Livingood hired John Nolen to design the new town, to be named Mariemont, taking the same name as the Emery vacation estate in Rhode Island. At the time, Nolen was the nation's most famed landscape architect, having completed important projects around the United States, including the design for Kingsport, Tennessee. Nolen would bring his considerable talents to the Mariemont project, supplying the new community with much of its final shape, including its diagonal streets, town center, and large park. The town would have a mixture of housing options, from detached single-family homes to modest apartments in substantial buildings. It would also have all the components necessary for a complete community—shops, schools, churches, an inn, and even a hospital. As originally conceived, the plan would also set aside land for industrial development, though this eventually only occurred outside the village itself.

Work on the model village began with a ceremonial groundbreaking in April 1923, Mary Emery herself turning the first shovel of soil. Early work focused on street grading and preparations for basic services, such as water and sewers, with much of the construction to be let out to individual architects and construction firms. Livingood established the Mariemont Company to handle the multitude of contracts. Construction in 1924 centered on the Dale Park neighborhood, where much of the modest housing would congregate, especially in low-rise apartment buildings, and in the town center, where a Tudor inn would provide the centerpiece of the business district. Despite positive press, both locally and around the nation, Mariemont grew only slowly, attracting less immediate interest than Livingood would have liked. Construction peaked in the mid-1920s, with many building lots remaining available through the lean years of the Great Depression.

When Mary Emery died in 1927, the building of Mariemont was well underway, its school and hospital complete, and town homes, apartments, and cottage dwellings renting to new residents. However, the village was still very much a work in progress, with only 50 single-family homes having been constructed, and

John Nolan's Mariemont took on a distinctly English feel with its Tudor revival architecture and its quaint small-town flavor. The hotel sat at the center of town, representing Nolan's attempt to create a complete village at the outskirts of Cincinnati. (Courtesy of the Cincinnati Historical Society Library.)

most of the well-planned streets leading to no new structures. In the mid-1920s, Mariemont was simply too far from the city to attract many working families, who still required easy and inexpensive transportation to the employment-rich areas near the city. Mariemont's success would only be secured as the metropolis expanded out to engulf it.

The completed village would become one of the most desirable communities in the region by the end of the century, both beautiful and convenient. But high property values would ensure that Emery's primary goal of providing working families a sanctuary from degraded urban neighborhoods would not be met. Overwhelmingly white and wealthy, Mariemont could hardly be seen as a solution to Cincinnati's housing problems. Perhaps more important, the vision that created Mariemont would guide other twentieth-century developments as well, though most were not so thoroughly planned as the suburban Garden City. This vision was essentially anti-urban, proposing that the best way to solve the problems of the city was to leave the city altogether. Mariemont was just a small

part of a national trend of migration out of the city and into what had been the countryside all around. Mariemont was indicative of the suburban solution to urban problems.

Despite this growing anti-urban sentiment, through the 1920s the American economy faired well and so did its cities. After the chaos of World War I and the Red Scare and labor unrest of 1919, the nation returned to the "normalcy" promised by President Warren G. Harding. For cities around the nation, the era was one of literal brightness, as electricity brought greater lighting to the urban night. Grand movie palaces graced downtowns, and more modest theaters dotted the neighborhoods. Trolley systems deposited more and more office workers in front of taller and taller downtown skyscrapers, and more and more shoppers in front of massive downtown department stores. Jazz clubs, dance parties, and speakeasies gave the 1920s a distinctly urban feel. In many ways, it was the last great urban decade, a moment in time when the promise of cities seemed to far outshine their problems.

The urban celebration of the 1920s might have been more intense in larger cities, in New York's Harlem Renaissance, in the sheer excitement of Jazz Age Chicago, or the broad streets of burgeoning Los Angeles, but in sedate Cincinnati there were advances to cheer. In 1921, novelist Sinclair Lewis came to Cincinnati to research a new book he had planned. Shining in the success of his critique of small-town America, *Main Street*, published the year before, Lewis now set his

By design, Mariemont offered a variety of housing, from spacious homes to modest apartments. Rather quickly, however, high rents insured that the population would not be as diverse as the housing options. (Courtesy of the Cincinnati Historical Society Library.)

sights on American cities. He created a fictional city, first called Monarch City and then Zenith, to be the home of his protagonist, George Babbitt. Zenith was a composite of several cities Lewis knew well, including Minneapolis and Seattle, but perhaps most closely it resembled Cincinnati, where Lewis researched life in a middle-sized city. After spending months in Cincinnati, Lewis would create a novel set in a "metropolis that is yet a village," an "overgrown town." Lewis actually wrote the novel while in England over the next year, and when it appeared in 1922, *Babbitt* became an instant success and an icon of the 1920s.

Despite its realism, *Babbitt* was a satirical study of the middle-class world of striving, of the struggle for success. Ultimately, Babbitt's bland life spoke to a growing sense of sameness and meaninglessness. Babbitt himself was "prosperous but worried," not unlike the city itself. Despite the satirical portrait of Babbitt's life, Cincinnati proudly claimed itself to be Zenith, as did Kansas City, Minneapolis, and several other cities. Apparently publicity, even bad publicity, was a good thing. Perhaps more important, Lewis himself would look fondly on his stay in Cincinnati and recognize that "it gave me a renewed sense of the exact flavor of a large American city of today." After decades of relative decline, Cincinnati could be pleased simply to earn recognition as a typical large American city.

Although Babbitt *presented a rather unflattering portrait of middle America, Cincinnatians often expressed pride in their city's connection to Sinclair Lewis's work. Here actor Willard Louis plays George Babbitt in the screen version.*

6. A CITY SHAPED BY DEPRESSION AND WAR

Over the course of 15 years, beginning in the fall of 1929, Cincinnati's history would largely move to more distant forces. The dual crises of the Great Depression and the World War that ended it shaped the city in numerous ways, just as they did the nation as a whole.

The Great Depression began in earnest in 1930, after the late 1929 collapse of the stock market. Despite some relief from New Deal policies initiated under Franklin Roosevelt in 1933, the Depression would last until preparations for World War II once again provided full employment in the nation. In the interim, new federal welfare and work relief programs provided some income to Cincinnati families. At its peak, one of the early programs, the Civil Works Administration employed over 23,000 men and women in Hamilton County, most of them working on public projects such as roads and sewers. Later, the Works Progress Administration provided jobs for some of the unemployed, particularly in the construction of public buildings and roadways. The Civilian Conservation Corps, with a unit stationed in Mount Airy Forest, built roads, trails, and other infrastructure in the city's parks. Although famous for their inefficiency, these programs did also create some lasting, important products from all that labor, including Columbia Parkway running out the east side, numerous park buildings in Cincinnati, and millions of trees planted throughout the region. All told, the federal government spent about $100 million on local projects designed primarily to give people work.

During the Depression, government help was critical in cities, where unemployed workers and their families began to congregate in shantytowns, and where even the employed found it difficult to make ends meet because of cut wages and reduced hours. By 1933, greater Cincinnati had lost nearly 59,000 industrial jobs. Although bank failures did not plague Cincinnati the way they did other areas, the loss of industrial jobs and the reduction of wages crippled the city's economy.

The Depression hurt the vulnerable in the city the most. From 1929 to 1933, during the most precipitous economic decline, Cincinnati lost 41 percent of its

wage-earning jobs. Still, Cincinnati's continued economic diversity did provide the city with some buffer to the steep economic downturn. Some cities, reliant on just one or two major industries, witnessed even more spectacular unemployment, including steel cities like Gary, Indiana and Pittsburgh, and automobile cities like Detroit. In Cincinnati, some industries maintained much of their vitality, including the soap industry, where new, cheaper brands offered alternatives for cash-strapped families. Procter and Gamble adjusted to the economic downturn, making some cuts to keep afloat, but also initiating new waves of advertising, including over radio waves, to shore up flagging sales. Indeed, after hard times at the depth of the depression in 1933, the company found ways to expand sales through the remainder of the downturn.

Other industries fared even better in the 1930s. Radios became the most important consumer product during the Depression. With automobiles once again beyond the reach of most families, the modest cost of radios allowed working families the opportunity to connect with the world in a new way. Radio entertainment provided important distractions during hard times, and news programs kept the nation informed about the economy at home and the trouble brewing in Europe. Franklin Roosevelt himself became a masterful

The Great Depression presented extreme challenges for Cincinnatians, including men who found themselves unemployed for long periods for the first time in their lives. Here men pass their time in Garfield Park in 1931. (Courtesy of the Cincinnati Historical Society Library.)

Radio became an important part of urban culture in the 1930s, offering cheap entertainment and timely news through the Depression. Here men and boys gather to listen to a broadcast outside a shop selling radio sets in Walnut Hills. (Courtesy of the Cincinnati Historical Society Library.)

radio personality, using a weekly address to speak to the nation about his efforts to right the economy and provide relief to struggling families. Through it all, companies selling radio equipment flourished, including Cincinnati's own Crosley Corporation, founded by Powel Crosley, Jr.

Crosley was one of Cincinnati's most interesting figures. In the business of manufacturing phonographs and other electronic equipment, Crosley built his family a radio using parts then readily available. In the late 1910s, building radios from sets was much more common than purchasing them pre-assembled, and much less expensive too. After developing a better set, Crosley was able to retain the inexpensiveness of home-built radios through the advantages of mass production at his Hamilton Avenue factory. By 1922, the Crosley plant was manufacturing 500 radio receiving sets every day. At a new manufacturing plant in Camp Washington on Colerain Avenue, Crosley provided work for hundreds of employees during the Depression, becoming one of the world's largest producers of radios.

Crosley combined his interest in selling radios with his interest in broadcasting programs. After all, the market for radios depended on the ability to receive programs of interest, so Crosley hoped to encourage the demand for radios by

providing entertainment through WLW, his first radio station, and through other stations he purchased, including WSAI. Begun in 1922 at only 50 watts, WLW grew quickly in wattage and influence. In 1923, it leapt to 500 watts, then to 50,000 in 1928. By that time the station was quite successful, broadcasting a mix of locally produced shows and programming purchased from national networks. In 1934, at the depths of the Depression, WLW reached 500,000 watts on its 700 clear channel, a power so great that it could be heard around the world. Unfortunately for people in Mason, Ohio, home of Crosley's broadcast tower since 1928, WLW's wattage prohibited the reception of other stations. Some complained they could hear WLW even without their radios on, including through vibrations amplified by metal faucets. Despite these problems, and complaints from distant stations that couldn't compete with the power of Cincinnati's giant station, through the Depression and World War II WLW provided important news and entertainment. In the Depression, WLW had dozens of employees, including many on-air talents. The station even had a payroll of 100 musicians, many of whom worked fulltime. For some local talent, WLW offered the opportunity to gain nearly national exposure, even when the station returned to 50,000 watts in the 1940s. One such talent, Rosemary Clooney, came to Cincinnati with her sister Betty from Maysville, Kentucky and began performing on WLW in 1945, launching her long and successful singing career.

The success of Powel Crosley, who remained the company's president through the Depression, is evidenced by his purchase of the Cincinnati Reds in 1934. After the purchase, the old Redland Field, originally constructed in 1889 and expanded in 1912, became Crosley Field and the Reds began a long relationship with WLW, which had the power to broadcast baseball games to a large, regional audience.

Although Crosley's great success lay in radio, he desperately wanted to enter the automobile industry. He invested profits from his radio business into a new automobile factory, and by 1939 Crosley had produced 5,500 cars. After World War II interrupted this production, Crosley once again attempted to build his car business, producing smaller, more efficient cars than the major manufacturers in Detroit. Unfortunately, for both Crosley and the urban environment, the national trends toward more powerful and larger cars left Crosley with a limited market for his smaller vehicles. He gave up producing automobiles in 1951.

In addition to the radio industry, other areas of the local economy fared well during the Depression. The election of Franklin Roosevelt also meant the end of Prohibition. The passage of the 21st Amendment ended the failed experiment of government prohibition of alcohol sales, and in April of 1933 Cincinnati began to revive its once vibrant alcohol industry as brewers, distillers, and distributors rehired workers and prepared for business as usual. By 1935, the city was home again to more than a dozen breweries. Although this represented a dramatic decline from the turn-of-the-century peak in the industry, it did represent a significant recovery. Old giants in the field, including John Hauck Brewing and Christian Moerlein were gone for good, but breweries once again offered good work in the city, providing a much-needed boost to the local economy

and to the spirits of many residents. By 1938, 13 Cincinnati breweries employed approximately 2,500 workers.

If some industries fared well during the Depression, most did not, and high unemployment plagued the city. As the Depression worsened, and before the New Deal offered greatly increased federal aid, the city relied on older sources of relief, including state funds and local charities. A study of unemployment in 1932, completed for the Ohio Unemployment Insurance Commission, revealed not just economic consequences for the unemployed but serious psychological consequences as well. The study involved 108 families in Cincinnati, all of them experiencing unemployment and most of them relying on work relief to make ends meet. For the 55 white families studied, the average weekly wage had fallen from $35.62 to just $7.61, much of which was supplied by government work relief. African Americans fared even worse, as the 39 black families studied saw weekly wages fall from $26.47 to a miniscule $4.32—an 83 percent drop. As the data indicate, African Americans earned less than whites when employed and when unemployed, as they were less likely to receive government work relief. And, given extensive poverty within the African-American population, black families were less likely to have savings that might sustain them in hard times.

As the panic of 1929 turned into the economic downturn of 1930 and eventually the Great Depression of the 1930s, Cincinnatians were forced to seek aid anyplace they could, especially from government. Here unemployed residents stand in line at a Social Services office. (Courtesy of the Cincinnati Historical Society Library.)

Interviews with the unemployed revealed how completely the prolonged downturn affected the lives of families. Many complained about the inability to pay rent and the very real threat of becoming homeless. Some even complained that they could not adequately feed their children or purchase needed clothing. And even in 1932, just two years into a 10-year depression, the stress of financial burdens and unemployment was beginning to take its toll. One woman complained, "I stay worried all the time, and am almost crazy. Half of the time my husband and I don't speak." Others noted that gifts from friends and family kept them alive, but still hardships mounted. "If this depression lasts much longer," another woman noted, "I don't see how we can live through it. My husband has gotten awfully crabby and mean and doesn't seem to care about anything."

Urban poverty expanded rapidly, but the Depression may have hit Appalachia hardest, as hunger, even starvation, came to describe the fate of rural counties in Kentucky, West Virginia, Tennessee, and Ohio. The Depression would mark the beginning of a new great migration out of these failing rural regions and into neighboring cities, including Cincinnati, which saw influxes of Appalachians through the 1970s. Although Cincinnati held greater economic promise than did the collapsing economies of rural Kentucky and Tennessee, often arriving migrants from the upper South found themselves cast as ignorant and lazy, stereotypes that would hound Appalachian migrants for decades.

The New Deal created a series of programs that offered employment during the Depression, much of it focusing on building infrastructure. Here men lay sewer pipes in a segregated work team. (Courtesy of the Cincinnati Historical Society Library.)

During the depths of the Depression, homeless residents created squatter camps in marginal space within cities, including this shantytown under a bridge along the Ohio. (Courtesy of the Cincinnati Historical Society Library.)

Clearly many Cincinnatians were driven to despair, but many others were driven to crime. In 1934, Cincinnati ranked well above the national average in murders (75) and aggravated assaults (411). Perhaps just as important, a study of crime in the city found that a remarkable percentage of the worst crimes occurred in the city's densely populated basin, where 120,000 people lived in just 4 square miles. More than 70 percent of the murders occurred in the basin, particularly in the West End, as did more than 75 percent of the aggravated assaults. The city had a crime problem even before the Depression began, and the new statistics revealed the concentration of crime in densely populated black neighborhoods. This indicated to many reformers that those neighborhoods would have to change dramatically.

The solution to the massive West End slum would come through equally massive federal involvement. The Federal Housing Authority, created as part of the New Deal, funded slum clearance to make way for two large public housing projects, Laurel Homes, built for whites, and Lincoln Court, which would be exclusively black. To make use of available federal housing dollars, in 1933 the city created the Cincinnati Metropolitan Housing Authority, the body that would oversee the construction and operation of public housing. Using a new Basin District Redevelopment Plan, the Housing Authority envisioned the demolition of 145 city blocks and their reconstruction in 16 "superblocks" with new government-financed housing. The limited monies made available through the Public Works Administration forced the city to envision a smaller project, in which the demolition would take place along Lincoln Park Drive,

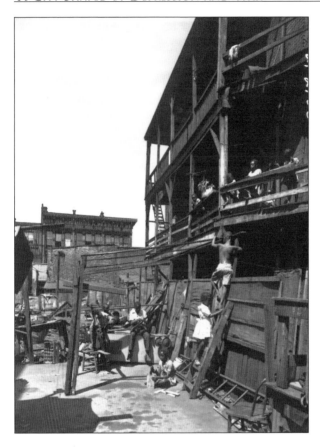

Segregation, enforced by custom and peer pressure among whites, kept African Americans in over-crowded and declining neighborhoods. By the 1940s, when Paul Briol took this photo, most of the city's growing black population had been confined to slums. (Courtesy of the Cincinnati Historical Society Library.)

the street that led from downtown directly to the entrance of the recently completed Union Terminal.

Like most Midwestern cities, Cincinnati was remarkably segregated in the 1930s, and not by accident. In 1921, the Cincinnati Real Estate Board made its position on race relations known when it made segregation its official policy: "No agent shall rent or sell property to colored [*sic*] in an established white section or neighborhood and this inhibition shall be particularly applicable to the hilltops and suburban property." By 1930, 70 percent of the city's black population lived in the basin, and 90 percent of them lived in the West End. Thus, the plans to demolish a largely black neighborhood and replace it with two public housing projects, one white and one black, would mean a significant decrease in housing available to African Americans, who already faced housing shortages.

With its first units available for occupancy in 1938, Laurel Homes did offer superior, modern housing to its residents, but its 1,039 units could not replace the 1,630 that had been destroyed to make room for the new project. In addition, the units made available to African Americans in Lincoln Court, completed in 1942, could not compensate for the housing lost to demolition. In total more than 750 buildings had been destroyed to make way for the new projects, including

churches, shops, and other businesses. In sum, a neighborhood was removed, replaced by acres of housing exclusively for the poor.

Although initially intended for white residents, lack of interest among whites to live in the largely black West End forced the Housing Authority to shift Laurel Homes to black occupancy, a policy that sped the ongoing shift in the neighborhood's demographics, away from its previously mixed-race composition and toward an overwhelmingly black population. At the same time, the government projects actually reduced the number of units available in the West End, at a time when the population of the neighborhood continued to rise. In the end, the projects could not stem the deterioration of the West End, particularly as the housing shortage intensified, forcing more families to double up in already cramped quarters.

The creation of Laurel Homes and Lincoln Court was just the beginning of the destruction of the old West End, as continued concerns about the slum encouraged further "urban renewal." The 1948 Master Plan envisioned the destruction of a large swath of the West End to make way for a new limited access highway, the Millcreek Expressway. The highway construction begun in the 1950s, new public

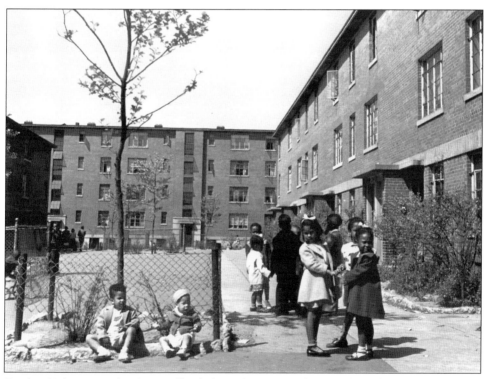

In the 1950s, Lincoln Court offered clean, up-to-date housing for African Americans in the West End. Unfortunately, the demolition that cleared a neighborhood to make way for Lincoln Court removed more housing than the government project provided. (Courtesy of the Cincinnati Historical Society Library.)

housing along its wide trench, and the complete removal of the Kenyon-Barr neighborhood to the south and west of the new roadway would permanently transform the West End. Taken together, the redevelopment efforts of the 1930s through the 1950s could hardly be deemed "urban renewal," though this is what planners initially called it. Anti-urban in their conception, the plans envisioned nearly depopulated space, available for new transportation links to more distant suburbs and for new land uses, such as light manufacturing. This vision held no future for the old urban neighborhoods, its older architecture, streetscapes, and mixed land use. Once the home to a diverse population, including many of the city's most successful businessmen, some of whom had lived on Dayton Street's "Millionaire's Row," and in Clark Street's neat townhomes, planners now predicted that a homogenous neighborhood, nearly completely poor and black, could be successful. The planners were clearly wrong.

The failure of the massive mid-century government intervention in the West End can be marked in many different ways. Almost by design, poverty persisted in a neighborhood composed mostly of subsidized housing. Crime rates remained high and school performance remained low. Perhaps just as troubling, the transformation of the West End contributed to the dramatic loss of population Cincinnati would experience in the second half of the twentieth century. From a

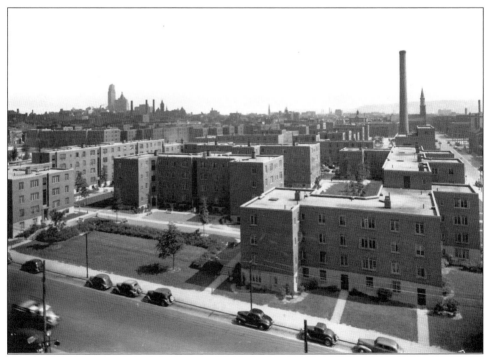

By 1941, government urban renewal efforts had turned the West End into a sea of housing projects, where the poor would be contained for decades to come. (Courtesy of the Cincinnati Historical Society Library.)

peak of nearly 70,000 people, the West End's population plummeted, largely by design, to less than 20,000 by 1980.

Not until the 1990s would the West End be reborn, with a new vision, one that harkens back to how cities actually did succeed, through diverse land uses and a mixing of diverse people. Supported by a new, massive federal government investment, the city replaced much of the failed public housing projects of mid-century with new, integrated housing, some rented at market rates, some with subsidies, and with still more housing offered for sale. The City West project also returned streets to the neighborhood, breaking up the mega-blocks created by the earlier projects.

As if the economic malaise were not enough, in 1937 the city had to battle a familiar foe: the flooding Ohio River. The 1937 flood reached nearly 80 feet, the highest water ever recorded at Cincinnati, and nearly 30 feet above the official flood stage. In total the river spent 19 days above flood stage, wreaking havoc through the low-lying sections of the city and disruptions throughout the region. On January 24, near the height of the flood, rain continued to fall, and water covered nearly one-sixth of the city, forcing 50,000 city residents out of their homes. All of the bridges across the Ohio had closed, except the Roebling Suspension Bridge, and even that remained open only through extraordinary efforts to protect its approaches. High waters forced the closing of the city water works, and as reservoirs dried up, parts of the city ran out of potable water, even as the muddy river lapped up city streets. The growing crisis took a terrible turn after rising waters toppled fuel tanks in the Mill Creek Valley and sparks ignited a floating inferno, which in turn destroyed several buildings, including one of those owned by the Crosley Corporation, as fires raged without possibility of firefighters controlling the blazes.

The flood devastated areas well away from the Ohio itself. Unable to escape into the Ohio, water draining the rain-soaked region backed up the Mill Creek, all the way to Hartwell, and up the Little Miami, creating a massive temporary lake that reached above Newtown. The waters engulfed much of the new Union Terminal property but spared the terminal building itself. Just north of the terminal, Crosley Field lay inundated, with 21 feet of water covering home plate on January 26. The *Times-Star* joked, "If you are going out to the game tomorrow enter the park by rowing over the centerfield fence." Residents paddled boats down Hamilton Avenue in the business district of Northside. Procter and Gamble employees at first attempted to surround Ivorydale with a sandbag levee, but when the waters proved too much they instead moved valuables to the higher floors, including unshipped products that would have been ruined by the rising waters. Along the Little Miami Valley, water topped protections surrounding Lunken Airport, preventing its use for 17 days. All told, damage was extensive, especially in the Mill Creek Valley and along the Ohio itself. The Riverdowns Racetrack would require rebuilding as would much of neighboring Coney Island Amusement Park, which had become a popular diversion for residents attempting to forget their nation's economic troubles. The property damage throughout the

113

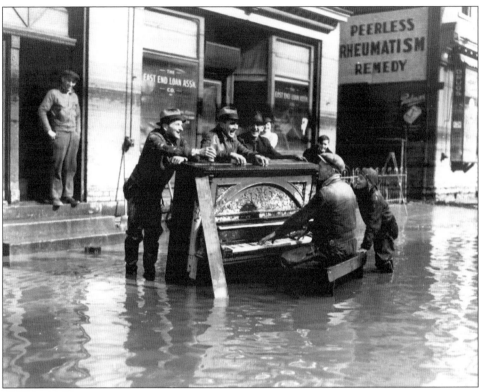

Making the best of a bad situation, men sang as floodwaters slowly receded from the East End business district. The 1937 flood was the worst in city history. (Courtesy of the Cincinnati Historical Society Library.)

Ohio Valley was extensive, and eight people died in the city, twelve in Hamilton County altogether.

Although the flood was a relatively fleeting crisis, particularly in comparison to the Depression that continued unabated after the waters receded, two permanent changes resulted. First, the Army Corps of Engineers quickly approved plans to prevent Mill Creek flooding from the Ohio and provided funding for a barrier dam proposed by the city in 1925. In 1941, construction on that dam began. Unfortunately, World War II delayed construction, and the dam was not yet high enough to prevent another inundation during high water in early 1945. Not until the city of Cincinnati loaned money to the federal government did the Army Corps finish the project in 1948. The dam immediately proved its worth, protecting the Mill Creek Valley, and Crosley Field, from high water that would have prevented opening day baseball on April 12, 1948. Since then, the dam has proved so successful that most Cincinnatians do not give the rising Ohio a second thought.

The second permanent change proved less positive for the city. With Lunken unusable for over two weeks, the city's airport gained an unfortunate nickname:

"Sunken Lunken." The flood gave further impetus for finding a new airport location, one out of the river basin and ideally one with more room for longer runways. In 1928, Edmund H. Lunken had purchased land for the airport and given it to the city. The City added to the acreage and created Lunken Municipal Airport in an effort to participate in the young commercial airline industry. Unfortunately, the flat land in the Little Miami River valley near its juncture with the Ohio was always prone to flooding, not just during the extremely high waters of 1937, and the valley itself was prone to fog.

After the 1937 flood, officials began to search for higher ground. In 1955, the city purchased two small airports in Blue Ash and hoped to build a large municipal airport there. But in the same year, a county bond issue to expand Blue Ash airport failed, and local opposition stymied expansion plans for the airport in the northern suburb. Instead, the focus for expansion would turn south, to Kentucky, where federal support had begun in the 1940s, with the creation of the Kenton County Airport (actually located in Boone County), several miles from Cincinnati. The Northern Kentucky site had significant advantages over Lunken. It was perched on a broad plateau well above the flood plain and far from extensive residential development. The Boone County site would give the airport plenty of room to grow, and it also had a key advantage over the Blue Ash location: local support. By the end of World War II, airlines were already using the new field.

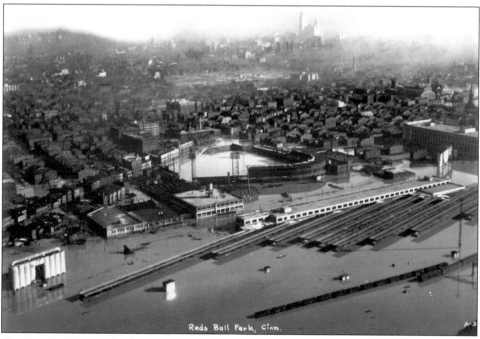

Reds Ball Park, Cinn.

Crosley Field lay under feet of water at the height of the 1937 flood, as did much of the West End. (Courtesy of the Cincinnati Historical Society Library.)

The new airport's phenomenal growth over the next 50 years would be important to the region, especially in the 1980s and 1990s when Delta Airlines made a series of major investments, greatly expanding the facility itself and the number of employees who worked there. While Boone County clearly benefited disproportionately, with large numbers of the airport's thousands of workers choosing to live near their work and with light industry, warehousing, and office space clustering around the airport, the entire region benefited from the frequent flights and good access through direct connections. Still, the airport's location well away from Cincinnati ensured that the city would not capture much of the financial benefits of the success.

One of the many New Deal programs to affect Cincinnati was run through the Department of Agriculture and its Resettlement Administration. Begun in 1935, this program envisioned the construction of a series of "Greenbelt" communities outside the nation's industrial cities. Cincinnati was one of just three initial locations, along with Milwaukee and suburban Maryland. Using eminent

Coney Island provided diversion during the Depression, particularly for young men and women who flirted on the imported sandy beach. Unfortunately, an official segregationist policy kept African Americans out of Coney Island. (Courtesy of the Cincinnati Historical Society Library.)

domain, the Resettlement Administration purchased 100 farms in rural Hamilton County, just to the west of the old railroad suburb of Glendale and within easy automobile commute to the industrial Mill Creek Valley. Here, federal planners laid out the curvilinear street plan that had become representative of suburban living and envisioned a modest community with mixed housing surrounded by a greenbelt of forests, farms, and recreational space.

For the approximately 2,500 men employed by the massive project, Greenhills was an instant success. They worked to create a nearly complete community, one with modest housing, a small business strip, and a community center, but without the industrial park envisioned for Mariemont a decade earlier. In theory, Greenhills would provide a complete sanctuary from the hazards of the city, with the negative aspects of the city literally kept away from the new town by the "protective greenbelt." And, while Mariemont quickly turned into a middle-class sanctuary, the nearly universally modest housing combined with initial income caps on residents ensured that Greenhills would indeed be a refuge for the working class. Envisioned as an entirely rental community, Greenhills was said to offer the best of the city and the country. It would be "healthful, safe, and pleasant," three qualities fewer and fewer people were willing to attribute to the city, while offering the advantages of modernity—the sewers, paved streets, and electricity still often lacking in truly rural locations.

Greenhills opened for occupancy in 1938, initially offering housing for 676 families. Its greenbelt was reserved for parks, farms, and community gardens. As early as 1939, the Hamilton County Parks District began the acquisition of that land, creating Winton Woods, the large and diverse parkland that now provides the greenbelt around Greenhills. Ten years later, the Army Corps of Engineers would begin to build a flood control dam and reservoir in the greenbelt, using federal lands to create Winton Lake, which would become the centerpiece of Winton Woods when completed in 1952.

Although a success in itself, Greenhills could not really aid the city proper. Indeed, one of the guiding forces of the Resettlement Administration, Rexford Tugwell, expressed a desire to solve the problems of the city by simply removing the city itself. "My idea," Tugwell declared, "is to go just outside centers of population, pick up cheap land, build a whole community, and entice people into it. Then go back into the cities and tear down whole slums and make parks of them." Greenhills reflected the anti-urban intentions of garden city planners and New Deal bureaucrats. Even the use of "resettlement" in the title of the administration and its location within the Department of Agriculture indicated that the Greenbelt program was designed not so much to improve the city as to encourage its eventual replacement. If Greenhills provided a safe and comfortable place for its residents to live, the program envisioned no solutions for those left behind in the city, including the growing African-American population, which at first was not welcome in Greenhills anymore than it was in most suburbs. Taken to its extreme, the philosophy guiding the Greenhills project could only succeed when everyone had left the city.

The original plan for Greenhills may have been completed in 1938, but nearly 3,500 acres of land remained in agriculture in an area north of the development. In 1942, responsibility for this land passed to the Federal Public Housing Authority, which immediately began developing a new plan to add housing. In 1949, Congress allowed the Public Housing Authority to sell "excess" greenbelt lands, making possible the transfer of North Greenhills to an interested developer. The development would be led by the Cincinnati Community Development Company, formed in 1948 to facilitate the building of housing in the region. This company in turn hired Ladislas Segoe, the chief consultant in both the 1925 and 1948 city plans. In 1952, Segoe developed a plan for a community that could house 36,000 people in North Greenhills and provide space for light industry and shopping. Since the city of Cincinnati would have to supply water to the new development, it had to formally approve of the plans, which it did before the Community Development Company began purchasing land from the federal government in 1954.

The actual developer of the land would be Warner-Kanter Company, which had experience in large-scale housing projects. Warner-Kanter renamed North Greenhills, calling it Forest Park, in an effort to differentiate its work from the modest community built by the federal government. By 1956, it opened the new community's first subdivision, Cameron Heights, which housed 400 families. Forest Park grew quickly, and by 1960 it was home to nearly 5,000 people. A year later it incorporated as a village.

With Forest Park's location along the newly constructed Interstate-75 and the under-construction Interstate-275, the new community held great promise in the early 1970s. Its proximity to expanding businesses in the Mill Creek Valley and to shopping at the recently developed Tri-County shopping center, as well as the popular Winton Woods County Park, made Forest Park an ideal suburb for families of middle incomes. In addition to all of these amenities, the developer advertised the value of living in a planned community, one designed for convenience and attractiveness.

Forest Park would undergo rapid change in the early 1970s, however, and not just because the community continued to grow. In 1970, the village contained just 424 African Americans, less than three percent of its population. A rapid influx of blacks, many of them relocating from failing neighborhoods in the city of Cincinnati, made Forest Park 12 percent black by 1975. The rapid change concerned some whites in the community, with some even taking the appearance of unkempt yards, a growing problem with speeding automobiles, and even a few abandoned properties, as sure signs that blight would soon overtake the area. Numerous neighborhood organizations, many of them newly created, sought to stem the negative changes. In a movement that focused on the appearance of property, rather than on the color of residents' skin, Forest Park advocates managed to oversee something that very few communities in the nation had witnessed—successful integration. Indeed, the integration of Forest Park through the 1970s provided middle-class blacks with affordable and attractive housing

One of three Greenbelt cities constructed by the federal government during the Great Depression, Greenhills represented current thinking on how to solve the problems of the city. Greenhills offered inexpensive housing for working-class families and insulated the community from encroaching industry by creating a park buffer, now Winton Woods. (Courtesy of the Cincinnati Historical Society Library.)

options outside the city, making the community less significant for its planned origins than for its unplanned integrated outcome.

Despite the development of Greenhills and the eventual addition of Forest Park, the Depression and the war that followed slowed suburban growth for more than a decade. Limited incomes followed by limited opportunity due to war mobilization stifled demand for housing, and the suburban boom would await peaceful prosperity in the late 1940s. In the meantime, the city recovered slowly in the late 1930s, despite a second dip in employment that began in 1937. As World War II began, Cincinnati was the 17th largest city in the nation, and its diverse economy ranked it 13th in industrial production.

As the nation prepared for war, the federal government funded the building of several massive military plants and then contracted out their operation to existing companies with manufacturing experience. Scattered around the nation for strategic purposes, one of these plants was located outside Cincinnati, in Evendale. Built in 1940, the plant was operated by Wright Aeronautical Corporation, which produced piston aircraft engines for use on military aircraft. By the end of 1942, with the United States fully involved in the war, the Wright plant employed nearly 30,000 workers, making it the region's largest employer. The plant had already supplied 60,000 aircraft engines to the war effort.

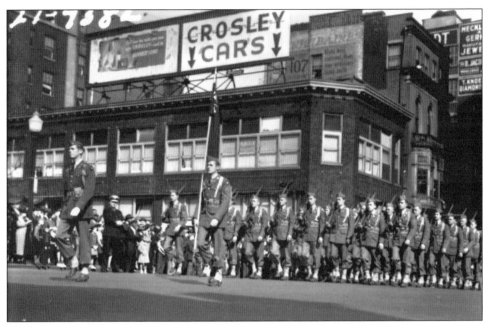

Patriotism surged once again during World War II. Here soldiers march through downtown, under a sign advertising Powel Crosley's entrance into the automobile industry. (Courtesy of the Cincinnati Historical Society Library.)

Part of the wartime boom that lifted the nation out of the Depression, the Wright Aeronautical plant's location outside the city signaled the continuing trend of suburbanizing industry. Clearly a plant the size of the Evendale facility, one of the largest in the nation upon its completion, would require an amount of space simply unavailable near the core of the city. More growth would come in Oakley, Norwood, and Fairfax, creating jobs that fueled a housing boom in new working-class suburbs, including Deer Park and Reading.

Other Cincinnati companies participated in war production as well, including the United States Playing Card Company, which produced parachutes to be fitted onto bombs dropped at low elevation. The Gruen Watch Company made war instruments, especially for aircraft. Local machine tool companies were critical in aiding the nation's rapid retooling for war production, and chemical companies shifted production to meet military demand. Early production of DDT, the pesticide used to fight the spread of disease, especially typhus, was centered in Cincinnati.

After World War II, the federal government expanded its nuclear program begun during the war with the specific goal of developing an atomic bomb. Success in that endeavor—and indeed the success of the bomb in bringing an end to the war in the Pacific—encouraged a continued pursuit of nuclear weapons development. After the Soviet Union exploded its first nuclear bomb in the fall of 1949, the United States planned an expansion of its nuclear

weapons production, further developing its original Manhattan Project sites, including Tennessee's massive Oak Ridge facility, and building new facilities, including a site in rural Hamilton County near the small town of Fernald. Just 18 miles from downtown Cincinnati, the Fernald site had access to ample water, good rail facilities, and the skilled workforce of the metropolitan area. The plant would process uranium, producing bomb-grade material that would supply other facilities, including Savannah River in Georgia, Hanford in Washington State, and Rocky Flats in Colorado. The 1,000-acre facility operated under great secrecy after opening in 1951, and most Cincinnatians never knew that a significant component of the infrastructure of the nuclear arms race lay just minutes from the city.

After acquiring the land through eminent domain, the Atomic Energy Commission developed the Fernald facility. The federal government then contracted with a private company, National Lead of Ohio, to operate the plant. Employment at Fernald peaked at nearly 3,000 in 1956, at the height of the early Cold War arms race. Production ended in 1989, as the Cold War disintegrated along with the Communist governments of Eastern Europe and the Soviet Union.

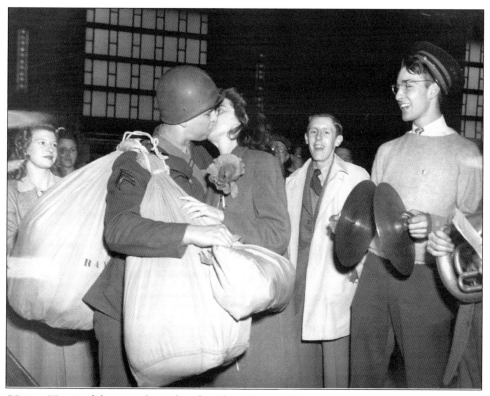

Union Terminal became the sight of endless "farewells" and "welcome homes," as soldiers and nurses headed off to serve during World War II. (Courtesy of Archives & Rare Books Department, University of Cincinnati.)

The processing of uranium at Fernald required no nuclear fission, but it did create considerable waste, much of it toxic. Unfortunately, National Lead had been careless with this waste. Even before its closure, growing awareness of toxic threats generally, and the specific problems associated with Department of Energy (DOE) atomic facilities, drew attention to Fernald. Cincinnatians began to learn more about the operations there and about airborne uranium dust and contaminated wells. Local residents initiated a lawsuit to require the federal government to clean up the mess, and after five years the parties agreed to a settlement—one that required the Department of Energy to pay $73 million. In 1992, the DOE signed a clean-up contract with a company now known as Fluor Fernald, which is still at work at the site.

Structural investments during World War II would clearly affect the region well after the war was over, but demographic shifts undoubtedly had a larger effect. Beginning in the 1940s and increasing through the 1950s, a massive rural-to-urban migration reshaped the region around Cincinnati and the city itself. Facing declining economic prospects in the rural counties of West Virginia, eastern Kentucky, and eastern Tennessee, migrants headed toward nearby cities, most of them to the north. As agriculture continued to falter in a region that would

World War II meant hardship and loss for many Americans, but it also ended the Depression. Here Cincinnatians enjoy an evening of dancing at Coney Island's Moonlight Gardens in the 1940s. (Courtesy of the Cincinnati Historical Society Library.)

become known as Appalachia, farm families were forced to seek employment in urban settings. After World War II, advances in coal mining technology caused a permanent employment slide in that critical industry too, as machines replaced men. Coal regions provided limited opportunities beyond the mines, and miners and their families found themselves with few choices other than leaving. Out-migration itself further hurt the region, making it difficult for service workers to stay as entire towns lost their livelihoods. Through the 1950s, West Virginia lost one-fifth of its population while eastern Kentucky lost one-third, and the out-migration continued in the 1960s.

Cincinnati became an important destination for these migrants, particularly given its proximity to Kentucky, where most of the city's Appalachians originated. Tens of thousands arrived in the Cincinnati area, and although they settled in all parts of the tri-state, they clustered particularly near expanding industries and in areas with inexpensive housing. In the 1950s, as Over-the-Rhine continued to lose its German-American population, Appalachians eagerly moved into the neighborhood's inexpensive and centrally located housing. Other neighborhoods also gained a significant Appalachian presence, including Lower Price Hill and the East End, which, like Over-the-Rhine, offered inexpensive though often substandard housing.

Although the inner-city neighborhoods would gain reputations as the home to Cincinnati's poor, white Appalachians, not all migrants moved into these troubled areas. Indeed, those who acquired good industrial jobs tended to live near their employment in the suburbs, including Norwood, Hamilton, and Newport. Just as important, although the stereotype of the poor, uneducated "hillbilly" would label all Appalachians, the migrants were a remarkably diverse group. Both whites and blacks arrived from the Appalachian counties. Some arrived with easily marketed skills, others arrived only with a strong work ethic. Some were illiterate, others possessed college degrees.

Despite this diversity, all Appalachians had to confront stereotypes and even discrimination, as native Cincinnatians often assumed an Appalachian accent indicated a lack of education or sophistication. The ubiquity of the hillbilly stereotype was just one reason why urban life was uncomfortable for many migrants, many of whom had to transition from the beautiful hills of Kentucky to the crowded streets of inner-city neighborhoods. Still, these neighborhoods did at least provided familiar community. New evangelical churches sprang up to allow Appalachians to maintain religious traditions, and other organizations provided support as migrants made the difficult transition into city life.

Unfortunately, many migrants found themselves mired in the problems of urban slums. Poor environments contributed to poor health. Stuck in some of the worst schools in the city, many Appalachian families found no way out of the poverty with which they arrived. Just like African Americans trapped in decaying neighborhoods, poor Appalachians found themselves paying too much rent for too little comfort. After decades in which too many migrants had experienced little progress, concerned residents created the Urban Appalachian Council in

1974. The new organization had the dual purpose of preserving and promoting Appalachian culture as well as providing services to struggling Appalachian families. Through the work of this organization and others, the metropolis would eventually come to understand how much Appalachian migrants had contributed to the creation of Cincinnati's unique culture.

After 15 years of Depression and war, the late 1940s brought new hopes of progress and stability. Thanks to the G.I. Bill, many returning veterans had the opportunity to attend college, swelling the number of students at local universities. Here a young family sits outside temporary housing in Varsity Veteransville on the University of Cincinnati campus. (Courtesy of Archives & Rare Books Department, University of Cincinnati.)

7. THE HIGHWAY METROPOLIS

In 1938, the Cincinnati Federal Writers' Project issued a boastful history of the city's industrial progress, *They Built a City: 150 Years of Industrial Cincinnati.* Designed mostly to employ writers and researchers, the project also reminded Cincinnatians of brighter economic times before the Depression, and it anticipated renewed growth in the near future. While the authors could hope for economic improvement, they clearly could not anticipate the changes that would transform the city and the region. "The city has reached its maturity; its pattern is set," the introduction claimed. Prosperity after the war gave Cincinnatians new opportunities to reshape their community, to solve lingering problems and face new challenges. As in cities around the nation, Cincinnati witnessed remarkable growth on its vibrant fringe, especially after a massive government investment in the highway system that would be the core of suburban transportation. At the same time, infrastructure within the city decayed, or in the case of the extensive city trolley system, was purposefully removed. Despite grand plans and concerted governmental effort, the city core continued to decline. The Federal Writers' Project was wrong—the pattern of the city was not set. The urban pattern would be remade in the postwar era, as Cincinnati became a highway metropolis.

The central city continued to decline as a percentage of the population in the metropolis. In 1920, before road building and automobile ownership began to dramatically reshape the city, more than 65 percent of the metropolitan population still lived in Cincinnati. That number decreased over the century, and by 2000 less than 20 percent of the metropolis lived in the city that gave the region its name. In part this shift reflects the remarkable growth outside the city limits, but Cincinnati's decline was more than relative. The city's population peaked at just over 500,000 in 1950 and in the next 50 years fell by nearly 35 percent to just over 330,000. Cincinnati's population decline in no way made it unusual among the nation's older cities, particularly those in the Midwest. Cleveland, St. Louis, Detroit, and Louisville all witnessed steeper declines, as did most of the small industrial cities of Massachusetts, New Jersey, Pennsylvania, and New York. Of course, knowing that the decline of their city was part of a larger trend did not give comfort to Cincinnatians concerned about the future of their home.

English Woods provided subsidized housing out of the basin for white families in the late 1940s. Government housing projects were as segregated as the rest of the city. (Courtesy of the Cincinnati Historical Society Library.)

Increasing segregation became one of the defining characteristics of the new metropolitan pattern. The postwar era would be marked by unsettled race relations as the African-American population continued to grow with the migration of families out of the South. Blacks caught in the population shift sought better access to power, driving political changes in the city. At the same time, Cincinnati was deeply affected by the Civil Rights Movement that gained momentum in the 1950s and reached its peak in the 1960s. Through it all, however, segregation not only persisted but also deepened as whites fled inner-city neighborhoods, often settling in all-white communities in the suburbs.

Segregation continued beyond race, too, as Cincinnatians increasingly divided themselves by income and wealth, the poor held at increasing geographical distance from the vibrant areas of the region. Subdivisions that dominated suburban development effectively separated residents by income, creating broad landscapes of roughly equally priced housing. This would be particularly true in the newest suburbs, such as West Chester and Deerfield Township, where relatively uniform developments gave the impression of a classless society in southern Butler and Warren Counties. Middle-class children grew up in a sea of middle-class housing, at least partly sheltered from the diversity of American society. Meanwhile, poor residents faced increasing isolation, particularly within a handful of neighborhoods in the city of Cincinnati.

Beyond the growing geographical divides among the diverse metropolitan population, the landscape segregated by land use as well. Suburban communities made good use of zoning to neatly separate residences from retail and other commercial spaces. Acres upon acres of homes sprung up without any significant pedestrian or mass-transit access to shopping or work sites. Zoning helped determine that the suburbs would be permanently reliant on the automobile, with increasing distances separating residential, commercial, and industrial spaces.

Although clearly the automobile would reshape cities in some way, city planners made certain that the influence would be dramatic. Planning efforts in the mid-1940s contained a vision of a new metropolis, one that made ample room for cars and assumed ever-increasing suburban growth. In 1948, the Planning Commission completed the *Metropolitan Master Plan*, which envisioned a new type of city, one reliant on limited-access highways to relieve traffic congestion and spur growth. The plan plotted two new highways: the Millcreek Expressway through the industrialized Mill Creek Valley and on to Dayton, and the Northeastern Expressway heading out the Deer Creek Valley and eventually to Columbus. Initially these limited-access highways were conceived as state-backed roads, receiving federal funding through their designation as federal routes. The plan envisioned these two highways coming together downtown, in Fort Washington

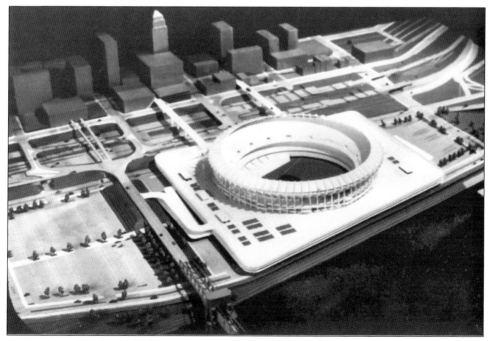

Beginning with the 1948 Master Plan, Cincinnati began a massive reconfiguration of its waterfront. This model of Riverfront Stadium, completed in 1970, shows the wide Fort Washington Way trench and acres of parking on the river. (Courtesy of the Cincinnati Historical Society Library.)

Way, a new trenched roadway with ramps onto various downtown streets and access to bridges to Kentucky.

Fort Washington Way actually led redevelopment on the riverfront due to the passage of the 1956 Interstate Highway Act, providing massive spending on the project and on the two highways it connected, now called Interstates 75 and 71. Construction of the highway required demolition of the central riverfront neighborhood, including the removal of Pearl Street by 1961 and all of the buildings on the south side of Third Street. While Fort Washington Way served its purpose for many decades, until higher traffic levels made the number of ramps in the downtown area too hazardous, the very wide trench completely separated downtown from the riverfront.

In 1946, in preparation for the master plan, the City Planning Commission published a study of "Riverfront Redevelopment" that spoke plainly about the problems that had long plagued the city's "doorstep." "While downtown Cincinnati is cramped and crowded," the introduction noted, "immediately adjacent to its heart lies this large stretch of wastefully used land which has no

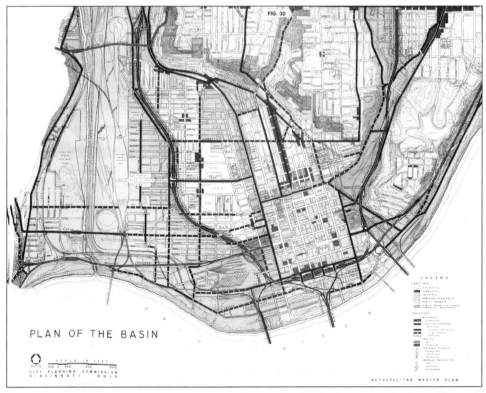

The 1948 plan envisioned a downtown nearly encircled by highways, with the Mill Creek Expressway to the west and the Northeast Expressway to the east. Planners hoped to keep downtown vibrant by improving automobile access. (Courtesy of Archives & Rare Books Department, University of Cincinnati.)

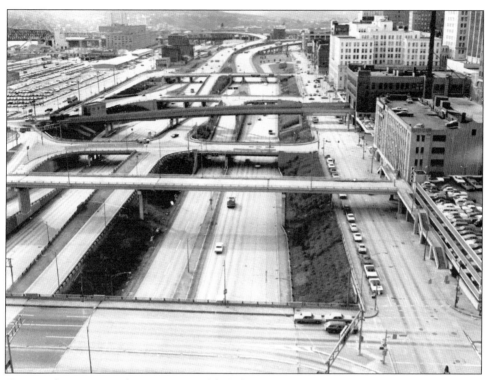

Fort Washington Way became a critical link between Interstate 71 and Interstate 75, but it also separated downtown from the riverfront. The city removed an entire neighborhood to build the highway trench and acres of parking in an effort to make downtown more commuter friendly. (Photograph by Jack Klumpe, Courtesy of Archives & Rare Books Department, University of Cincinnati.)

hope of self-redemption." With the decline of waterborne shipping, the public landing was a shadow of its former self, and the factories and warehouses that once surrounded that critical commercial spot no longer prospered. Indeed, even before the 1937 flood inundated the entire waterfront up to Third Street, the central waterfront had already taken on an abandoned look. As late as 1900, 6,000 people had lived in this part of town, but by 1940 only 2,900 remained, most of them so impoverished as to have no real housing options but to remain in the declining neighborhood.

The plan envisioned a new riverfront, one devoid of its former uses, with the entire neighborhood removed, including warehouses and residences. The plan sanctioned the removal of all of the remaining residences and their replacement with new high-rise towers. Eventually, only one such tower, One Lytle Place, came into being. On the cleared riverfront itself, however, surface parking would dominate, punctuated by two large structures: Riverfront Stadium, completed in 1970, and the Coliseum, completed five years later. In addition, work began on a large new park behind a "serpentine wall" along the river. The wall would serve

129

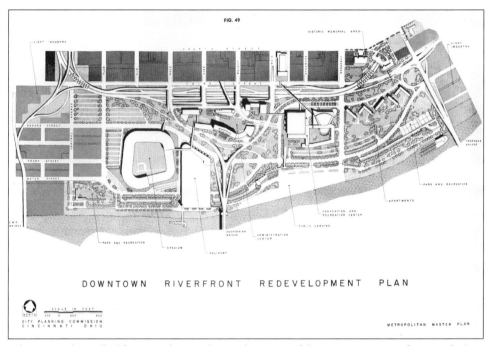

The 1948 plan called for a nearly complete replacement of the Cincinnati riverfront, including the creation of a stadium, convention center, and modern apartment buildings, as well as park lands. (Courtesy of Archives & Rare Books Department, University of Cincinnati.)

as flood protection during high water, but also as an attractive place for watching outdoor entertainment or simply watching the river flow.

Although the city plan was finished in 1948, extensive work on the riverfront awaited some significant funding source. This came after 1962, when city voters passed a bond issue and the city government designated the central riverfront an urban renewal area, allowing the federal government to provide additional funding.

In the late 1960s, the city initiated another major redevelopment effort in an attempt to keep downtown flourishing. This effort focused on Fountain Square at the center of downtown. The city demolished the block to the north of Fifth Street, added a new 600-space parking garage underground, and created a larger public square. At the same time, the wrecking ball made space for two new office buildings on the square, now both occupied by Fifth-Third Bank. In October 1971, the city celebrated "Fountainfest," a party on the new square for the unveiling of the newly refurbished and relocated Tyler Davidson Fountain. Moved up from street level to the elevated square, the fountain had done an about-face and now looked to the west.

The new Fountain Square would serve as a central meeting place in the city, where lunchtime crowds could enjoy good weather and where political rallies could gain visibility and media attention. It would also serve as an important node in the new skywalk system. Begun in 1968, the skywalk allowed pedestrians to

130

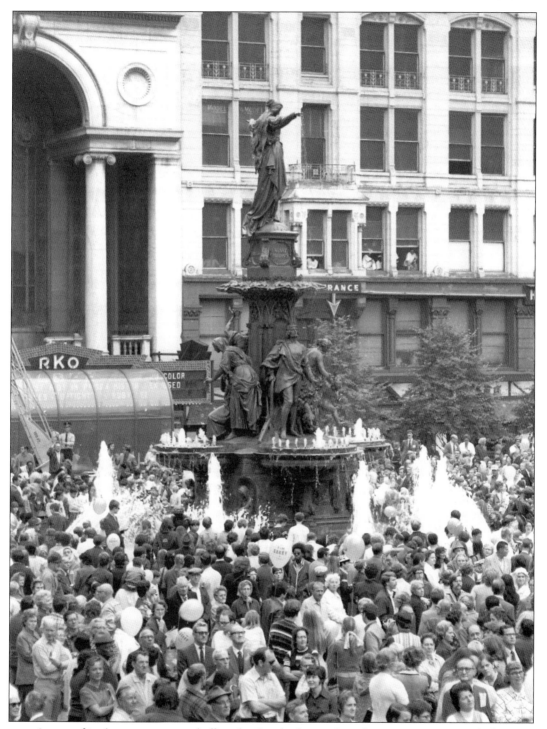

As part of its downtown renewal effort, the City built an enlarged Fountain Square in the late 1960s, moving the Tyler Davidson Fountain itself, revealed here in its new location in 1971. (Courtesy of the Cincinnati Historical Society Library.)

walk above city streets on a maze of walkways connecting the major department stores, hotels, and Fountain Square. To the east of the square the skywalk traveled through the new 580 Building on Walnut and to the south through the new Weston Hotel, built in replacement of the much loved Albee Theater, also demolished as part of the modernization of downtown. To the west, the skywalk traveled both through the Carew Tower and between Fifth and Sixth Streets, reaching out to new hotels that clustered around the new Convention Center, opened in 1967 on the western edge of downtown.

Taken together, the massive changes that radiated out from the new Fountain Square spoke to a continuing faith in downtown but also in a new vision of what the center of a city should be. Rather than an eclectic mix of theaters, offices, residences, and retail that served Cincinnatians who lived in and around the center of the city, downtown would now serve visitors primarily—office workers by day and conventioneers and sports fans on weekends. With a diminishment of housing and entertainment at its core, Cincinnati joined the long list of American cities with a downtown that effectively closed for the evening.

Changes in the metropolis spread well beyond downtown. The preference for automobiles among the growing middle class meant steadily decreasing ridership

The skywalk system, built with the reconstruction of Fountain Square in the late 1960s, allowed pedestrians to navigate much of downtown without the hassle of crossing car-clogged streets, but it also deprived sidewalks of much-needed vitality. (Courtesy of the Cincinnati Historical Society Library.)

on the city's streetcars. Not only did falling income from fares jeopardize the trolley system, but political pressure to remove the obtrusive lines grew as well. As more and more metropolitan residents relied on automobiles exclusively, they increasingly complained about trolleys that moved too slowly in city streets, creating obstacles for faster moving autos, and, just as problematic, creating obstacles with their passengers, who often had to step into traffic to reach trolleys in the middle of roadways.

In the great conflict between private automobile transportation and public mass transportation, clearly automobiles would win. Although streetcars saw a temporary jump in ridership during the Second World War's tight gas market, after the war individual lines closed one by one due to falling ridership, until the spring of 1951, when the last trolleys made their runs in Cincinnati. Ostensibly replaced by a modern bus system, really public transportation had been replaced by privately owned cars.

The growth of automobile traffic had other consequences, as well. After the wartime boom, rail travel fell steadily. By 1953, only 51 trains arrived at Union Terminal each day, and nine years later that number had fallen to just 24. As the city searched for some other use for the magnificent building, train travel dwindled until 1972, when passenger trains ceased their use of the terminal. As the rail yards behind the terminal changed to meet the needs of new, taller freight trains, the concourse of the station had to come down. The Winold Reiss murals, representing the great industries of the city and centrality of workers within them, found a new home in the Greater Cincinnati Airport, south of the city in Northern Kentucky.

The symbolism could hardly have been more poignant. Rail transportation, so important to the building of great cities, had been critical to the growth of downtowns all around the nation. Trains had well served cities and the industries within them. Airports, however, would represent a new era, one that featured the "out-skirts" of town, the suburbs, where growth would continue. Certainly the Greater Cincinnati Airport would benefit the entire region, but its location in Northern Kentucky would encourage growth well away from the city's center, in Hebron and in other communities recently linked to the city by I-275. The migration of Reiss's murals of men and women at work in the city would reflect the reality of more and more regional residents finding homes and jobs far from the city's core. While in most instances the richness of Cincinnati's culture would remain at home, here great art, a symbol of the city's greatness, fled to a suburban sanctuary, too.

Meanwhile, Union Terminal languished, its intended use never to return. In 1975, the city purchased the building and continued to search for a new occupant. In 1980, the terminal opened as a shopping complex and briefly offered hope that the building had found new life. But, perhaps reflecting the larger decline of the West End and the entire city basin, the complex floundered. By 1985, just one tenant, Loehmanns, remained. By this time, however, a new plan envisioned the terminal as a collection of museums, and with taxpayer support, the Cincinnati

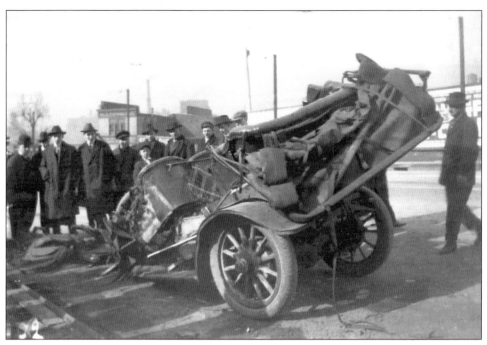

As more and more cars crowded city streets, accidents became more frequent. Here a car has lost a battle with a trolley car on Gilbert Avenue in 1917. Opponents of trolleys would use such accidents as evidence that the older mass transportation system needed to be replaced. (Courtesy of the Cincinnati Historical Society Library.)

Museum of Natural History, the Historical Society, and an Omnimax Theater opened to the public in 1990. In 1998, the Union Terminal became the home of another successful destination—the Children's Museum—and the Museum Center had secured its place as a critical cultural institution in the city.

The highway projects envisioned in the 1940s largely reached completion in the 1970s. Interstate 75, the most important of the region's highways, opened in 1964, providing good access between Cincinnati, Dayton, Toledo, and Detroit to the north, and Lexington, Knoxville, Chattanooga, and Atlanta to the south. It also provided new opportunities for automobile commuting within Cincinnati. Interstate 71 opened in 1974, providing access to Columbus and Cleveland to the north and Louisville to the south, but again its real significance for the city would involve its encouragement of growth within the city's eastern suburbs. Five years later, the circle freeway, I-275, opened as well. Theoretically designed as a by-pass highway, its great circumference made this an unlikely route for most through traffic. Instead, this initially underutilized highway became the primary avenue of economic growth in the region, as residences, retail, and even industry mushroomed along its route.

The highways encouraged the continuing shift of industry onto larger suburban tracts. The trend was most obvious in the conversion of the wartime

aircraft engine factory just north of Lockland, which would eventually face Interstate 75. The factory had fallen into disuse after the 1945 peace, but just four years later General Electric had purchased and re-opened the plant to manufacture jet engines. In 1942, working under a U.S. Army Air Force contract, General Electric had developed the world's first jet engine at its Lynn, Massachusetts plant. That engine was quickly put to use on a number of military aircraft. After the war, demand for new generations of jet engines forced G.E. to seek out a second factory, and it settled on the federally owned plant in Evendale.

The Korean War caused a boom in production and employment in Evendale, and by the war's end 12,000 were once again employed at the plant, which itself also expanded. Even after the Korean War ended, G.E. continued production at the Evendale plant, focusing not just on jet engines for the military, but also on commercial engines for the rapidly growing airline industry. Continued advances in jet technology kept the plant busy, producing increasingly powerful and efficient engines. Although G.E. engines would propel a growing fleet of commercial jets around the globe, its employees remained particularly proud of its contributions to America's military power, especially during the Cold War.

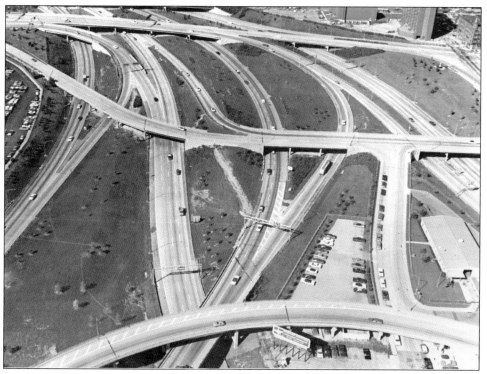

By the mid-1970s, a tangle of highways had replaced large parts of downtown. Here I-75 passes through what used to be the Kenyon-Barr neighborhood. (Photograph by Jack Klumpe, Courtesy of Archives & Rare Books Department, University of Cincinnati.)

G.E. engines powered several of the military's most important aircraft, including F-16 fighter jets and B-2 bombers.

General Electric's expansion into Cincinnati was a boon to the entire region. Since its initial growth in the 1950s, G.E. Aircraft Engines remained one of the region's largest employers, despite sometimes dramatic dips in demand for new engines, caused by decreased defense spending at the end of the Cold War and periodically poor performances in the airline industry. In 1987, General Electric recognized the importance of its Cincinnati facility when Evendale became the world headquarters of the renamed G.E. Aircraft Engine Corporation.

Although some African Americans moved to the suburbs and gained good access to suburban jobs, the growth at the city's vital fringe had little positive impact on the growing black population in the city. Cincinnati's African-American population rose quickly in the decades after World War II, but the political power of blacks rose only slowly. The most important postwar African-American leader was Theodore M. Berry. Born in Maysville, Kentucky, Berry arrived in Cincinnati before the age of three and spent his childhood in a series of foster homes in the West End. In 1924, Berry graduated from Woodward High School as valedictorian. He worked his way through the University of Cincinnati, and then the U.C. law school. A lawyer by 1932, he became an assistant prosecuting attorney for Hamilton County in 1939, the first African American to gain that post. By that time he had also served as the president of

Theodore M. Berry was Cincinnati's first black mayor and one of its most accomplished politicians. (Courtesy of Archives & Rare Books Department, University of Cincinnati.)

the local chapter of the National Association for the Advancement of Colored People (NAACP). During the Great Depression, Berry, like most black Americans, shifted his political allegiance from the Republican Party (the party of Lincoln), to the Democrats (the party of Franklin Roosevelt), and he became active in Democratic politics.

After World War II, Berry continued to serve the NAACP using his considerable legal skills, and he translated his personal charm and political prowess into a long career on city council beginning in 1949. After serving as vice mayor in 1955, Berry became the victim of white backlash in 1957, as the specter of a black mayor convinced many to vote for an all-white slate. Berry returned to council in 1963 and then served in the Johnson Administration, where he headed the Office of Economic Opportunity's Community Action Programs, including Head Start for at-risk preschoolers and the Jobs Corps for unemployed teens. After returning to Cincinnati from Washington, Berry again served on council, and in 1972 he became the first black mayor of Cincinnati.

Berry's influence on the city was considerable, not just as a black pioneer breaking color barriers through much of his life, but also as an effective leader supporting just laws and equal protection under those laws. Among his many lasting impacts, Berry inspired others to seek political office, including William Mallory, who also grew up in the West End, and eventually served as the Ohio House of Representatives majority leader. Much loved and admired, Berry has been honored repeatedly since his retirement from public service in 1975. His name now graces a 20-acre park in the East End, a new street on the riverfront, and, fittingly, a Head Start building in his old neighborhood, the West End.

Of course Berry's success in politics did not signify that all was well in Cincinnati race relations, that the city had somehow avoided the effects of racism that plagued the entire nation. Indeed, the Civil Rights Movement that began the transformation of the nation in the 1950s also began the transformation of Cincinnati. Begun as a series of legal initiatives, largely supported by the NAACP, and a series of nonviolent protests including boycotts and sit-ins, the Civil Rights Movement at first focused on the desegregation of the South. This growing campaign gathered momentum through a series of small victories, and in the mid-1960s the movement scored major successes with the passage of two key federal laws guaranteeing equal rights, including voting rights, for African Americans.

Through the first decade of intense activism, the focus of the movement remained primarily on the South, with Northern activists, black and white, giving financial support and often traveling south to participate in protests and marches. In the early 1960s, this remained the strategy for Cincinnati's most famous Civil Rights activist, the Reverend Fred Shuttlesworth, who moved to the city from Birmingham in 1961, where he had been a principal leader in a series of actions to desegregate that city since 1955 and the target of assassination attempts, including a bombing that destroyed his Birmingham home in 1956. In Birmingham, Shuttlesworth had helped form the Southern Christian Leadership Conference, which became the vehicle for Martin Luther King's rise to national

prominence. In Cincinnati, first as pastor of the Revelation Baptist Church in the West End and later as the founder and pastor of the New Light Baptist Church in Avondale, Shuttlesworth became a principle organizer of African Americans and whites eager to participate in the movement, many of whom regularly traveled south with Shuttlesworth to support key events.

In the mid-1960s, the focus of the Civil Rights Movement began to shift away from the slowly desegregating South and toward the rapidly segregating North. Despite the many victories accrued by the movement, including the critical federal legislation, many urban blacks in the North saw no improvements in their lives. Energized by the activism focused on the South and very often participants in it, African Americans in the North initiated efforts closer to home, particularly in an attempt to improve housing and employment opportunities, acting through Civil Rights organizations, including the NAACP and the Urban League, which organized in Cincinnati in 1949. Not surprisingly, Cincinnati's homegrown activism sprang from the largest African-American neighborhoods, including the West End and Avondale. By the 1970s, Cincinnati had a new generation of Civil Rights activists, including Carl Westmoreland from Lincoln Heights, who became a key organizer in Mount Auburn, and William Mallory, who had grown up in the West End's Park Town community and would spend much of his life in politics.

Frustration grew throughout the North, as city governments expressed either an inability or unwillingness to take significant steps to improve the deteriorating conditions in black inner-city neighborhoods. In many cities, including Cincinnati, worsening economic conditions combined with increasing conflict between largely white police forces and black residents. Trying to deal with higher crime rates principally caused by rising illegal drug activity, the police found themselves in frequent conflict with a significant population of unemployed black youth, who increasingly turned to crime for income. By the late 1960s, then, the once peaceful Civil Rights Movement had turned into a series of "Long Hot Summers," leaving dozens of cities heavily damaged by riots, replete with arson and looting. The worst riots occurred in Los Angeles in 1965 and Detroit and Newark in 1967, where together 100 people died, mostly from gunfire.

Cincinnati too experienced riots in the late 1960s, though they were not nearly as destructive as those in many other cities. In the early summer of 1967, shortly after Martin Luther King had preached in Avondale and Lockland, still delivering his message of nonviolence, the *Enquirer* ran a wire story concerning the prospect of urban unrest in the coming months under the headline "Nation Braced for Summer Race Riots." Just a week later, Cincinnati experienced its first rioting in the Civil Rights era, initiated by the arrest of a black protester, Peter Frakes, who was protesting the conviction of Posteal Laskey for the murder of Barbara Bowman. Frakes's arrest sparked four days of violence, centered along Reading Road in Avondale, by then Cincinnati's central black neighborhood. The riots caused considerable damage, as participants hurled Molotov cocktails and otherwise set a series of fires. Some rioters smashed store windows, particularly in Avondale's business district, and on the first night looters ransacked the Sears on Reading.

The next day Ohio National Guardsmen patrolled the city, as up to 1,500 rioters continued to rove the streets. By late evening firefighters had responded to 47 calls, most of them arson-related. On the third day, two teenaged boys became the riot's first gunshot victims, though both survived, as arson and looting continued. That would be the last day of the unrest, however, and for three more days National Guardsmen kept watch over the city. In total, 316 people had been arrested during the riots and at least 30 injured, but there had been no riot-related deaths.

A year later, Martin Luther King himself was dead, assassinated in Memphis on April 4, 1968. As the news of King's murder spread, riots broke out across urban America, with the worst in Washington, D.C., as African Americans expressed outrage. In three days of violence around the country, 28 people had been killed. In Cincinnati, an uneasy calm pervaded the city, with only minor incidents marring the mourning of King. Police attempted to stay clear of aggrieved and mourning blacks.

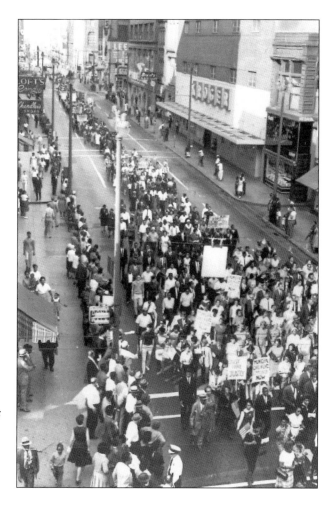

By the mid-1960s, the Civil Rights Movement had moved North, demanding equal access to jobs and housing. Here one of the many marches for equality moves along Race Street in 1964. (Courtesy of the Cincinnati Historical Society Library.)

Four days after King's death, however, Cincinnati's calm was broken when a black man, James Smith, attempted to protect an Avondale jewelry store from an attempted robbery, using his own shotgun. In a struggle with the potential thieves, also black, Smith's gun fired, tragically killing his wife. Rumors spread that a white police officer had actually killed the woman, and in a neighborhood ready to explode with rage, the erroneous story was enough to spark violence. Shortly after rioting began, a group of young African Americans dragged a white University of Cincinnati graduate student, Noel Wright, and his wife from their car in Mount Auburn. Wright was stabbed to death and his wife beaten. The next night, the entirety of Hamilton County was under curfew, and nearly 1,500 national guardsmen were stationed around the city to quash the violence. After two days of calm, the city lifted its curfew.

Altogether the effects of the nation's many riots were staggering, not just in lives lost and property damaged, but in the devastation to urban America generally. Already perceived by many Americans as increasingly dangerous places because of rising crime rates, the riots convinced thousands to flee urban neighborhoods for the relative safety of the suburbs. Although middle-class blacks participated in the exodus, the movement is often called "white flight." Like all cities that

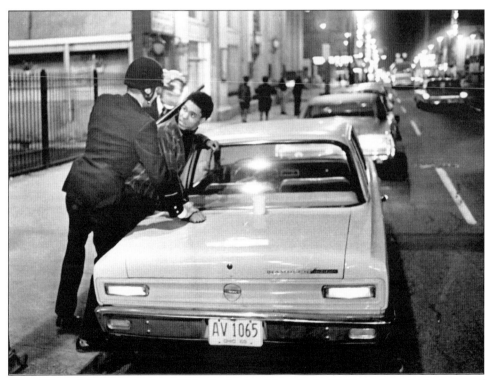

Riots followed the assassination of Martin Luther King, Jr. in 1968, during which dozens of African Americans were arrested. (Photograph by Jack Klumpe, Courtesy of Archives & Rare Books Department, University of Cincinnati.)

140

experienced riots, Cincinnati also witnessed a steeper urban decline, not just at the epicenter of the riots, Avondale, which has never recovered from its riots, but in many city neighborhoods. Obviously destructive in the short term, the riots would have negative consequences for decades, as black neighborhoods found themselves further removed from regions of prosperity and safety.

In the 1970s, Cincinnati struggled to integrate its public schools, nearly 20 years after *Brown v. Board of Education* declared racially segregated schools illegal. The city devised a number of solutions to mix students, most of whom lived in segregated neighborhoods—nearly all white like Hyde Park and Westwood, or nearly all black like the West End and Avondale. The district created a number of magnet schools to attract students from around the city, mixing students of different races from different neighborhoods. Since the majority of students would not enter a magnet school, solutions eventually had to involve the bussing of students, sometimes over great distances, to create better racial balance within the district. Integration within city schools would take extraordinary efforts given the level of segregation in the neighborhoods, and many white families simply were unwilling to have their children ride long distances on buses to aid in integration, especially when neighborhood schools offered a good education but more distant schools might not. Bussing plans, and the integration they sought to achieve, clearly played a role in encouraging even more "white flight" to the suburbs.

The incentive to move children out of the city school district became even greater in 1974, when the U.S. Supreme Court issued its ruling in *Milliken v. Bradley*. The high court ruled that cities could not force suburban districts into bussing arrangements to ease desegregation efforts. Thus, the courts declared it a constitutional right of suburban communities to keep their children in *de facto* segregated schools (by nature of the segregated communities they served), while larger districts had to devise some means to desegregate. In 1976, racial imbalance within Hamilton County schools revealed the larger problem of on-going discrimination in housing. On the east side of the city, Forest Hills schools were just one-fifth of one percent black, while on the west, the Oak Hills district was just one-tenth of one percent black. In a county that was nearly one-quarter African American, Maderia, Indian Hill, Mariemont, Norwood, St. Bernard, Sycamore, Reading, Deer Park, and Northwest schools all had a student body that was less than five percent black. In many cases, those figures would hardly improve over the next 30 years.

Meanwhile, in 1976, the city of Cincinnati's schools were 50 percent black, and with continued white flight the student body would be over 80 percent black within 30 years. Some integrated suburban schools did provide excellent models for other districts, including the large Princeton district, which was more than 30 percent black in 1976, and the Greenhills-Forest Park district, which was more than 13 percent black. Still, for parents seeking better schools for their children, moving to the suburbs became an obvious solution. Unfortunately, for some parents "better" simply meant "white." As the middle class abandonment of the

city continued through the 1970s, conditions in city schools deteriorated, and moving out of the district looked like a better and better choice.

Fleeing higher taxes, higher crime rates, urban unrest, and struggling schools, many Cincinnatians gave up on their city, choosing the seemingly idyllic suburban lifestyle instead. In 1970, the city still had over 450,000 residents, but in the next decade it lost 67,000, and by the year 2000 the city had just 330,000 residents, having lost nearly 25 percent of its population in the preceding 30 years. Meanwhile, the suburbs, particularly those along the new highways, grew rapidly, as subdivisions turned former farmland into acres and acres of middle-class housing. All around the city's perimeter, but especially along the I-75 and I-71 corridors, populations mushroomed in the 1970s and 1980s. Suburban developments, including four major shopping malls along I-275, at first offered convenient shopping with free parking for the growing suburban population, and by the 1980s some suburbs witnessed growth in office and warehouse space too, providing job growth well outside Cincinnati's city limits.

The ring of suburban malls, many of them along the circle freeway, undercut the market for downtown shopping, particularly as Shillito's, Pogue's, and McAlpin's all created large suburban shops that carried the same goods at the same prices with the advantage of convenient and free parking. Suburbanites, and just as importantly, rural residents outside the city, no longer had to travel into the city, fight traffic, and find parking to shop at the massive downtown stores. Not surprisingly, one by one the large stores closed, and only extraordinary efforts by the city have kept Lazarus and Saks Fifth Avenue downtown. Meanwhile, the explosion of retail space in the suburbs left older malls competing with newer ones, strip malls competing with enclosed malls, etc.

As in other metropolitan regions, Cincinnati grew ever more polarized, with wealthy residents moving farther away from poorer neighborhoods. Communities like Loveland, Milford, and Blue Ash attracted much of the metropolis's wealth, while Cincinnati itself and other industrial suburbs, like St. Bernard and Norwood, lost population and wealth. Although some city neighborhoods, including Mt. Lookout, Hyde Park, and Clifton, retained their wealth and good reputations, other neighborhoods declined precipitously, including Avondale and Walnut Hills, as the wealthiest residents fled for more secluded regions. Exclusive suburbs could take great pride in their safe, beautiful neighborhoods and their successful school systems, but the city struggled to compensate for declining population and tax revenues, even as the concentration of poverty in the city required ever-growing expenditures for social services.

Although popular culture gave suburbs the reputation as bland, uniform expanses of white, middle-class America, suburban diversity persisted. Some suburbs had been born as small industrial cities, such as Lockland, which retained its working-class essence. Other suburbs remained predominantly working class as well, including Reading and Fairfax, both near good industrial jobs. Some suburbs even developed large African-American populations, including Lincoln Heights and the Hazelwood neighborhood in Blue Ash.

Despite this diversity, though, the newer suburbs took on a rather uniform character, particularly the distant suburbs that sprang up outside Hamilton County, where middle-class neighborhoods replaced more and more farmland. Clermont County grew rapidly after the completion of I-275, nearly doubling in population between 1970 and 2000. In those same years, Boone County more than doubled, rising from just 33,000 to nearly 86,000 residents, growth clearly sparked by I-275 and the decision to place the airport in that county.

Suburban development had obvious benefits, as road and housing construction helped fuel economic growth, and residents enjoyed the advantages of home ownership and the amenities of their new communities. Still, suburban growth had increasingly obvious costs as well, including decreasing air quality, increasing traffic, and a diminishment of the promised convenience of suburban life. As developments consumed open land and created increasingly dense populations, many of the problems of the city moved to the suburbs in time. Commercial corridors, including Colerain and Beechmont Avenues, became renowned for their traffic and visual blight, two of the problems that had long plagued urban shopping districts. Even taxes would increase over time, though never matching

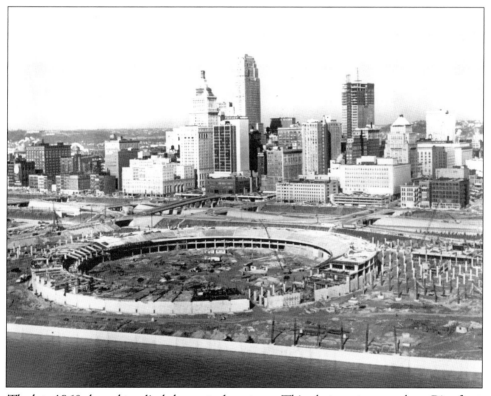

The late 1960s brought radical change to downtown. This photo captures work on Riverfront Stadium in the foreground, Fort Washington Way in the center, and the DuBois Tower in the background. (Courtesy of the Cincinnati Historical Society Library.)

the higher rates in the city. Still, the re-creation of services in the suburbs, including building school systems and fire and police departments, in addition to all the infrastructure of sprawl—roads and sewers particularly—was an expensive undertaking. Fortunately for suburbanites, much of the cost of growth was subsidized by outside funding, especially as the state and federal governments financed road and school construction.

Other negative consequences of suburban growth affected the entire region. Racial polarization was especially strong and perhaps most important. Following a precedent set as early as the 1940s, whites continued to flee city neighborhoods as African Americans moved in to them. Walnut Hills, once a wealthy white neighborhood that flourished before the Great Depression, witnessed dramatic population loss during the second half of the twentieth century, shrinking by two-thirds its former size by the year 2000. At the same time, the flight of whites out of the neighborhood left what had been a fairly integrated neighborhood 84 percent black by the end of the century. Just as dramatic, Mount Auburn, the city's first fashionable suburban retreat, lost nearly half its population in the last half of the 1900s and went from nearly 100 percent white in composition to nearly three-quarters black. These shifting racial demographics demonstrated the continuing racism that plagued the region, as neighborhood-by-neighborhood whites left their homes in the city to find more exclusive, secure, and homogenous retreats in the suburbs.

In the city, African Americans found themselves in declining neighborhoods, as businesses closed, some of them following white money into the suburbs, and crime increased, partly because job discrimination and poor education left young African-American men disproportionately unemployed. Thus, the movement of wealth and jobs continued unabated from neighborhoods where African Americans found homes but also found themselves still isolated from prosperity. Even city planners continued to see the city's own neighborhoods as places to drive through rather than to. New thoroughfares—secondary roads—featured better access to highway exits and more direct routes east and west. Walnut Hills suffered the invasive construction of a new commuter route, now called Martin Luther King Avenue, an important link between the still prosperous eastern neighborhoods and the job centers at the University of Cincinnati and Corryville's many hospitals. In addition, Walnut Hills suffered the indignity of the intrusion of I-71, its noise, pollution, and even the initial destruction required to construct the roadway as it pushed through the western edge of the neighborhood. Unfortunately, Walnut Hills gained none of the advantages of the highway itself. No exits allowed easy on-off access from the declining Peebles Corner business district to the highway.

Given the strong suburbanizing trend, the city of Cincinnati found itself under great stress in the 1970s. This stress was heightened by the faltering national economy, a decline that particularly affected the industrial heartland. The process of de-industrialization now struck the nation as a whole, as more and more industrial goods came from Japan, Germany, and developing nations.

The Midwest was particularly hurt by the loss of good, blue-collar jobs. Two oil crises, one in 1973 and another in 1979, further damaged the economy and sent shivers through the American automobile industry. Combined with the growing problems in metropolitan structure, the region's uneven growth, and increasing segregation, the faltering regional economy posed serious threats to the city's future. Fortunately for Cincinnatians, the dark decade of the 1970s also brought the most wonderful of distractions: baseball.

The completion of Riverfront Stadium in 1970 gave the city a new symbolic center. Prominently featured in nearly every photograph of downtown, the stadium represented the importance of major-league sports in a city that in some ways was no longer among the nation's elite. As home for the Cincinnati Reds for 22 years, and for the Bengals for nearly as long, Riverfront became one of the most visited buildings in the region. While not a terribly attractive stadium, inside or out, many city residents would come to express deep affection for the structure, not for its appearance but because of what happened there. While many baseball fans lamented the 1969 closure and demolition of the older Crosley Field in the West End, Riverfront became home to baseball lore in its very first season, both as the site of an unusually exciting All-Star game (in which hometown hero Pete Rose scored the winning run in typically aggressive fashion) and as the site of the 1970 World Series.

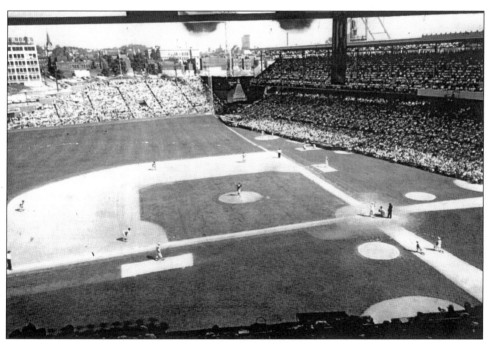

Crosley Field remained the West End home of the Cincinnati Reds until the end of the 1969 season. Fans loved the stadium but hated the parking. Many even feared the neighborhood. (Courtesy of the Cincinnati Historical Society Library.)

The excitement of 1970 was just the beginning, however, as the Reds created one of the strongest teams in baseball history in the subsequent years, gaining the nickname "the Big Red Machine" and winning the World Series in 1975, in a stirring seven-game contest against the Boston Red Sox, and again in 1976, with a sweep of the New York Yankees. Led by future Hall of Famers Joe Morgan at second base, Johnny Bench catching, and Cincinnati's own Pete Rose playing third, the Reds fielded perhaps the most remarkable starting eight players in baseball history. In 1976, as the team dominated the National League and the local media throughout the summer and into the fall, the Reds fielded an exceptionally talented and exciting team, leading the major leagues in nine offensive categories, including home runs and batting average. Seven of the eight starters made the National League All-Star team, and the eighth, Cesar Geronimo, who would bat over .300 that year and win his third consecutive Gold Glove award for fielding, deserved the recognition as well.

Manager Sparky Anderson led the Cincinnati Reds to three World Championships in the 1970s. His "Big Red Machine" helped Cincinnatians forget the many troubles of the 1970s. (Photograph by Jack Klumpe, Courtesy of Archives & Rare Books Department, University of Cincinnati.)

Although not of great concern for baseball fans thrilled at the dynasty the Reds had put together in the early 1970s, the starting eight could represent something else as well, something beyond the sport. In a society still racked by racial and ethnic conflict and marked by geographical segregation, the Reds represented one institution where people of very different backgrounds came together to work toward a common goal. Two whites, Rose and Bench, three Hispanics, Dave Concepcion, Toney Perez, and Geronimo, and three African Americans, Ken Griffey, George Foster, and Morgan, together represented the positive side of America's diverse culture. While other cities struggled to accept diversity within their professional sports teams, Cincinnatians simply reveled in their team's success. Meanwhile, the team's many stars provided young Cincinnatians the opportunity to find heroes that did not look just like themselves.

Baseball history would also be made at Riverfront in 1985, when Pete Rose broke Ty Cobb's record of 4,192 career hits, and in 1990, when the Reds won the World Series after leading the Pennant race from "wire to wire" and sweeping the heavily favored Oakland A's. The previous year, however, Pete Rose's gambling addiction had gained national attention, and after a lengthy investigation by Major League Baseball, Commissioner Bart Giamatti banned Rose from baseball, preventing him from stepping inside Riverfront again until it was no longer used for major league games. This occurred in 2002, at the close of the season, when Rose came home for a softball game with other Reds greats. Three months later, demolition crews imploded the stadium, making way for yet another incarnation of the city's riverfront. In March of 2003, the city celebrated the opening of the new Great American Ballpark, which Cincinnatians can only hope will have as glorious an existence as its predecessor, and hopefully a longer one.

The return of economic growth in the mid-1980s sparked a building boom in Cincinnati, as it did in many American cities. The boom featured new suburban office parks and expansive subdivisions far from the city's core, but it also involved extensive private-sector construction downtown for the first time since the 1920s. While important additions to the skyline had been made in the intervening decades, including the Kroger Building on Vine Street in 1959 and the DuBois Tower on Fountain Square in 1970, prime office space exploded in the 1980s with the construction of several large buildings. Most of these followed the International Style then dominant among skyscrapers, of which both the Kroger and DuBois towers were examples, the former the city's worst and the latter perhaps its best. At first the growth focused on Fourth Street, the old financial center of the city, with the construction of Atrium I in 1982 and Atrium II in 1984, joining the recently completed Central Trust Center (1979) nearby. In the same year Atrium II opened, so did two new towers, Columbia Plaza, now known by the name Chiquita, its largest tenant, and the Cincinnati Commerce Center, now known by its largest tenant, Convergys. Often critiqued as ugly glass boxes, these International Style buildings did highlight the strengths of their designs—sleek, modern exteriors and open, flexible interiors. While perhaps unattractive, particularly compared to stylish neighbors, including the Cincinnatian Hotel

Johnny Bench anchored the "Big Red Machine" with his All-Star catching and hitting. By the time he retired in the 1980s, he had already become one of the city's most admired sports heroes. (Photograph by Jack Klumpe, Courtesy of Archives & Rare Books Department, University of Cincinnati.)

across Vine from the Commerce Center, these newer additions to the skyline did at least represent a resurgence in center-city construction. The amount of high-quality office space mushroomed in the early 1980s, attracting new businesses and capturing the expansion of firms already downtown. The building boom ceased in the early 1990s, as commercial space peaked with the opening of two more towers, the dramatic postmodern 312 Walnut Building, which faces the river and the city's stadiums with a curved glass façade, and the Chemed Center on Fifth Street, completed a year later.

One of the new buildings of the 1980s deserves special attention: Procter and Gamble's new World Headquarters, completed in 1985. This new structure played off the modernist features of the building that had served as the headquarters of the growing company since 1956, located just next door, and the new construction added to the corporate gardens that separated the buildings from Fifth Street. Unlike the older building, however, the new headquarters featured two domes

that helped enclose the gardens and bracketed the entire eastside skyline. The postmodern touches allowed the building to fit at once with its modernist neighbors and older buildings in the city, such as the similarly topped former *Post* building. While the new building represented the continued growth of Procter and Gamble and its ongoing commitment to its hometown, the new structure revealed ambivalence about the city itself. Although just blocks from Fountain Square, the Procter complex looks as though it might be more comfortable in the suburbs. Its expansive gardens separate the buildings from the rest of the city, with the L-shaped building pushed to the back of the mega-block. Although they are visually attractive, the gardens themselves do not invite public use. They are clearly corporate property. The city obviously benefited from Procter's decision to build downtown, but the complex created an odd void in the city's center—a place of almost no street life, none of the energy that is so evident just blocks away.

The changing metropolis of the late twentieth century left the region with a typical post-industrial city, perhaps one with more character and cultural amenities than most that went through the wrenching changes of the era. Industry continued to shift out of the city's core, continuing a long trend of movement toward more spacious, economical, and convenient locations well outside the city. The city of Cincinnati's decline fits the pattern of cities around the region. Indeed, several cities suffered much more deeply, including Detroit, Cleveland, and St. Louis, all of which lost more population and jobs than Cincinnati. These and many other cities have been in constant search for a formula to rekindle growth and attract new residents.

In Cincinnati, the consequences of de-industrialization are evident on the landscape, but now older buildings can mean more than just lost jobs. New industrial parks, in suburban Hamilton, Butler, and Boone Counties particularly, attracted manufacturing from within the city and captured new growth in expanding fields, and so older plants have rarely found new industrial tenants. Among the most visible closures within the urban core came in 1987 when General Motors opted to shutter its Norwood plant, located at the very heart of the small city. At the time, the plant employed over 4,000 people and supplied the city with 35 percent of its tax base. Working with General Motors, however, the city of Norwood was able to recover relatively quickly from the economic blow, as G.M. demolished its old facility, preparing it for redevelopment. A mixed retail/office complex, called Central Parke, rose in the old factory's stead, providing the city with a new image and representing a new economic niche for the rapidly de-industrializing city.

Given its convenient location between the two major interstate highways and along the connecting Norwood Lateral highway, the city would in short order convert several old industrial complexes into desirable commercial spaces, including the popular Rookwood redevelopment of the former LeBlond machine tool property. Norwood's transition from the 1980s through the early years of the twenty-first century represents the broader shift in the American economy— one away from heavy industry, more and more conducted beyond America's

borders, and toward a service economy, based in retail, health care, and finance. Norwood's success in this transition speaks to the power of the highways, which, like the railroads of 100 years earlier, helped determine that that city would be a good place to do business.

As traditional uses of urban land diminish, especially in industrial production and expansive retail opportunities, and as population continues to move farther from the core, the city has been forced to re-envision itself once again. Like earlier transitions from a river town to a thriving commercial city, and from a commercial port to an industrial city, the shift to the postindustrial city would bring with it serious problems but also opportunities. Just after the turn of the twenty-first century, though, many city residents were simply concerned about saving the city.

The Procter and Gamble World Headquarters represent a continued investment in Cincinnati but also the culmination of an architectural trend that ignored the cityscape. (Courtesy of Procter and Gamble Company.)

Epilogue: Saving the City

In April 2001, riots caused damage in several city neighborhoods, including Walnut Hills, Avondale, and particularly Over-the-Rhine. City police worked overtime, aided by county sheriffs and even state troopers, attempting to stop looters and vandals who roamed the city's poorest neighborhoods, breaking windows and setting numerous small fires. After three nights of violence, the city initiated a curfew, which ended the rioting before the city had to call up the National Guard.

Some city residents complained about uneven enforcement of the curfew, with police all but ignoring prosperous and predominantly white neighborhoods, while making arrests in black communities. But the most pronounced disparity went without comment. Suburban residents were not under curfew and could live their lives relatively unaffected by the violence in the city. While the riots brought into strong relief the differences between whites and blacks within the city, the separation between city and suburb became all the more apparent. In the coming months, suburbanites offered comment about what was wrong with the city—some part of which undoubtedly influenced their decisions to live outside of it. But no one suggested that the decision of so many whites to live outside the city itself was a critical factor, which it clearly was. Decades of suburbanization had drained wealth, talent, and energy from the city, as the region became ever more segregated by class and race.

Cincinnati has seen plenty of civil unrest in its past—in 1829, 1836, 1841, 1884. But by 1968 and 2001, the city was different. Cincinnatians had more options. And more and more they opted to leave the city and its problems behind. If the riot of 1841 represented a struggle for the control of the city, the 2001 riot signaled the near abandonment of some neighborhoods to poverty and hopelessness. Most of the metropolis's residents could watch the mayhem on television from the safety of their living rooms and think, among other things, thank God I don't live in the city.

In 2001, long-term trends, especially the suburbanization of jobs and retail, and short-term trends, an economic downturn and a spike in crime, both of which followed the riots, combined to convince many observers in and out of the city

that Cincinnati was at a critical moment. While Cincinnatians would disagree about what the city's problems actually were and would certainly disagree about what solutions should be attempted, a near consensus developed that something had to be done to save the city.

Boycotters leveled their sights on downtown, the old symbol of wealth and power in the city, apparently without a sense of irony that it remained one of the few diverse parts of the metropolis. Boycotters laid siege to a crumbling citadel, while much of the real elite of the region became ever more thankful that they had decided to move their businesses to Blue Ash and their homes to West Chester. Boycotters made purposeful connections to the tactics of the 1960s Civil Rights Movement, apparently unaware that those tactics made little sense in the twenty-first-century highway metropolis.

Clearly Cincinnati's problems would not be quickly or easily solved, but a growing recognition of what the city can offer its residents has presented some positive trends. No longer will city planners recommend the destruction of the city to ease suburban commuting or recommend the leveling of historic neighborhoods so that they might be replaced with monotonous housing projects. Anti-urban solutions of urban problems should no longer receive significant attention. In addition, more metropolitan residents have discovered the real advantages of urban living, its vibrancy and convenience. A revived market for quality housing in and around downtown has slowly convinced city leaders that perhaps they might encourage residential development instead of trying to revive downtown as a retail destination for suburbanites who already have good access to retail closer to home.

Despite the growing sense of crisis after the 2001 riots, Cincinnati retained some significant strengths, not the least of which was an active and concerned populous clearly eager to make the city better. Other strengths included the presence of large, homegrown companies, including Fifth-Third Bank, Procter and Gamble, and Kroger, all of which have made efforts to improve the city that supported their growth. These companies, and many others, have continued to employ thousands of workers in the city and have pledged support for important reforms, including the improvement of education and minority hiring in the city. In addition, a bond levy passed in early 2003 will partially fund a massive investment in the city schools, one that will match an equally impressive investment at the University of Cincinnati, where new and innovative buildings have dramatically altered the Clifton campus.

Investment in all the city's neighborhoods may be necessary to stem the loss of population, but most of the region remains fixed on the problems of downtown and Over-the-Rhine. Commentators seem to agree that the fate of the entire city rests with the success of the basin neighborhoods, and here, from the once-again rebuilt riverfront to the growing number of rebuilt historic apartments in the city's most troubled community, a rapidly increasing investment of public and private dollars offers hope that concerted effort to save the city is already well underway.

Downtown remains attractive to residents not only because it is an employment center, but also because it contains so much of the city's rich culture, in its architecture and streetscapes as well as its institutions. Since its founding, Cincinnati's cultural epicenter has been the city's center. Churches, libraries, theaters, music halls, and eventually museums clustered at the city's core. Although cultural institutions have dispersed around the metropolis, the twenty-first century downtown still possesses remarkable cultural attributes, some of them old, such as the main branch of the public library, and some of them relatively new.

Among the most important of the new institutions is the Aronoff Center, a 1996 edifice containing three theatres and gallery space. Designed by Cesar Pelli, the building anchors a revived Walnut Street downtown, and its patrons have contributed to a boom in fine dining in the area, to complement the already renowned Maisonette, which is just around the corner from the arts venue. Controlled by the Cincinnati Arts Association, created to unify the operations of the venerable Music Hall and refurbished Memorial Hall with the new center, the Aronoff has done exactly what its proponents claimed it would— bring people downtown in the evening, giving life to streets that were once

Cincinnati's Music Hall has been an important cultural icon since its construction in 1878. It has long served as a local treasure, both in the beauty it adds to the city's landscape and in the beauty of the music and dance that take place within its spacious hall. After 125 years of existence, it is also now a critical component of an arts "revival" in the city. (Photograph by Jodie Zultowsky.)

153

The Aronoff Center has served as the centerpiece of the revitalized Walnut Street since its completion in 1996. Restaurants have flourished around the arts center, benefiting from a dramatic increase in pedestrian traffic and evening patrons. (Photograph by Jodie Zultowsky.)

empty after office workers cleared out of town. Five years after its opening, the Aronoff complemented older arts venues, and together the three Cincinnati Arts Association facilities brought a million visitors to downtown and Over-the-Rhine in a single year.

Another important new edifice has risen just across the street from the Aronoff: the Contemporary Arts Center's new home. Since its beginnings in the 1930s and in borrowed space in the Cincinnati Art Museum, the Contemporary Arts Center has been a national leader in supporting modern art. Begun as the Modern Art Society, the organization brought to Cincinnati such now-famous artists as Paul Klee, Juan Gris, and Henri Rousseau. Zaha Hadid, the Iraqi-born, London-based architect, designed the Contemporary Arts Center's new home on Walnut Street, and both the building and its changing contents should be a popular destination downtown.

The Underground Railroad Freedom Center, a new museum dedicated to the struggle for human freedom, has risen on the riverfront. With construction initiated in the summer of 2002, the Freedom Center had been engaged in fundraising and institution building since 1995, partly on land made available by a reconstruction and contraction of Fort Washington Way, the highway that had so long disconnected downtown from the river. The center's exhibits and activities promise to provide insight for everyone from scholars to schoolchildren, with

connections reaching well beyond the walls of the Walter Blackburn-designed building. The museum should bring thousands of people to Cincinnati every year, and perhaps they will see a thriving city surrounding the Freedom Center. The $100 million Freedom Center cannot solve racial problems merely by its presence, obviously, but it can provide space for dialogue and reflection. Perhaps most important, it will provide Cincinnati with a permanent reminder of the Underground Railroad, which offered aid and comfort for those escaping slavery in the South, a permanent reminder of a time in American history when blacks and whites worked together in the name of freedom, even in Cincinnati.

Clearly saving the city will require more than just these three institutions. It will require reversing decades of anti-urban thinking, planning, and policy. Cincinnati cannot compete with its own suburbs by selling itself as just another neighborhood; but it can compete with them as a city—a place with stunning architecture, vibrant streets, and a diverse community. As in cities around the country, Cincinnati's rebirth will have to come in the form of street life and culture, not cheap parking and easy access.

BIBLIOGRAPHY

Aaron, Daniel. *Cincinnati: Queen City of the West, 1819–1838.* Columbus: Ohio State University Press, 1992.

Clubbe, John. *Cincinnati Observed: Architecture and History.* Columbus: Ohio State University Press, 1992.

Condit, Carl W. *The Railroad and the City: A Technological and Urbanistic Hitory of Cincinnati.* Columbus: Ohio State University Press, 1977.

Cronon, William. *Nature's Metropolis: Chicago and the Great West.* New York: W. W. Norton and Company, 1991.

Davis, John Emmeus. *Contested Ground: Collective Action and the Urban Neighborhood.* Ithaca: Cornell University Press, 1991.

Fairbanks, Robert B. *Making Better Citizens: Housing Reform and the Community Development Strategy in Cincinnati, 1890–1960.* Urbana: University of Illinois Press, 1988.

Fleischman, John. *Free and Public: One Hundred and Fifty Years at the Public Library of Cincinnati and Hamilton County, 1853–2003.* Wilmington, Ohio: Orange Frazer Press, 2002.

Glazer, Walter Stix. *Cincinnati in 1840: The Social and Functional Organization of an Urban Community during the Pre–Civil War Period.* Columbus: Ohio State University Press, 1999.

Goss, Charles Frederic. *Cincinnati: The Queen City, 1788–1912.* Cincinnati: S.J. Clarke Publishing Company, 1912.

Hedeen, Stanley. *The Mill Creek: The Unnatural History of an Urban Stream.* Cincinnati: Blue Heron Press, 1994.

Holian, Timothy J. *Over the Barrel: The Brewing History and Beer Culture of Cincinnati.* St. Joseph, Missouri: Sudhaus Press, 2000.

Hurt, R. Douglas. *The Ohio Frontier: Crucible of the Old Northwest, 1720–1830.* Bloomington: Indiana University Press, 1996.

Jacques, Charles J. *Cincinnati's Coney Island: America's Finest Amusement Park.* Jefferson, Ohio: Amusement Park Journal, 2002.

Kenny, Daniel J. *Illustrated Cincinnati.* Cincinnati: Robert Clarke, 1875.

McGrane, Reginald C. *The University of Cincinnati: A Success Story in Urban Higher Education.* New York: Harper & Row, 1963.

Maxwell, Sydney D. *The Suburbs of Cincinnati: Sketches Historical and Descriptive.* Cincinnati: G.E. Stevens and Company, 1870.

Miller, Zane L. *Boss Cox's Cincinnati: Urban Politics in the Progressive Era.* Chicago: University of Chicago Press, 1968.

———. *Suburb: Neighborhood and Community in Forest Park, Ohio, 1935–1976.* Knoxville: University of Tennessee, 1981.

———. *Visions of Place: The City, Neighborhoods, Suburbs, and Cincinnati's Clifton, 1850–2000.* Columbus: Ohio State University Press, 2001.

Miller, Zane L. and Bruce Tucker. *Changing Plans for America's Inner Cities: Cincinnati's Over-the-Rhine and Twentieth-Century Urbanism.* Columbus: Ohio State University Press, 1998.

Philliber, William W. *Appalachian Migrants in Urban America: Cultural Conflict or Ethnic Group Formation?* New York: Praeger Publishers, 1981.

Rogers, Millard F. Jr. *John Nolen and Mariemont: Building a New Town in Ohio.* Baltimore: The Johns Hopkins University Press, 2001.

Ross, Steven J. *Workers on the Edge: Work, Leisure, and Politics in Industrializing Cincinnati, 1788–1890.* New York: Columbia University Press, 1985.

Schorer, Mark. *Sinclair Lewis: An American Life.* New York: McGraw Hill, 1961.

Shapiro, Henry D. and Jonathan D. Sarna, eds. *Ethnic Diversity and Civic Identity: Patterns of Conflict and Cohesion in Cincinnati since 1820.* Urbana: University of Illinois Press, 1992.

Taylor, Henry Louis, ed. *Race and the City: Work, Community, and Protest in Cincinnati, 1820–1970.* Urbana: University of Illinois Press, 1993.

They Built a City: 150 Years of Industrial Cincinnati. Cincinnati: The Cincinnati Post, 1938.

Tolzmann, Don Heinrich. *The Cincinnati Germans After the Great War.* New York: Peter Lang Publishing, 1987.

Wade, Richard C. *The Urban Frontier: The Rise of Western Cities, 1790-1830.* Columbus: Ohio State University Press, 1996 edition of 1959 original.

The WPA Guide to Cincinnati: A Guide to the Queen City and Its Neighbors. Cincinnati: The Cincinnati Historical Society, 1987 edition of 1943 original.

Students of Cincinnati history will want to make use of the Cincinnati Historical Society's extensive collections. In addition to essentially all published material relating to the city, the society's library contains wonderful archival materials. The Cincinnati Historical Society's extensive map and image collections are also of great use, as are their newspaper and periodical holdings. One of the best sources for Cincinnati history is the Historical Society's journal, which has been variously titled over the years but had a long run as *The Cincinnati Historical Society Bulletin* and is currently published as *Ohio Valley History*, with a new, more regional focus.

The main Cincinnati and Hamilton County Public Library also has extensive local history holdings, including a wonderful postcard collection, and like the Historical Society, it has a knowledgeable and helpful staff. The Cincinnati Art Museum's recently opened Cincinnati Wing also provides wonderful evidence of the Queen City's vibrant art history.

INDEX

The Contemporary Arts Center opened to international acclaim in May of 2003. Architect Zaha Hadid's dramatic contribution to the cityscape and the CAC's contribution to the arts "revival" of downtown drew nearly universal praise, in spite (or perhaps because) of the fact that it clearly marked a departure from the city's past. (Photograph by Jodie Zultowsky.)